Patrick Moore's Practical Astronomy S

For further volumes:
http://www.springer.com/series/3192

Sketching the Moon

An Astronomical Artist's Guide

Richard Handy
Deirdre Kelleghan
Thomas McCague
Erika Rix
Sally Russell

Richard Handy
Poway, CA, USA
richhandy@live.com

Erika Rix
Zanesville, OH, USA
erika_rix@yahoo.com

Deirdre Kelleghan
Bray, County Wicklow, Ireland
deirdrekelleghan@gmail.com

Sally Russell
Berkshire, UK
art.and.astronomy@gmail.com

Thomas McCague
Oak Forests, IL, USA
mccaguetp@comcast.net

ISSN 1431-9756
ISBN 978-1-4614-0940-3 e-ISBN 978-1-4614-0941-0
DOI 10.1007/978-1-4614-0941-0
Springer New York Dordrecht Heidelberg London

Library of Congress Control Number: 2011937227

© Springer Science+Business Media, LLC 2012
All rights reserved. This work may not be translated or copied in whole or in part without the written permission of the publisher (Springer Science+Business Media, LLC, 233 Spring Street, New York, NY 10013, USA), except for brief excerpts in connection with reviews or scholarly analysis. Use in connection with any form of information storage and retrieval, electronic adaptation, computer software, or by similar or dissimilar methodology now known or hereafter developed is forbidden.
The use in this publication of trade names, trademarks, service marks, and similar terms, even if they are not identified as such, is not to be taken as an expression of opinion as to whether or not they are subject to proprietary rights.

Printed on acid-free paper

Springer is part of Springer Science+Business Media (www.springer.com)

This book is dedicated to lunar sketchers from all over the globe, for whom it was written. To Cloudy Nights Telescope Reviews for the encouragement and friendships that helped make this book possible. To all who want to pick up the pencil or brush and try their hand at representing the Moon.

– Richard Handy

To Bernard for his love, wonderful support, and expert advice. To my children, Olwen, Owen, and Oona, who listened to Moon talk beyond the call of duty. To my mam, Eileen, and in memory of my dad, Michael, who gave me my first telescope. To my dear friend, Jane, who opened my eyes to astronomical sketching.

– Deirdre Kelleghan

To my wife, Pattie, children Michelle and Thomas, my mother and in memory of my late father, all of whom have always been supportive, loving and make my life the joy that it is.

– Thomas McCague

In loving memory of my grandparents, Pauline and Charles Withers and Elizabeth and Raymond Mayer, who enriched my life in so many ways and taught me to always believe in myself.

– Erika Rix

To my father, Len, and the memory of my mother, Eileen, for their enduring love and encouragement in all my endeavours, and for their foresight in rousing a sleepy child to watch the first man step onto the Moon.

– Sally E. Russell

Foreword

Sketching celestial objects is a habit that goes back to my previous astronomical incarnation as a teenager living under dark rural skies. The books I read on amateur astronomy back then instructed the amateur to sketch objects viewed, and I did so. It was simply part of the hobby, as I understood it. In the years since, I have learned that making such a sketch is actually as much an observing technique as a means of making a complete record. Going from the eyepiece to the paper and back, to make sure you have recorded what can be seen, causes you to look more closely and to *think* about what you see. Such interaction over time makes you a more careful and perceptive observer. For this reason, and to encourage people to try their hand at this technique, most books promote the idea that the act of sketching is far more important to the observer than the beauty of the result, a perception I shared for a time.

Involvement in the online astronomy forum Cloudy Nights, however, has changed that perception. The forum community includes a number of astronomy artists (as well as a separate forum to accommodate them) who not only share the results of their work, but freely offer advice to others interested in making better astronomical sketches. Like many who count themselves members of the Cloudy Nights community, I have learned a great deal about sketching from these artists. To this day I still can't hold the proverbial candle to artists such as the authors of this book, but looking over their collective shoulders in the forum has allowed me to steadily (if slowly) improve my own abilities to a degree I would likely not have achieved on my own. For although practice is surely the key to improvement, without instruction what do you practice?

A forum is a useful thing but lacks the portability of a book. In 2007, several of these master sketchers, including two of the authors of this current volume, collaborated on a book in the Patrick Moore's Practical Astronomy Series entitled *Astronomical Sketching: A Step-by-Step Introduction*. This very accessible manual for the astronomer-artist covers a wide range of objects commonly observed by amateur astronomers, and has become one of my most frequently used and frequently recommended astronomy references. Of course, it includes a solid introduction to sketching features viewed on the Moon.

But the Moon presents some unique challenges to the astronomer-artist, dear Selene being so fond of tricks of the light, and therefore deserves a more thorough treatment than a general manual of technique can provide. *Sketching the Moon: An Astronomical Artist's Guide*, by five of the best lunar observer-artists working today, steps in to effectively fill this need. All the major types of lunar features are covered, with a variety of sketching techniques applied to each. These techniques are

explained and illustrated in ways that take the mystery out of artwork, rendering it (so to speak) more accessible to anyone interested in going farther than merely illustrating their notes.

So, here we have at last the necessary instruction, neatly packaged and portable, that allows practice to make perfect. All you need now are a few art supplies and a clear moonlit night.

Thomas Watson

Preface

Due to its proximity and lack of an obscuring atmosphere, our rocky, cratered, and lava-flooded Moon is the only celestial body that displays three-dimensional form on its surface when viewed through earthbound binoculars or telescopes. All other planets and their moons are either so distant or so cloud covered that there is virtually nothing in terms of tangible surface form to sketch or photograph. In contrast, the Moon provides a surprisingly rich diversity of three-dimensional shapes and contours for the lunar sketcher. From the smallest crater to huge, circular mountain ranges built by basin-forming impact events, and the mare formed by lava flooding those basins, the Moon's rugged and varied topography reflects the history and the violence of impacts and the secondary processes of volcanism. Lit by the Sun during the changing angles of the long lunar day, the dramatic play of shadows and light upon its features are fascinating to observe, sketch, or photograph throughout a lunation.

We are fortunate to live in a period when reasonably priced telescopes and binoculars of good optical quality are available to almost everyone. Each can open lunar vistas of remarkable detail and drama. We can explore the Moon visually while recording the memories in the form of our sketches. Sketching the Moon's complex features is an excellent way to become a better observer while exercising our sketching skills. Sketching gives us time with our subject, inviting us to take a concentrated look at its contours, highlights, and shading. As we observe the Moon, we are often surprised to see features that are puzzling due to lighting or topography. A sketch can capture that scene, helping us convey to others important details of what was noted.

A good lunar sketch is a graphical representation of a visual *observation*. The strongest emphasis should be placed on "observation", being that it is the basis of the activity. The level of concentration required for creating a sketch works to sharpen our observing skills; no activity does this more efficiently. Experience with our chosen media develops our technical abilities to represent those observations. Sharing our sketches demonstrates our various personal styles and teaches us how others handle the subject and media.

Observation experience and media mastery can yield excellent sketches, some of them quite worthy of being called art. However, it is very important to emphasize that we need only create as faithful a rendering as our seeing, equipment, and abilities allow. Creating a work of art is not the aim of lunar sketching, regardless of the fact that there are many who do that routinely! Lunar sketches can be as simple or as intricate as we each decide to make them. The only limits are imposed by time and resolution and, ultimately, our skill developed through practice and perseverance. When we put too much

emphasis on art, it can become quite intimidating to those who have limited experience. And to that extent, art can be exclusive rather than an invitation to the joys of observing. Choose a medium that attracts you the most and begin by reading and following the associated tutorials, starting with "Basic Sketching, A Place to Begin" for a brief instruction on outline sketching and shading. Do not worry about whether your sketch is "artistic" or not. Does it represent your observation? Then it is a good sketch! It's as simple as that.

Key to Map of Featured Targets*

1	Ch. 1.1	Craters Geminus and Bernoulli – E. Rix
2	Ch. 1.2	Crater Gassendi – T. McCague
3	Ch. 1.3	Crater Eratosthenes – S. Russell
4	Ch. 1.4	Crater Copernicus – D. Kelleghan
	Ch. 11.4.19	Crater Copernicus – C. Lee
5	Ch. 1.5	Crater Langrenus – R. Handy
6	Ch. 1.6	Crater Clavius – D. Kelleghan
	Ch. 11.4.9	Crater Clavius – C. Lee
7	Ch. 2.1	Mare Crisium – D. Kelleghan
8	Ch. 2.2	Palus Epidemiarum – S. Russell
9	Ch. 2.3	Mare Serenitatis – T. McCague
10	Ch. 3.1	Montes Apenninus – R. Handy
11	Ch. 3.2	Mons Pico and Montes Teneriffe – R. Handy
	Ch. 3.4	Mons Pico and Montes Teneriffe – S. Russell
12	Ch. 3.3	Montes Harbinger – T. McCague
	Ch. 11.4.7	Craters Aristarchus and Prinz – S. Russell
13	Ch. 4.1	Rima Hyginus – E. Rix
14	Ch. 4.2	Rima Ariadaeus, Rima Hyginus, Rimae Triesnecker – R. Handy
	Ch. 4.3	Rimae Triesnecker – T. McCague
	Ch. 11.3.3	Rima Ariadaeus and Crater Agrippa – P. Grego
	Ch. 11.4.10	Rima Ariadaeus – D. Holt
15	Ch. 4.4	Rima Cauchy, Rupes Cauchy with Tau and Omega Cauchy Domes – E. Rix
	Ch. 7.4	Rupes Cauchy – D. Kelleghan
16	Ch. 5.1	Dorsa Smirnov – R. Handy
	Ch. 5.2	Dorsa Smirnov – T. McCague
17	Ch. 5.3	Crater Arago and Environs – S. Russell
18	Ch. 6.1	Crater Kepler – E. Rix

xi

	Ch. 6.2	Crater Kepler – T. McCague
19	Ch. 6.3	Crater Maginus – T. McCague
20	Ch. 6.4	Crater Tycho – D. Kelleghan
21	Ch. 7.1	Rupes Recta – E. Rix
22	Ch. 7.2	Scarp at Lacus Mortis – T. McCague
23	Ch. 7.3	Rupes Altai – S. Russell
	Ch. 7.5	Rupes Altai – R. Handy
24	Ch. 9.1	Mons Gruithuisen, Gamma and Delta – S. Russell
25	Ch. 9.2	Milichius and Hortensius Dome Fields – R. Handy
26	Ch. 11.2	Crater Theophilus – H. Roberts
	Ch. 11.4.6	Craters Theophilus, Cyrillus and Catharina – P. Mayhew
	Ch. 11.4.8	Crater Theophilus – E. Graff
27	Ch. 11.3.2	Sinus Iridum – P. Grego
28	Ch. 11.3.3	Craters Delisle and Diophantus – P. Grego
29	Ch. 11.3.4	Crater Parry – P. Grego
30	Ch. 11.4.1	Crater Petavius – C. E. Hernandez
	Ch. 11.4.11	Crater Petavius – R. Handy
31	Ch. 11.4.2	Mare Orientale – M. Rosolina
32	Ch. 11.4.4	Mare Imbrium near Aristillus and Autolycus – L. A. Hernandez
33	Ch. 11.4.5	Alpine Valley, Craters Aristillus, Eudoxus and Cassini – A. Massey
34	Ch. 11.4.12	Crater Maurolycus – C. E. Hernandez
35	Ch. 11.4.13	Crater Schiller compilation – S. Russell, M. Rosolina, R. Handy, E. Graff, J. Perez, E. Rix
	Ch. 11.4.15	Crater Schiller – D. Holt
36	Ch. 11.4.14	Crater Anaxagoras – D. Kelleghan
37	Ch. 11.4.16	Crater Ptolemaeus – L. A. Hernandez
38	Ch. 11.4.17	Crater Bullialdus – E. Rix
39	Ch. 11.4.18	Crater J. Herschel – H. Roberts
40	Ch. 11.4.20	Crater Plato – C. E. Hernandez

*Note: Tutorial and Gallery Sketches of the whole Moon are not included

Key to Map of Featured Targets

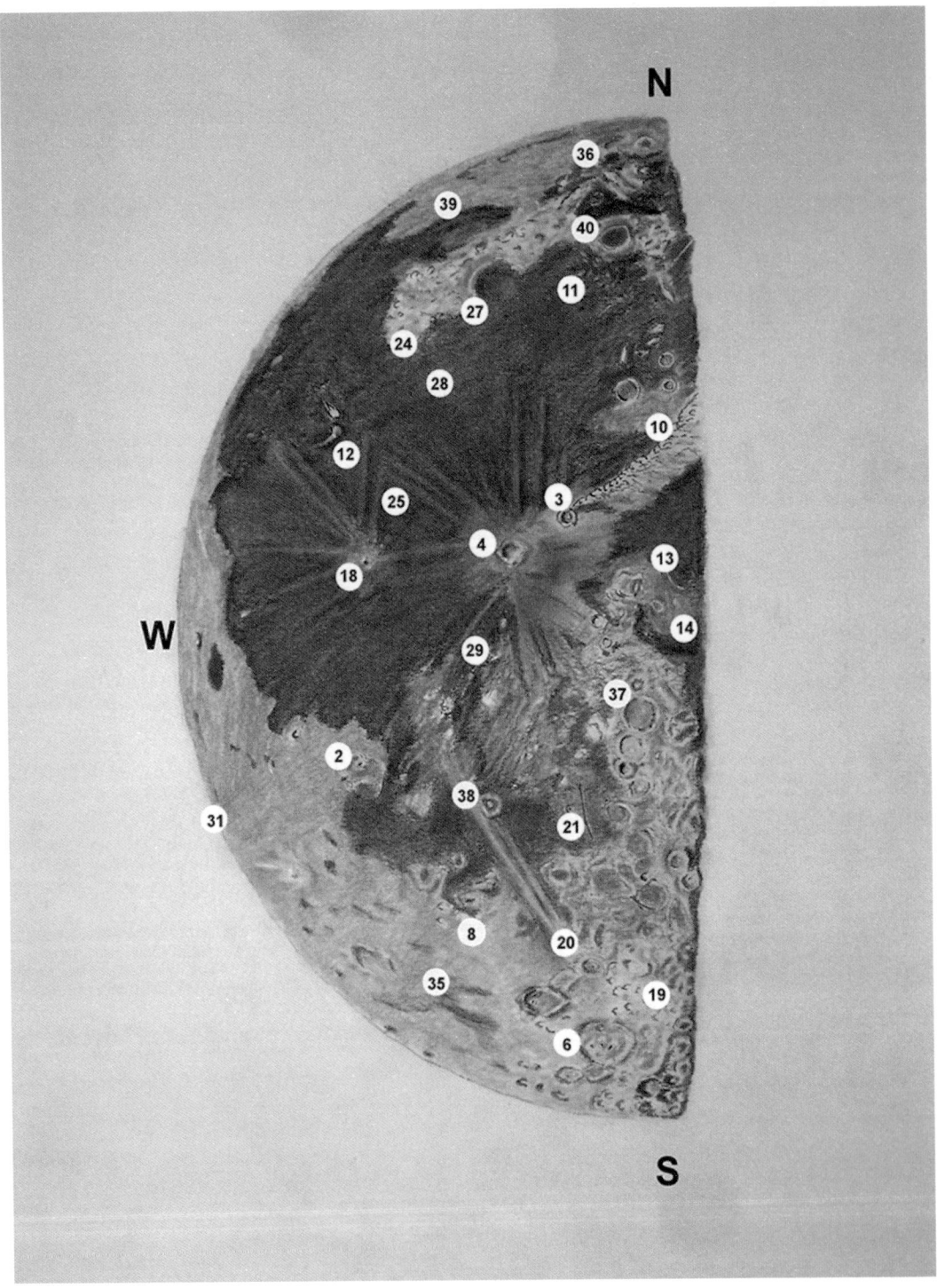

Key to Map of Featured Targets xv

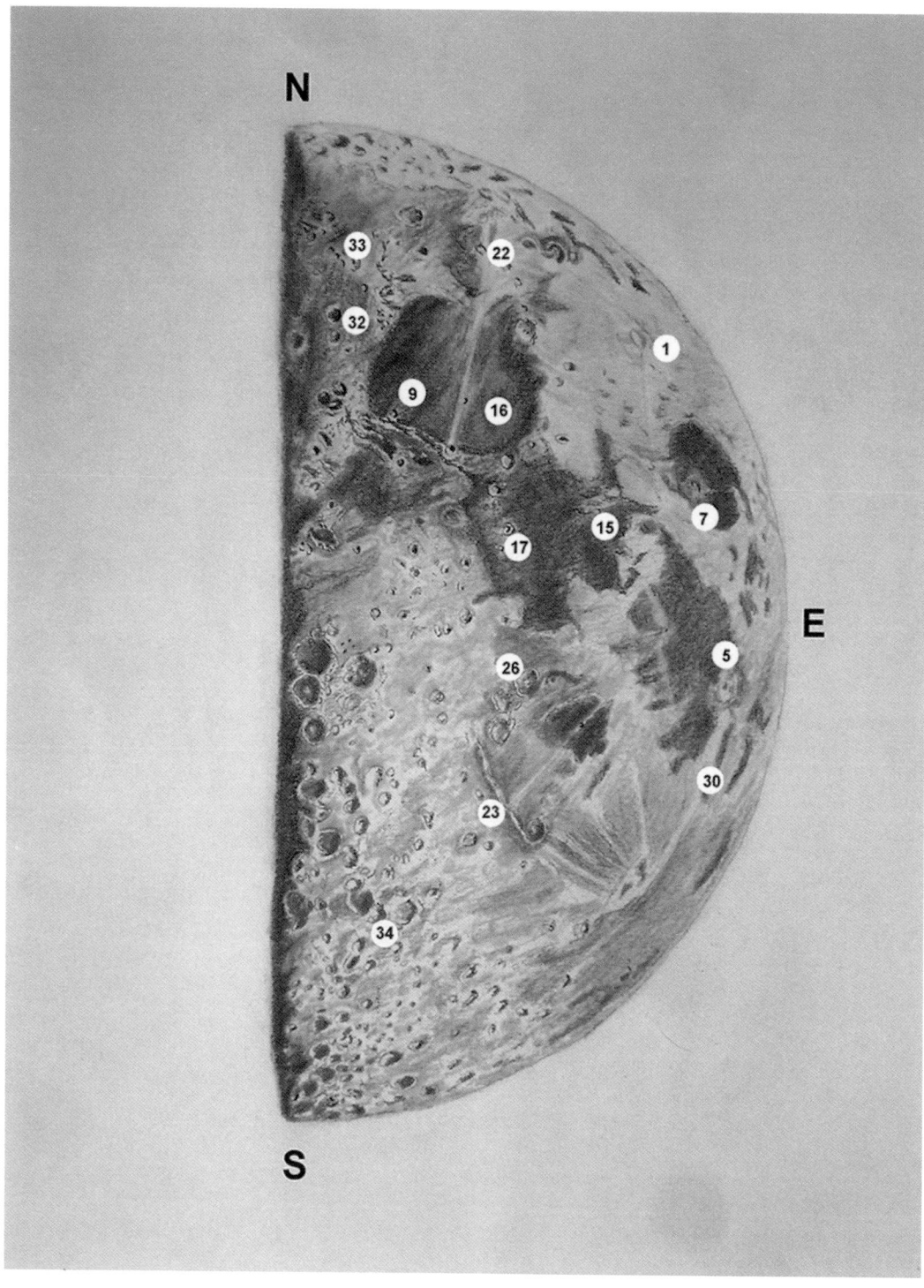

Acknowledgements

Richard Handy

I would like to thank the co-authors of this book, Erika Rix, Sally Russell, Deirdre Kelleghan and Thomas McCague for the willingness and perseverance required to bring this book to completion. To Charles Wood for his wonderful LPOD website, for his support of lunar sketching and his vast knowledge of lunar geology that educates as it incites inquiry about the Moon. I want to thank Jeff Woodall, Tim O'Brien and Raijah Thomas for their enthusiastic support. To my sister Rebecca Larson for her constant encouragement of my book ventures.

Deirdre Kelleghan

Astronomical sketching is an exercise in learning that cannot be matched for wonder, visual stimulation, and pure excitement. My journey toward the work in this book was anchored from the support of many individuals and groups. Jane Houston Jones (JPL) was the first person to introduce me to astronomical sketching and educational outreach. Dunsink Observatory (DIAS), Blackrock Castle Observatory, and Birr Castle Science Centre sponsored my International Astronomical Sketching Exhibition in IYA 2009. The Irish Federation of Astronomical Societies, including The Irish Astronomical Society, were always encouraging. The members of The Astronomical League gave me an opportunity to talk about drawing the moon at their annual convention in New York. The energy Rich, Erika, Thomas, and Sally have expelled in the production of this book has my total admiration. Their drawings are beautiful and inspirational. I acknowledge whole heartily the excellent Cloudy Nights' community, the best place for Moon sketchers to learn and grow. My lunar sketching and outreach interest has blended totally in that I now use drawing as an educational tool in my work to share the Moon with children.

Thomas McCague

Just 5 years ago after retiring from my full-time profession, I began thinking about ways to improve on my enjoyment of lunar observing. In my youth, I dabbled in sketching, so I started again in earnest but this time I posted some of these cryptic sketches on-line using the safety of the nickname given to me by my friends and colleagues, namely Frank McCabe. It was about this time I met up with all of my talented co-authors. With their guidance and direction, I could see steady improvement in my renderings. Therefore, to Rich, Dee, Erika and Sally a warm and heartfelt thank you. Without the four of you, I would still be recording my written observing notes with minimal crude drawings intended for my eyes only. Furthermore, I would like to acknowledge my dear friend Dale Holt as a fellow sketcher who always gives to me an honest assessment of my sketching efforts. Sketching the Moon is alive and well in the twenty first century thanks to lunar sketchers everywhere.

Erika Rix

The astronomy community has an abundance of people willing to selflessly share their trials and errors, experiences, and techniques for the advancement of anyone who shares this hobby. What a wonderful thing to witness and be a part of. Rich Handy, thank you for your dedication to helping others build the confidence to not only try their hands at astronomical sketching, but to provide means for sharing and learning through the Astronomy Sketch of the Day website as well as conceptions for projects such as this book. Thank you to Cloudy Nights Telescope Reviews for providing an invaluable friendly online atmosphere for amateur astronomers to gather. To my fellow co-authors, it has been a joy working with such a talented group of astronomical sketchers! I want to especially thank my husband, Paul, and friends, Gary Gibbs, Tom Trusock, and Howard Fein for their support and encouragement.

Sally Russell

When I chanced upon a web page featuring a superb lunar drawing by Rich Handy, I had no idea that I was about to embark on an extraordinary sketching journey. Thank you Rich, for your generous encouragement to try my hand at 'white on black' lunar sketching, for your invitation to join in with the camaraderie of the 'Cloudy Nights' observing and sketching community where I have made so many new friends, and for giving me the opportunity to play a part in this project. Rich, Erika, Tom and Dee; it's been a real privilege working with you. Thank you for your help, hard work, and dedication in seeing this project through. Special thanks go to my husband and son, Adam and Cameron, who have uncomplainingly learned to live with my passion for the Moon! And to my fellow astronomers with whom I have shared so many joyous hours under dark skies – thank you for your friendship, advice, encouragement and inspiration over the years.

The five of us would like to thank Thomas Watson for his invaluable assistance in reviewing and editing our work. For his technical advice and tutorial submissions, thanks go to Jeremy Perez. Many thanks also to our sketch or tutorial contributors Eric Graff, Peter Grego, Harry Roberts, Alexander Massey, Carlos E. Hernandez, Leonor Ana Hernandez, Michael Rosolina, Chris Lee, Peter Mayhew and Dale Holt.

Finally, we would like to say a special thank you to John Watson, Astrobooks, for his guidance and to our editor, Maury Solomon, Springer Science and Business Media, LLC, for her advice and support.

Contents

Foreword, by Thomas Watson .. vii

Preface ... ix

Key to Map of Featured Targets ... xi

Basic Sketching – A Place to Begin .. xxi

1 Sketching Craters ... 1
 1.1 Charcoal – Geminus (by Erika Rix) .. 1
 1.2 Conté on Black Paper – Gassendi (by Thomas McCague) 7
 1.3 Graphite Pencil – Eratosthenes (by Sally Russell) 11
 1.4 Pastels on Black Paper – Copernicus (by Deirdre Kelleghan) 15
 1.5 Conté Crayons on Black Paper – Langrenus (by Richard Handy) 18
 1.6 Pastel and Conté on Black Paper – Clavius (by Deirdre Kelleghan) .. 21

2 Sketching Maria (Seas) .. 25
 2.1 Pastels and Conté Crayons on Black Paper – Mare Crisium
 (by Deirdre Kelleghan) .. 25
 2.2 Conté Crayon and Pastels on Black Paper – Palus Epidemiarum
 (by Sally Russell) ... 28
 2.3 Graphite Pencil – Mare Serenitatis (by Thomas McCague) 33

3 Sketching Mons (Mountains) ... 37
 3.1 Conté on Black Paper – Montes Apenninus (by Richard Handy) 37
 3.2 Pen and White Ink on Black Paper – Mons Pico and Montes
 Teneriffe (by Richard Handy) ... 41
 3.3 Graphite Pencil – Montes Harbinger (by Thomas McCague) 45
 3.4 Pastels on Black Paper – Mons Pico and Montes Teneriffe (by Sally Russell) 49

4	**Sketching Rilles (Lava Channels)**	53
	4.1 Charcoal – Rima Hyginus (by Erika Rix)	53
	4.2 Conté Crayon on Black Paper – Rima Ariadaeus, Hyginus and Rimae Triesnecker (by Richard Handy)	58
	4.3 Graphite Pencil – Rimae Triesnecker (by Thomas McCague)	61
	4.4 Black Felt-Tipped Pen on White Paper, Stippling – Rima Cauchy (by Erika Rix)	64
5	**Sketching Dorsa (Wrinkle Ridges)**	69
	5.1 Carbon Pencils – Dorsa Smirnov (by Richard Handy)	69
	5.2 Graphite Pencil – Dorsa Smirnov (by Thomas McCague)	73
	5.3 Conté Crayons on Black Paper – Environs of Arago (by Sally Russell)	76
6	**Sketching Crater and Sunlight Rays**	81
	6.1 Charcoal – Kepler (by Erika Rix)	81
	6.2 Conté Crayons on Black Paper – Kepler (by Thomas McCague)	87
	6.3 Conté Pastel Pencil on Black Paper – Maginus (by Thomas McCague)	91
	6.4 Mixed Media – Tycho (by Deirdre Kelleghan)	94
7	**Sketching Rupes (Scarps)**	103
	7.1 Charcoal – Rupes Recta (by Erika Rix)	103
	7.2 Conté Crayon on Black Paper – Lacus Mortis Fault (by Thomas McCague)	108
	7.3 Graphite Pencil – Rupes Altai (by Sally Russell)	111
	7.4 Pastels and Conté on Black Paper – Rupes Cauchy (by Deirdre Kelleghan)	116
	7.5 White Felt-Tipped Paint Pen on Black Paper, Cross Hatching – Rupes Altai (by Richard Handy)	119
8	**Sketching the Phases**	123
	8.1 Conté on Black Paper – Full Phase (by Erika Rix)	123
	8.2 Graphite Pencil – Waxing Crescent, First Quarter, Full and Waning Gibbous Phases (by Thomas McCague)	128
	8.3 Ink Wash – Waxing Gibbous Phase (by Sally Russell)	132
	8.4 Pastels on Colored Paper – Waxing Crescent Phase (by Sally Russell)	139
	8.5 Pastel and Conté on Black Paper – Waxing Crescent and Waxing Gibbous Phases (by Deirdre Kelleghan)	144
9	**Sketching Domes**	149
	9.1 Graphite Pencil – Mons Gruithuisen Gamma and Delta (by Sally Russell)	149
	9.2 Conté on Black Paper – Milichius and Hortensius Dome Fields (by Richard Handy)	153
10	**Sketching Lunar Eclipses**	159
	10.1 Oil Pastels on White Paper (by Thomas McCague)	159
	10.2 Pastels, Conté, Grated Pastels on Black Paper (by Deirdre Kelleghan)	163
	10.3 Colored Pastels on Black Paper (by Sally Russell)	166

11 Additional Tutorials and Sketching Gallery 173
 11.1 White and Black Charcoal on Black Stock – Crescent Moon
 and Earthshine (by Jeremy Perez) 173
 11.2 Ink and Ink Wash – Theophilus (by Harry Roberts) 178
 11.3 Pencil Sketching and Cybersketching – Sinus Iridum, Rima Ariadaeus,
 Agrippa, Delisle, Diophantus, and Parry (by Peter Grego) 181
 11.4 Sketching Gallery 185

12 General Hints and Tips 195
 12.1 Art Equipment 195
 12.2 Observing Equipment 205
 12.3 General Comfort 207
 12.4 Miscellaneous 208

A Final Note from the Authors 211

Appendix A: Observing Forms 213

Appendix B: Glossary 217

Appendix C: Resources 227

Index 229

Basic Sketching – A Place to Begin

If this is the first time you have ever attempted a lunar sketch, you will probably benefit from a brief introduction to outline sketching, which is composed of simple line drawing and simple shading. The only tools required are a No. 2 graphite pencil, an eraser, and a sheet of white paper. For these exercises, we will refer to a photograph of the crater Theophilus as we sketch (**Fig. 0.0.1**).

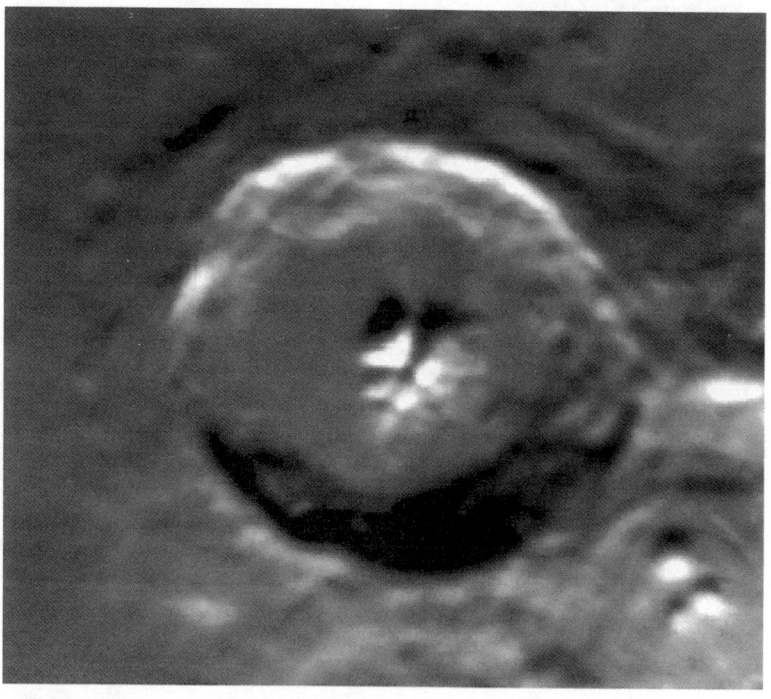

Fig. 0.0.1

Sketching a Crater's Outline

Step 1

Start by looking at the crater to determine its general shape. Is it circular or more elliptical? Is the crater rim irregular with protrusions or indentations along its perimeter? You will need a place to start your outline, so choose the 12-o'clock position on the rim and create an outline as you continue clockwise around the rim until the 12-o'clock position is reached again. Do not worry if your line strays as you copy the rim; simply go ahead and start a new line at that point. You can use the eraser to correct any mistakes later **(Fig. 0.0.2)**.

Step 2

The next step is to draw the line that represents the crater floor. Carefully compare the line that you are drawing to the rim of the crater as you draw **(Fig. 0.0.3)**.

Fig. 0.0.2

Fig. 0.0.3

Basic Sketching – A Place to Begin

Step 3

Now add the detail of the central peaks in the center of the floor **(Fig. 0.0.4)**.

Step 4

Next, sketch the glacis (or outer slope of the rim). This is not always easy to discriminate, but generally it is about the width of the rim to floor distance. You have now completed a simple outline drawing of the crater Theophilus **(Fig. 0.0.5)**.

Fig. 0.0.4

Fig. 0.0.5

Shading a Crater

The outline sketch of Theophilus that you just finished is a good place to learn how to apply shading to lunar sketches. In the photograph of Theophilus, the direction of the light is coming from the bottom of the picture. Note how the shadows are aligned with features such as the central peaks? Shadows in a drawing can impart three-dimensional appearances to two-dimensional outline sketches.

Step 5

Start by outlining the shape of the large shadows that fill the lower wall of the crater and its central peaks (**Fig. 0.0.6**).

Step 6

Then fill in these shadow outlines with moderate pressure on the pencil until they are the darkest you can make them (**Fig. 0.0.7**).

Fig. 0.0.6

Fig. 0.0.7

Basic Sketching – A Place to Begin

Step 7

Continue filling in the outline of the shadows, making sure that areas that are partially lit are shaded a lighter gray **(Fig. 0.0.8)**.

Step 8

Fill in the lighter gray shadows of the terraces on the lit rim **(Fig. 0.0.9)**.

Fig. 0.0.8 **Fig. 0.0.9**

Step 9

Continue in like fashion until the inner wall, floor, and the shadows of glacis' dark slopes are adequately shaded **(Fig. 0.0.10)**.

Step 10

Add the lighter shadows on the lit faces of the glacis **(Fig. 0.0.11)**.

Fig. 0.0.10

Fig. 0.0.11

Basic Sketching – A Place to Begin

Step 11

Continue until you feel that you have added enough detail to the glacis **(Fig. 0.0.12)**.

Fig. 0.0.12

Step 12

You have finished your first fully shaded sketch of Theophilus! **(Fig. 0.0.13)**

If you practice outline sketching and simple shading, you will soon become proficient at quickly capturing the characteristic shapes that make craters instantly recognizable. Not all craters will appear nearly face-on as seen with Theophilus. The closer a crater is to the lunar limb, the more elliptical its rim appears. This is simply a consequence of foreshortening from our point of view as earthbound observers.

Fig. 0.0.13

Basic Sketching – A Place to Begin

xxxi

Continue these exercises with a few photographs to get a feel for sketching craters in different orientations:

Photograph of Bullialdus **(Fig. 0.0.14)**
Photograph of Aliacensis, Werner and Krusenstern **(Fig. 0.0.15)**
Photograph of Aristoteles and Eudoxus **(Fig. 0.0.16)**
Photograph of Gassendi **(Fig. 0.0.17)**

Fig. 0.0.14

Fig. 0.0.15

Fig. 0.0.16

Fig. 0.0.17

Chapter 1

Sketching Craters

There is no spot on the Moon's surface that has not been impacted by an asteroid, comet, meteorite, or the ejecta created by these lunar collisions. Craters range in size from the huge mare-flooded basins thousands of kilometers wide, to large terraced craters with towering central peaks (like Pythagoras, Tycho, and Copernicus), all the way down to small, simple bowl or conical-shaped craters. They possess morphological differences, based on the size, mass, and velocity of the impactor that can help us understand the creation and erosion of these ubiquitous and much-loved lunar forms.

1.1 Charcoal – Geminus (by Erika Rix)

I enjoy sketching craters away from the terminator in order to grab as much detail as I can from within the crater walls. By doing this, I have the added advantage of relaxing without the worry of the shadows changing too quickly, or worse, my target being swallowed up by shadows during the waning phase before I have time to complete the sketch. The downside of sketching further away from the terminator is that the view lacks the vast dramatic blackness of the shadows as they play against ridges and crevices. The different shadow effects have their own advantages; therefore, how close your target is to the terminator will depend on your observing goal on any given night.

Geminus and Bernoulli are featured in this tutorial and were approximately 11° away from the terminator during the waning Moon.

Suggested Materials

- 8½″ × 11″ sheet of white sketching paper on a clipboard (Rite in the Rain paper was used for this tutorial)
- Assorted blending stumps and tortillons
- Chamois for blending large areas (I used my fingertips instead for this tutorial)
- Charcoal pencil (6B soft was used in this tutorial)

R. Handy et al., *Sketching the Moon: An Astronomical Artist's Guide*,
Patrick Moore's Practical Astronomy Series, DOI 10.1007/978-1-4614-0941-0_1,
© Springer Science+Business Media, LLC 2012

- Charcoal vine in a wooden holder
- Flat piece of compressed charcoal
- Exacto knife for sharpening charcoal vine and pencil sharpener for the charcoal pencil
- Sandpaper for sharpening blending stumps and tortillons
- Cloth rag to wipe your fingertips

Step 1

Lightly create a rough outline of the main crater with your charcoal pencil. Concentrate on shape and proportion. By creating a light outline, you will be able to sketch over the original markings without the need to erase.

Add the shaded areas of the crater as shown in **Fig. 1.1.1**. The shadows can change rapidly, especially closer to the terminator. Because of this, it's important to capture their shapes straight away and then concentrate on the other features; otherwise, you will find yourself "chasing" the shadow changes, making it nearly impossible to complete the sketch. Another advantage of adding the shadows at the beginning of the sketch is that it helps to provide an anchor in which to add the rest of the markings.

The charcoal vine is a nice in-between size for adding thicker markings that still need to have a sharp, detailed edge. Compared to a narrow-pointed charcoal pencil, the charcoal vine reduces the time needed for filling in shaded areas in and around the craters. On the other hand, a regular piece of compressed charcoal would be cumbersome for these areas unless your sketch area is large enough to accommodate its size.

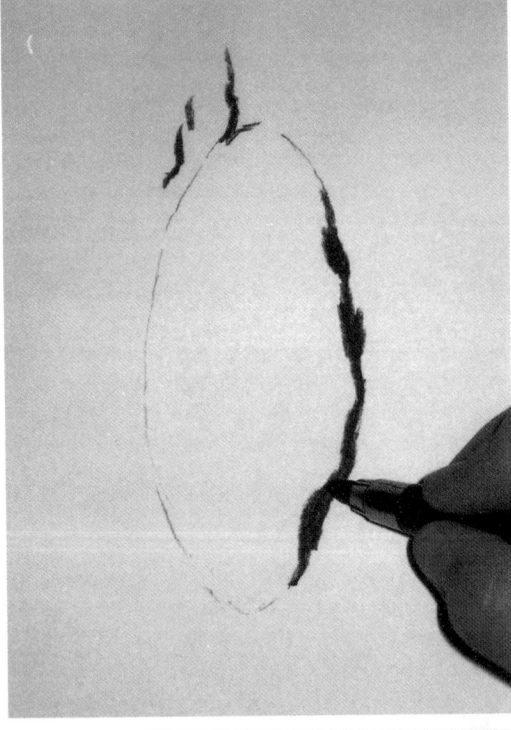

Fig. 1.1.1

1.1 Charcoal – Geminus (by Erika Rix)

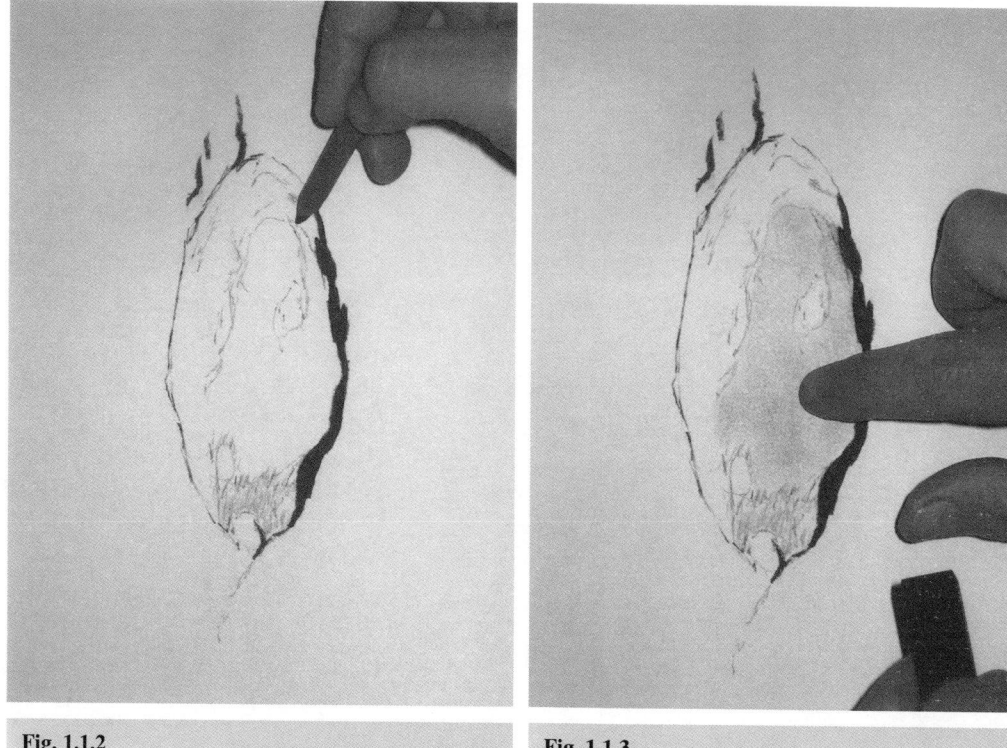

Fig. 1.1.2

Fig. 1.1.3

Step 2

Add subtle shadings inside the crater using the charcoal pencil (**Fig. 1.1.2**). These shadings may include finer details such as craterlets, texture on the crater floor, central peaks, or the terraced crater wall. Increase the magnification if seeing conditions will allow.

Step 3

There are several tools used for applying charcoal to your paper and each has pros and cons. Although your fingertips will ultimately leave oily residue on your sketch, using your fingertips may give you better control for an even, light layer of charcoal.

Ensure your fingertip is clean, brush it across the compressed piece of charcoal, and then fill in the crater floor with your "loaded" fingertip as shown in **Fig. 1.1.3**. Try not to smudge the dark shadowed areas; however, it can be rubbed out later with a clean blending stump if you do. Use of an eraser with Rite in Rain paper may result in altering the paper's tooth. When that happens, it is difficult to apply a smooth layer of charcoal over it as the sketch progresses. If you do wish to use an eraser, I would recommend a clean vinyl or kneaded eraser.

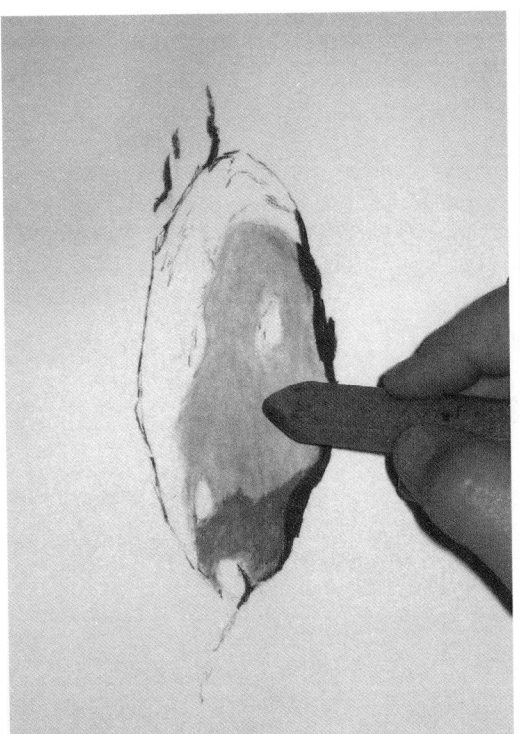

Fig. 1.1.4

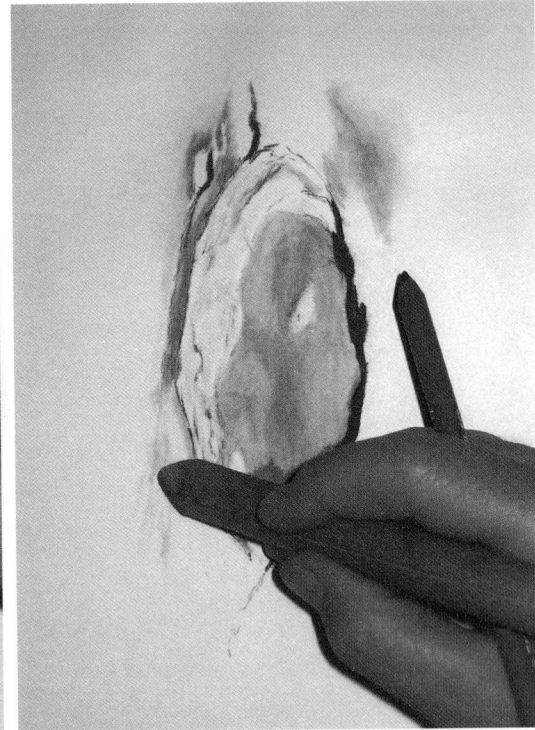

Fig. 1.1.5

Step 4

Blend the crater floor with a large, clean blending stump (you can clean your blending stump with sandpaper). A blending stump will create a smooth finish and give you better blending control along the edges of the crater floor. Blend the lighter areas first and then the medium-shaded areas. Lastly, blend the darkest shaded areas (**Fig. 1.1.4**). If you smudge any of the areas into each other, you can rub out the smudges with a clean blending stump.

Step 5

Study the crater floor. You will notice an uneven contrast in the crater floor that was used for this tutorial. If you observe any darkened areas, add more charcoal and then blend. Next, add more of the finer details along the crater wall with your charcoal pencil and blend where needed with a fine-tipped blending stump or tortillon. If you blended too much, go back over those areas with a sharpened charcoal pencil so that the sharper details stand out in the sketch.

Add details around the outer edges of the crater and then blend (**Fig. 1.1.5**). Take your time and wait for seeing conditions to steady. Patience pays off when adding finer details to a sketch.

1.1 Charcoal – Geminus (by Erika Rix)

Fig. 1.1.6

Fig. 1.1.7

Step 6

If there are companion craters, you should now add them following Steps 1–5. Use the main crater as a reference for the companion craters' proportions and locations. I like to start with the larger companion craters and then work my way down to the smaller ones **(Fig. 1.1.6)**.

Step 7

Now is the time to extend the sketch by adding background. Pay attention to contrast and add more charcoal where needed to depict albedo. There may be highlighted areas where no charcoal should be added at all. Again, I applied the background with my fingertips **(Fig. 1.1.7)**.

Another useful method of applying background is to rub a flattened piece of charcoal directly onto the paper and then blend with a chamois. The chamois will remove most of the charcoal and leave you with a very smooth, light background similar to what your fingertips will create. The risk is that sometimes the edges of the charcoal will leave dark streaks on the paper that are difficult to remove, even after rubbing smooth with your chamois. Although the process is much quicker using the charcoal directly on the paper and blending with the chamois, spending a little extra time using your fingertips may give you more control.

Step 8

The last companion crater is added, and now it's time to concentrate on the background details. Using your charcoal pencil, roughly draw in the shaded areas around the ridges **(Fig. 1.1.8)**.

Fig. 1.1.8

Fig. 1.1.9

Step 9

Blend with the larger blending stump and then add another layer of detail to the background for depth. Blend again slightly if needed. If you have blended too much, add the finest details once more with your charcoal pencil. Really concentrate on the sharpest edges that you observe through the eyepiece. Wait for steady seeing and take your time. These last details that you observe and then add to your sketch create a crisp, realistic representation of your observation (**Fig. 1.1.9**).

Supplementary Sketch Information

August 26, 2010, 07:37 UT
PCW Memorial Observatory, OH, USA
Zhumell 16″ Truss-Dobsonian (f/4.5), 12 mm Burgess, 2x Barlow, 300x Magnification, 13%
 T moon filter. Temperature: 59°F (15.1°C). Humidity: > 90%. Seeing: Antoniadi III-I.

Phase: 342.4°, Lunation: 16.19d, Illumination: 97.6%
Libration in Latitude: −05:48, Libration in Longitude: −02:06
Altitude: 46:49, Azimuth: 206:48.

Fig. 1.1.10 Erika Rix observing on a typical winter night with her Zhumell 16″ truss-Dobsonian (f/4.5), PCW Memorial Observatory, OH, USA

1.2 Conté on Black Paper – Gassendi (by Thomas McCague)

As a target for this crater tutorial sketch, I selected the 110-km, floor-fractured crater, Gassendi, just a half day beyond the sunrise terminator. If you are sketching features right at the terminator, the rapidly changing shadows can make sketching a difficult race against the clock. However, a crater such as Gassendi, observed at just a little over 12 hours beyond the sunrise terminator, still has dramatic shadows to add interest. If you choose to sketch Gassendi during a similar lunation, you will have an hour or two to sketch this feature before the shadows change significantly.

Suggested Materials

- Conté crayons
- Conté pastel pencils, both white and black
- Black Strathmore 400 Artagain paper
- Art gum eraser
- Small clean brush for eraser crumbs
- Small pieces of paper towel for blending
- No. 2 blending stumps
- X-Acto knife
- Sandpaper block and emery boards for sharpening and maintaining pencils

The sharp contrast between light and shadow on the Moon can be easily imitated using this combination of pencil and paper. Since I sketch mostly using a clipboard for a backing board, I like to cut several pieces of 9- × 12-in. size pieces from a 19- × 25-in. sheet of paper. While sketching lunar shadow features at the terminator, it is best to work at a moderately quick pace – alternatively, choose targets further from the terminator shadow line until you can accurately estimate typical sketching time with your selected media. With practice, you may consider the method used here the fastest way to complete a lunar crater on paper. Sketching highlighted areas is sometimes quicker than sketching shadows; thus, using white on black can be an ideal way to quickly sketch changing features near the terminator. This combination of media for sketching the Moon has become my favorite way of rendering lunar features.

Step 1

Begin by applying white Conté crayon (chalk) held flat against the page. This will be a fairly light application, using only the weight of the pastel crayon. Our goal is to make an even, random application in preparation of creating the foundation of the illuminated lunar surface.

Using your fingertips, blending stumps, or paper towel pieces, blend until you achieve an even, light-gray tone on the paper (**Fig. 1.2.1**). You may find your fingertips work more quickly. Repeat the application and blending process if needed until you have the desired shade of gray. The bright foundation represents the sun-illuminated lunar surface and should not be made excessively bright. Add more white if needed or rub out the excess white with your fingertips.

Step 2

While studying the crater, draw a light outline of it using the Conté pencil as in **Fig. 1.2.2**. If an error is made, it can be rubbed out and blended into the background.

Shape and brighten the sunlit-intense areas by pressing more firmly with your Conté pencil, creating the brightest white regions including the rims and mountains on the crater floor.

Continue in the same fashion, adding additional neighboring craters and features.

Fig. 1.2.1

Fig. 1.2.2

1.2 Conté on Black Paper – Gassendi (by Thomas McCague)

Fig. 1.2.3

Fig. 1.2.4

Fig. 1.2.5

Step 3

Using a small broken piece of Conté crayon held flat to the paper, add additional white for the brighter background regions (**Fig. 1.2.3**). Blend and adjust the newly brightened regions with your fingertip or paper towel, and perhaps some erasing to match the eyepiece view.

Step 4

If an eraser was used, brush away the erasure crumbs before continuing (**Fig. 1.2.4**). If tones were altered after erasing, correct and adjust the sketch until it again matches the telescope view. Don't worry about the black shadows yet. Concentrate on getting the whites and grays of the lunar surface as close as you can to what you see on the Moon's surface in, and around, the crater. When the overall illuminated lunar tones look correct, it will then be time to go after the dark shadows described in Step 5.

Step 5

There are at least two easy ways to add the shadows: you can erase down to the black paper, or you can add black Conté with a pencil as shown in **Fig. 1.2.5**. Be warned – black Conté does not erase as well as the white. It also cannot easily be covered with white unless it is completely erased first. If you work carefully, it is completely manageable and you will not damage the paper.

Fig. 1.2.6

Step 6

Using the previous steps, adjust the final appearance of the sketch to closely match the eyepiece view. You will be left with a personal, realistic, and permanent record of this particular observing session that you can go back to enjoy and compare during future apparitions and sketches of the same crater. Not too difficult right **(Fig. 1.2.6)**?

Preserving the Sketch

Upon completion of the sketches I rendered for this book, I preserved all of them by using an acetone containing acrylic base resin spray fixative. It is important that this chemical spray is used outdoors and that it is applied in very small amounts (1-second spray bursts) with sufficient drying time between no more than three applications. Follow the directions on the container and be careful not to use too much or it will darken all bright areas of the sketch.

Supplementary Sketch Information

Gassendi Crater on black Artagain paper
Sketch Date: February 6, 2009, a time of favorable libration for this crater using a 10-in. f/5.7 Dobsonian telescope riding on an equatorial platform and a 9 mm eyepiece for 161x at 00:15–03:00 UT

Seeing: Antoniadi III
Weather clear, calm, 19°F (−7°C)
Lunation 10.7 days
Moon 83% illuminated

1.3 Graphite Pencil – Eratosthenes (by Sally Russell)

Individual craters viewed at a high magnification are really good subjects for sketching. I generally tend to use a telescope on a driven mount so that my target can be kept in the field of view for extended periods of time. I find this simplifies the capture of very fine details in a sketch, but this is just a personal preference. It is also possible to make very detailed drawings when using a non-driven mount if you are a visual observer already well practiced at using this type of equipment.

In this example, crater Eratosthenes was viewed less than a day after sunrise, so the shadows both within the crater itself and being cast by the surrounding mountains (part of the Montes Apenninus) were still quite crisp and obvious, even though they were not very extended.

Note: The sketch in this example was made from a high power telescopic view using a refractor with a mirror diagonal giving a mirror image at the eyepiece. The finished sketch can always be scanned then electronically flipped to the correct orientation if desired.

Suggested Materials

- Drawing board (plus masking tape to fix the paper in place)
- White cartridge paper (80 lb weight – paper size 8″ × 12″ was used in this tutorial)
- 2B, 4B and 6B graphite pencils
- Pencil sharpener
- Kneadable eraser
- Plastic eraser

Fix the paper to the drawing board using either the built-in clip(s) on the board (if it has any) or with masking tape applied lightly at the paper corners. The temptation to begin sketching immediately will be very great, but it is worth studying the view for a while beforehand to thoroughly familiarize yourself with the target.

The Moon seen at high power can be thoroughly overwhelming. But in a sense, lunar features are really just different areas of tonal gray defined by their light/dark boundaries. The different tonal depths of adjacent areas set the crispness of the boundary line between them. So, for example, a light-toned area next to a slightly darker toned area will give the appearance of a much softer boundary line than a light-toned area set next to a very dark-toned area. These are the crisp boundaries that we see (in our mind's eye) as being lines when we set about sketching.

Step 1

Sharpen your 2B pencil and use it to lightly sketch in the outlines of the crater rim, central peaks, and main surrounding terrain features **(Fig. 1.3.1)**. Take your time so that you get the positions as accurate as possible. I find it quite useful to judge the sizes of features in comparison with the diameter of the crater – e.g., the length of the ridge of mountains at the top of the sketch is approximately equivalent

Fig. 1.3.1

Fig. 1.3.2

Fig. 1.3.3

to one crater diameter. Don't be afraid to erase and re-sketch these outlines if you feel it necessary to get the layout correct. It is far easier to do this now, rather than once you have begun to add any shading and detail. In this example, note the breaks that have been left in the crater rim, top and bottom. The breaks show that these areas were very brightly lit at the time of the observation.

Step 2

Using the 4B pencil, start blocking in the main areas of deepest shadow. For the shadowing within the crater, make your pencil marks in parallel with the curve of the crater rim. This will help denote the terracing of the inner crater walls, and the effect will be reinforced if you leave similarly aligned gaps showing the highlights present within the terracing (**Fig. 1.3.2**).

Now add the shadows cast from the central peaks and those on the outside of the crater wall (**Fig. 1.3.3**). You have now defined the

1.3 Graphite Pencil – Eratosthenes (by Sally Russell)

Fig. 1.3.4

Fig. 1.3.5

major feature of your sketch and have essentially 'frozen the moment' by fixing the extent of the shadowing as you saw it at the beginning of your observing session.

Step 3

Blunt the tip of the 6B pencil until it is soft and rounded by gently scribbling with it on a scrap piece of paper. Now hold the pencil on its side so that there is the largest possible area of graphite in contact with the paper. Use a light and gentle sweeping motion to shade in the crater floor. I find it helps to hold the pencil at least half way down its length when doing this, as the pencil tip will then just rest on the paper (rather than being pressed down) which gives a softer effect to the finished shading **(Fig. 1.3.4)**.

Remember to leave spaces of untouched paper to denote the sunlit sides of the central peaks and any crater floor highlights. If needed, use a kneadable eraser molded into a fine point to remove small amounts of graphite to further enhance these highlights. Continue building up deeper tones where required by adding further layers of graphite to complete the floor of the crater **(Fig. 1.3.5)**.

Step 4

In a similar fashion, and again using the 6B pencil, start adding graphite to the outer surrounds of the crater to represent the smooth lunar mare, building up the tones in layers by using slightly lighter or heavier pressure on the pencil as you did before **(Fig. 1.3.6)**. If you add the shading by making a gentle cross-hatching motion with your pencil, it will give the area an overall fairly uniform finish yet will still convey a slight texture to the surface. Make sure to spend a good few minutes at the eyepiece

Fig. 1.3.6

Fig. 1.3.7

every so often to study your subject well, then try and capture the subtle tonal differences of these uneven surface regions, as they will define the topography of the wider area around the crater.

Step 5

Continue adding the mare background, working your way around the crater and the previously drawn terrain features, blending the background lightly with your fingertip to soften out the pencil shading lines as you go (**Figs. 1.3.7** and **1.3.8**).

Step 6

With the 4B pencil, add the remaining smaller shadows on the outlying landmark features and then, to finish and tidy up your sketch, carefully erase any smudge marks with the plastic eraser.
Figure 1.3.9 is the finished sketch.

Fig. 1.3.8

1.4 Pastels on Black Paper – Copernicus (by Deirdre Kelleghan)

Fig. 1.3.9

Supplementary Sketch Information

The tutorial sketch was completed on March 5, 2009 at 23:09 UT with the Moon at 8.8 days old (69% illuminated) under clear and calm conditions (seeing: Antoniadi II). I used a 105 mm f/5.8 refractor on a driven mount with a 3.5 mm eyepiece, plus 2x Barlow lens, giving a magnification of around 350x.

1.4 Pastels on Black Paper – Copernicus (by Deirdre Kelleghan)

Suggested Materials

- Soft pastels
- White Conté crayon
- Black Daler Rowney paper 300 gsm
- Field easel

I set up my scope at 15:30 UT with the intention of sketching the daytime Moon, but when I noticed that Copernicus was so close to the terminator, it became a more desirable choice.

While I waited for darkness to fall, I observed the crater and the surrounding area. For long lingering moments, I took great delight watching the shadows and subtle rays on the mare floor, and how the rising sun mingled with the lunar surface. The ejecta blanket between the crater rim and the terminator was so intricate and heavily textured in appearance that it will be food for another drawing.

Copernicus is a super complex crater. It sits on the lunar surface like an almighty chess piece; ruling, demanding, magnificent. Because it is so laden with multi-faceted structural aspects, this king of craters presents a substantial challenge to the sketcher. Its terracing, central mountains, ejecta blanket, rays, and rugged ramparts play with light in sensational ways.

Step 1

To begin this sketch, a thin, white sun-lit edge was captured with a simple line by using a white Conté crayon (**Fig. 1.4.1**).

Step 2

One of the most-defining shapes on view that night was the deep, black shadowed floor. I always try to capture strong shapes quickly, as often, that shape defines a base on which to build the rest of the sketch.

The shadowed floor was added using black pastel. I started applying pastel in the middle of the dark shape and then used my finger to blend and push the color to the edge of it (**Fig. 1.4.2**).

Step 3

Using a white Conté crayon, I continued to add terracing while closely observing the gaps between the ridges. In order to keep the sketch balanced I worked on one side and then the other to develop

Fig. 1.4.1

Fig. 1.4.2

1.4 Pastels on Black Paper – Copernicus (by Deirdre Kelleghan)

Fig. 1.4.3

Fig. 1.4.4

the shape of the crater **(Fig. 1.4.3)**. I observed the surrounding areas and began to add layers of gray pastel. Choosing the shade closest to the lunar surface color, I used the stick on its side in long, even strokes.

Step 4

A close look at the ejecta material, as it was presented to my eye, invited me to apply pastel grays with my fingertips, pushing the material to approximate the lunar landscape.

Step 5

Returning to the crater, the final fine details were added with a pastel corner to the edge of the waxing shadow on the floor. While sketching, I observed two bright lines that suddenly began to radiate from the central mountain back toward the Pacman-shaped shadow that wrapped itself around most of the crater base.

Using the sharp point of a broken Conté crayon, I quickly added these new lines and used the blackest-black in the box of pastels to fill in the terminator. Then it was time to sketch in any additional crater rims that were discernable against the lunar night with the white Conté **(Fig. 1.4.4)**.

Figure 1.4.5 is the final drawing. Copernicus whispered checkmate, and he was right. This crater could take a lifetime of observing to capture its totality on paper – another opportunity waits.

Supplementary Sketch Information

January 24, 2010, 18:00–19:30 UT, Seeing Antoniadi I, 0°C, Meade LX90, Focal Length 2,000 mm,
 Hyperion 8 mm Modular Eyepiece, 250x
Bray, Co Wicklow, Ireland

Fig. 1.4.5

1.5 Conté Crayons on Black Paper – Langrenus (by Richard Handy)

Clear and calm weather greeted me as I pulled the cover off of my 12″ Schmidt Cassegrain telescope on a cool night in early November. While waiting for the scope to thermally equalize with the ambient temperature, I slipped in the wide-field eyepiece, a 35 mm Tele Vue Panoptic, for about 87x magnification. I took some time to search for my sketching target, the beautiful complex crater Langrenus. Sitting close to the eastern limb, its gleaming terraces cascaded to a somber floor and bright central peaks. Knowing that the waning shadows were soon to swallow the crater in lunar night, I worked swiftly to capture as much of the scene as possible, switching to a 12.5 mm eyepiece for 244x.

Suggested Materials

- White and black Conté crayons
- White Conté pencil
- Strathmore Artagain black paper 400 series
- Pink Pearl eraser
- Art gum eraser
- Plastic eraser
- Synthetic and natural sponges
- Blending stumps
- Pencil sharpener

1.5 Conté Crayons on Black Paper – Langrenus (by Richard Handy)

Fig. 1.5.1

Fig. 1.5.2

Fig. 1.5.3

Step 1

Using my white Conté pencil, I sketched the outline of the foreshortened ellipse of Langrenus. I made sure the outline of the crater accurately depicted the shape of the glacis' (the slope of ejecta just outside the inner crater walls) crest **(Fig. 1.5.1)**.

Step 2

Next, I drew the crater shadow line. As the sketch evolved, the shadow became "fixed" and, therefore, the time the scene was drawn was set at 9:38 p.m. PDT on Wednesday, November 4, 2009 **(Fig. 1.5.2)**.

Step 3

The Conté crayon stick was used to create the far inner wall of Langrenus. The crayon sticks are perfect for representing the brightest whites of the terraces **(Fig. 1.5.3)**.

Step 4

Using a light back and forth motion with the flat edge of the crayon, I added the somber gray floor. Following this application, a synthetic sponge was used to blend the crayon to match the tone seen through the scope. Note that I added the central peaks and outlines of their shadows **(Fig. 1.5.4)**.

Fig. 1.5.4

Fig. 1.5.5

Fig. 1.5.6

Fig. 1.5.7

Step 5

The glacis of the crater were added, as well as the background craters. Again, the flat of the Conté crayon was gently applied using a light to and fro motion **(Fig. 1.5.5)**.

Step 6

The foreground mare was blended with a synthetic sponge using a random, circular motion that was ideal for this purpose **(Fig. 1.5.6)**.

Figure 1.5.7 is the finished sketch.

Fig. 1.5.8 Richard Handy with his 8″ Mak-Cass and sketching kit waiting for the Moon to rise

1.6 Pastel and Conté on Black Paper – Clavius (by Deirdre Kelleghan)

Clavius is a difficult target for many reasons, and it takes a really interesting set of circumstances to entice me to attempt this huge feature near the lunar South Pole. Many of my Clavius observations were never sketched, as this crater-filled cauldron is often presented in a very oblique manor. Because Clavius has so much going on inside it visually, it is difficult to know where to begin.

On April 14th in 2008, Clavius offered me a wonderful, but challenging view – a vision to savor, devour, embrace and sketch. Porter and Rutherfurd, barely sunlit, were simulating the deepest, darkest cavities I have ever seen. Their total combined depths and deep shadow overspill invited wonder and curiosity. The central mountain in Rutherfurd, peeping above the 8,800-foot deep hole in the Moon, flagged this crater's presence in the chilling, gaping blackness.

Suggested Materials

- Soft pastels
- White Conté crayon
- Black Daler Rowney paper, 300 gsm

Fig. 1.6.1

Fig. 1.6.2

Step 1

"The essence of drawing is the line exploring space." ~ Andy Goldsworthy. This quote came into my mind as I started to outline Clavius with the white Conté crayon. I really enjoy the positives formed by the negatives in drawing: the energy, the concentration, and sometimes the result.

I carefully used my Conté crayon to outline the edges of Porter, Rutherfurd, and the general shape of Clavius (**Fig. 1.6.1**).

Fig. 1.6.3

Step 2

A very black pastel was used to begin filling in the dark shapes created by my outline. A hint of white pastel began the crater floor and the rest of the structure. I applied the pastel by using a small piece on its side to fill the area evenly. This gave me a base onto which I could add the smaller craters and their shadows (**Fig. 1.6.2**).

Step 3

Clavius D and C, and their long pointed shadows were added with a bare touch of a mid-gray pastel that was applied using a blending stick. The craters were added using the corner of a black pastel. Using my finger to apply a touch of black under the wall opposite Porter and Rutherfurd initiated yet more depth on the crater floor (**Fig. 1.6.3**).

1.6 Pastel and Conté on Black Paper – Clavius (by Deirdre Kelleghan)

Fig. 1.6.4

Fig. 1.6.5

Step 4

A little blending in this area, again using my fingers, helped differentiate the craterlets from the floor. At this point, I also alluded to the black totality of the terminator by drawing in a sweeping black shadow, which visually supported the very white sunlit wall opposite the large craters. I emphasized the top of the sunlit wall using the angled edge of a white Conté crayon to further brighten this feature (**Fig. 1.6.4**).

Fig. 1.6.6

Step 5

My field easel is excellent for long, involved sketches (**Fig. 1.6.5**). My fingers are most useful for blending and really adding something very direct to a sketch; often the tiny additions of finger blending are just not achievable in any other way.

Sometimes I rub my finger on the pastel and apply it that way. Most of the time, however, I rub pastel onto the edge of my page and then rub my finger on that marking to lift excess pastel as needed (**Fig. 1.6.6**).

Figure 1.6.7 is the finished sketch of Clavius. Sometimes adding the rich blackness of the terminator at the very end often gives me as much pleasure as building the detail.

Fig. 1.6.7

Supplementary Sketch Information

To draw the essence of this magnificent plain, using lines while exploring the dark and light spaces presented to me that evening, was one of my most enjoyable experiences in lunar sketching.

April 14, 2008, 20:30–21:45 UT, Clavius, Pastel and Conté, 200 mm Dobsonian FL 1,200 mm, 8 mm Tele Vue Plossl eyepiece, 150x
Bray, Co Wicklow, Ireland

Chapter 2

Sketching Maria (Seas)

Maria formed when impact basins were filled with basaltic lavas. Fractures in the lunar crust, which served as channels for lava flows that were located in the crustal/mantle interface, were created by collision energy. Although basins were produced in minutes by asteroid impacts, the slow inundations by the low-viscosity basalts (about the consistency of motor oil), took several hundred thousand years to fill the basins. Generally, maria exhibit dark, low-albedo characteristics of cooled basalt lava. The relative absence of craters in maria is partly the result of the fluidity of the maria lavas and their unrelenting flow for thousands of years as well as the impact and obliteration of the target areas caused by kinetic energy of the asteroids impacting the Moon.

2.1 Pastels and Conté Crayons on Black Paper – Mare Crisium (by Deirdre Kelleghan)

Suggested Materials

- Field easel
- Mungyo soft pastels – gray selection box
- Conté crayons – black and white
- Quilling needle
- Daler Rowney A3 black paper

Crisium stands on its own like an island on the eastern limb of the Moon. On this particular night in January 2009, my view of Crisium was very different and unusual as the mare was presented on the waning Moon. My view was absolutely engaging as Crisium was sliced down the middle by the terminator. The temperature had dropped to −3°C (26.6°F), and the seeing was good.

Fig. 2.1.1

Fig. 2.1.2

Fig. 2.1.3

Step 1

I set up my field easel with a board and my usual black paper. Using a dinner plate, I created an outline using white Conté crayon (**Fig. 2.1.1**).

Step 2

Quickly, I filled in the lunar surface area with a mid-toned gray pastel used on its side for an even tone. That application gave me a perfect base to work over with detail.

I was so taken by the stark darkness of the terminator and the lighter mare floor that I began to draw that right away. The white Conté line, sketched using the plate, became the waning terminator impinging on the Sea of Crisis. I used the blackest-black in the box of pastels to draw the edge of the terminator and begin the awesome shadows cast by the huge massifs surrounding the mare. The corner of a black pastel was used to draw the black shapes that defined the structures surrounding the area. A hint of shape sketched lightly with a white Conté crayon gave me a template for the Crisium Ring (**Figs. 2.1.2 and 2.1.3**).

Step 3

I closely observed the massifs, which were defined by their shadows. The blacks were sketched in first followed by the darker grays. Finally, I used the sharp corners of a white Conté crayon for the higher peaks still clinging to the sunshine (**Fig. 2.1.4**).

Step 4

In order to give a little context and balance to the drawing, I lightly sketched the surrounding areas outside Crisium using Conté crayon over the gray pastel base. I wallowed in the enjoyment of observing

2.1 Pastels and Conté Crayons on Black Paper – Mare Crisium (by Deirdre Kelleghan)

Fig. 2.1.4

Fig. 2.1.5

Fig. 2.1.6

Fig. 2.1.7

the sunlight still beaming in the darkness onto the rims of Cleomedes. The sharp hard corner of a new white Conté crayon was my choice for adding the very bright sunlit edges of hidden craters in the darkness beyond the terminator (**Fig. 2.1.5**).

Step 5

I added more detail to the surrounding areas by using a darker gray pastel on my finger to rub over the paler gray base of the lunar floor. Darker gray pastel gives the appearance of higher ground when applied over paler pastel (**Fig. 2.1.6**).

Step 6

My attention then turned to Dorsum Oppel. This wrinkle ridge wriggles its way across the mare floor just inside and below the massifs. Thin shadows and fine lines defining Dorsum Oppel were etched into the pastel using a quilling needle (**Fig. 2.1.7**). A quilling needle is invaluable for sketching dorsa and etching tiny craters or partially visible crater rims.

Fig. 2.1.8

The light is so different on the waning Moon – Palus Somni is a bare hint of itself; and Proclus, which so often takes the stage in this area, is barely visible, its ray system rendered imperceptible by the angle of the Sun's light. Standing in my garden looking at Crisium's mountainous ring filling my eyepiece is something I will never forget. I stood a quarter of a million miles away looking directly down on the tops of substantial structures as I was looking up! These massifs sported deep, almost vertical shadows, giving up waning secrets not privy to eyes viewing as the Sun rises on the lunar surface earlier in the month (**Fig. 2.1.8**).

Supplementary Sketch Information

January 13, 2009, 22:30–23:54 UT, 8-in. reflector on a Dobsonian mount, 8 mm Hyperion eyepiece, 150x, seeing Antoniadi I
Bray, Co Wicklow, Ireland

2.2 Conté Crayon and Pastels on Black Paper – Palus Epidemiarum (by Sally Russell)

Maria are relatively smooth plains on the lunar surface that present us with very different sketching opportunities compared with more-defined targets such as craters or mountains. Palus Epidemiarum is a small mare region in the southwestern portion of the near side of the Moon and is well presented a day or so after last quarter as illustrated in this tutorial.

Note: The tutorial sketch is a mirror image view as the refractor used for the observation was fitted with a mirror diagonal.

2.2 Conté Crayon and Pastels on Black Paper – Palus Epidemiarum (by Sally Russell)

Suggested Materials

- Drawing board (plus masking tape to fix the paper in place)
- Black paper, 12″ × 16½″ in size (90 lb weight Daler-Rowney 'Canford' paper was used in this tutorial)
- White Conté crayon
- White chalk pastel
- Craft knife for sharpening Conté crayon, pastel, and vinyl eraser
- Kneadable eraser and vinyl (plastic) pencil eraser
- Blending stump

Step 1

With a slightly sharpened Conté crayon, very lightly sketch the rounded outlines of the mare region and its major neighboring features (**Fig. 2.2.1**).

It is important to get the layout and relative scale of these as accurate as you can, as the remainder of the sketch is built up on and around them. Try to visualize the size and distances between the various features as being a multiple of one key feature to help you in mapping out the area of your sketch. In this example I used the brightly lit sinuous crater rim on the terminator at the top left of the sketch as my mental yardstick when gauging sizes and distances. It can also sometimes help, before drawing any lines at all, to put small dots of Conté crayon on the paper to mark the center top, bottom and sides of the planned sketch – these can then act as anchor points once you start applying Conté crayon to paper.

Fig. 2.2.1

Fig. 2.2.2

Step 2

Run your fingertip along the side of a piece of pastel to pick up some pastel dust (**Fig. 2.2.2**), then apply this to the paper to start filling in the mare regions, making sure to leave gaps where the major shadows occur (**Fig. 2.2.3**).

Applying a thin layer of pastel nearer to the terminator where the light level is low (at the top in this sketch), and a thicker layer of pastel where the light level is more intense under the higher sun angle further away from the terminator, will help achieve the effect of the curvature of the mare region. Pick up more pastel on your fingertip as many times as you find necessary and block in the entire mare region in this way, blending and smoothing the pastel on the paper with your fingertip as you go (**Fig. 2.2.4**).

Step 3

Now take up the Conté crayon again and start building up the major highlights on the crater rims and ridges. Begin to add in the smaller feature details (craters, mountains, etc.) that define the mare edges, adding any smaller areas of mare background as needed with pastel.

Fig. 2.2.3

Fig. 2.2.4

2.2 Conté Crayon and Pastels on Black Paper – Palus Epidemiarum (by Sally Russell)

Fig. 2.2.5

Fig. 2.2.6

Step 4

Sharpen up the edges of the major shadows being cast by the largest crater rim by using the kneadable eraser to remove small quantities of pastel background. In a similar fashion (and with either the kneadable eraser shaped into a small point or using the vinyl pencil eraser), define the smaller triangular shadows being cast by isolated peaks and smaller craters throughout the sketch area (**Fig. 2.2.5**).

Using the vinyl pencil eraser so that the long edge of the eraser is aligned with the direction of the rille, carefully rub out a very thin line of pastel to show the rille (Rima Hesiodus), which is just visible under this lighting (**Fig. 2.2.6**).

Fig. 2.2.7

Step 5

Now pick up a small amount of pastel dust directly onto the blending stump by rubbing it onto the side of the pastel (**Fig. 2.2.7**), then use this to fill in any small mare background areas missed when the main area of pastel was applied using your fingertip (**Fig. 2.2.8**). The narrow tip of the blending stump allows very small areas to be reached and filled in without disturbing the surrounding drawing.

Fig. 2.2.8

Fig. 2.2.9

Step 6

Your sketch is now almost complete! With the Conté crayon, add in any further small features (craters, hills, etc.) around the edge of the mare, and add texture (representing ejecta from crater Campanus) onto the mare background using a dotting motion. Now take the pencil vinyl eraser again and 'draw' in (by erasing away a little of the background, thus leaving dark markings against the bright mare) any further small shadows and rilles (such as Rimae Hippalus seen on the right of the sketch). Clean up the sketch surrounds by gently erasing any smudges with the kneadable eraser.

Figure 2.2.9 is the finished sketch.

Supplementary Sketch Information

The tutorial sketch was completed on September 3, 2010 at 03:00–04:35 UT with the Moon at 24 days old (35% illuminated) under clear and calm conditions (seeing: Antoniadi II). I used a 105 mm f/5.8 refractor on a driven mount with a 2.5 mm eyepiece giving a magnification of around 245x.

Fig. 2.2.10 Sally Russell with her trusty Astro-Physics 105 mm (f5.8) Traveler

2.3 Graphite Pencil – Mare Serenitatis (by Thomas McCague)

Suggested Materials

- Graphite pencils: 2H, HB, B, 2B, 4B, 6B
- Paper: acid-free, lignin-free paper of medium weight in a 9″ × 12″ size. You can use ordinary copy paper, but a better quality paper is recommended for sketches you plan to keep indefinitely.
- Erasers: gum, plastic and shaped pencil erasers
- Clipboard
- Bright light
- Cloth, paper towels, or facial tissues for wiping graphite from fingers
- Blending stumps
- Small brush
- An eraser shield may also be useful for correcting mistakes made along the way

I selected the 670-km diameter Mare Serenitatis for a graphite sketch of a lunar sea. This mare has three interesting features that come to mind: first, its overall shape is somewhat like a scallop shell; second, its floor brightness changes rather abruptly due to variances in lava composition; and finally, a bright ray (known as the Bessel ray) from a distant crater impact passes across the center of this sea near crater Bessel and points back to crater Tycho 2,000 km away.

One of my favorite ways to begin a graphite sketch of the Moon is to spread graphite dust shaved from a pencil across white paper to equal the tone of the gray lunar surface. Although light features can be erased away and darker features added with softer, darker graphite pencils, I chose a different approach for this sketch simply because there are a number of ways to begin any sketch.

Fig. 2.3.1

Fig. 2.3.2

Fig. 2.3.3

Step 1

As shown in **Fig. 2.3.1**, we will mark an outline in the shape of this entire feature using a 2H pencil. Be sure to use the lightest touch with your pencil as you may want to adjust and reshape this outline until you are satisfied that you have it right. If you have trouble seeing the outline, use a softer pencil such as HB or B and avoid the urge to press too hard.

You may also find that you can use brighter lighting, which will assist in seeing faint marks on the sketch paper. Since you can sketch the moon in full daylight during some phases, do not be afraid to use plenty of light at night.

Step 2

Next, using an HB pencil held at a shallow angle and varying the pressure a little, we begin to shade in the gray tones for the mare floor (**Fig. 2.3.2**). Work across the paper by doing the near side first and then make your way towards the far side. If you are left-handed like I am, you may want to work from far side to near side to minimize smearing your sketch.

Step 3

At this point, some of the features, that were supposed to be bright, might have become covered with graphite and will need to be cleaned up by erasing. For this step, we use shaped erasers that have been sanded to wedge shapes as with the pencil end eraser shown in **Fig. 2.3.3**. This same step can also be accomplished with the proper placement and use of an eraser shield in combination with a plastic eraser.

2.3 Graphite Pencil – Mare Serenitatis (by Thomas McCague)

Fig. 2.3.4

Fig. 2.3.5

Step 4

We now move on with the HB pencil to outline the darker features, followed by filling in the outlined regions with a (softer and darker) 2B pencil. By applying progressively softer pencil graphite (such as going from HB to 2B), you will not need to apply hard pressure to achieve a darker appearance, which could damage the paper (**Fig. 2.3.4**).

Step 5

Return to the previous shading done with the HB pencil to adjust the shadow darkness. It will be necessary to go over several previously shaded regions to adjust the appearance to darker tones as well as erase some additional smudging that may have occurred in the brighter areas.

Looking over the sketch, undesirable pencil lines may be seen. To eliminate these, use a blending stump to even out the appearance of all the gray tones. It may be necessary to load graphite onto the blending stump to aid with this adjustment. Before blending, load the blending stump by rubbing the pencil directly onto the tip of your blending stump. If a sketch is large enough, you may be able to blend with your fingers. A clean cloth or tissue can be used to remove the graphite from your fingertips if you choose this method. By moving from the use of a pencil to blending stump to eraser in succession for several cycles, you will be able to achieve the desired level of gray tones from lightest to darkest (**Fig. 2.3.5**).

Step 6

Finally, for the darkest features in this sketch, we use pencils through 4B or 6B. These pencils work nicely for the deepest shadowed regions. When you are satisfied that the sketch matches the eyepiece view, you can consider the drawing complete.

The finished sketch is in **Fig. 2.3.6**. You may want to include information concerning the circumstances of the sketch such as the time, date, and Moon phase. That is generally up to the discretion of the sketcher.

Fig. 2.3.6

Supplementary Sketch Information

Graphite Sketch of Mare Serenitatis on white sketching paper
Age: Nectarian Period Feature 3.9 billion years old
Size: 670-km across
Date and Time: February 13, 2009, 07:20–09:00 UT
Lunation: 18 days
Waning gibbous phase
Weather: clear, cold
Seeing: Antoniadi III
Illumination: 83.4%
Equipment: 10″ f/5.7 Dobsonian with 9 mm eyepiece at 161x, riding on an equatorial platform

Chapter 3

Sketching Mons (Mountains)

Lacking the global plate tectonics of the Earth, the mountains of the Moon were created by large impactors. They excavated huge volumes of regolith, which formed arcuate mountain ranges that flanked the newly formed basins. Platform massifs, such as those surrounding Mare Crisium, are thought to be a result of sub-lithospheric flow towards the basin center that compensated for the material removed from the lunar crust as ejecta. Concentric and radial faulting (caused by the impact) formed isolated massifs as the post-impact modification continued. Eventually the mare lavas flowed around the massifs and embayed the isolated blocks.

Another mechanism that was responsible for producing lunar mountains was the impact of moderately large asteroids in a limited area. Ejecta from the numerous craters built mountains as they overlapped pre-existing craters. The north polar region of the Moon has several large mountains that were caused by this process. Pre-existing crater rims, or portions of multi-ring basins, may have produced isolated mountains as a result of partial inundation by the flood of mare lavas. Examples of this are the Montes Teneriffe, the Montes Spitzbergen and the Montes Recti.

3.1 Conté on Black Paper – Montes Apenninus (by Richard Handy)

The evening of October 26, 2009 around 9:00 p.m. PDT was clear and calm over my little high desert town. I had my heart set on sketching the mountain range that surrounds the southeastern rim of the Mare Imbrium, the Montes Apenninus, which were shining brightly above the dark basalts that now fill the basin depths.

Suggested Materials

- White and black Conté crayons
- White and black Conté pencils
- Strathmore Artagain black paper 400 series

- Pink Pearl eraser
- Art gum eraser
- Plastic eraser
- Synthetic and natural sponges
- Blending stumps
- Pencil sharpener

Step 1

I like to start every sketch by drawing the largest craters in the selected scene first. I use these as a measuring scale to locate and size all the other features in the region of interest. In **Fig. 3.1.1**, the outlines of Archimedes and Autolycus were drawn first with a Conté pencil, and then I added Conon, Aratus, and Galen.

Step 2

My next addition was the mountain range created using a stick of white Conté crayon to define the bright cliffs and the foothills that fanned away from the range. The craters were given more detail at this stage as well (**Fig. 3.1.2**).

Fig. 3.1.1

Fig. 3.1.2

3.1 Conté on Black Paper – Montes Apenninus (by Richard Handy)

Fig. 3.1.3

Fig. 3.1.4

Step 3

Continuing to add detail to the cliffs and foothills, I carefully observed where the brightest mountains were located in order to place them in the sketch with the white Conté crayon (**Fig. 3.1.3**).

Step 4

Holding the white Conté crayon on its side, while using a gentle back and forth motion, allowed me to build up the grays that comprised the floor of the mare. Note that I began to sketch the hills of Montes Archimedes and the Apennine bench (**Fig. 3.1.4**).

Fig. 3.1.5

Fig. 3.1.6

Step 5

At this point in the sketch, I finished adding Conté to the floor prior to blending (**Fig. 3.1.5**).

Step 6

I used a piece of synthetic sponge to blend and smooth the mare floor. In addition, I developed the shadows of the mountains by using the black Conté crayon (**Fig. 3.1.6**).

This is the completed sketch finished at 10:17 p.m. PDT using my 12″ f/10 Meade SCT at 87x (**Fig. 3.1.7**).

3.2 Pen and White Ink on Black Paper – Mons Pico and Montes Teneriffe (by Richard Handy)

Fig. 3.1.7

3.2 Pen and White Ink on Black Paper – Mons Pico and Montes Teneriffe (by Richard Handy)

When the early morning lunar light just begins to rise over the northern shores of Mare Imbrium, Plato's bright rim and black floor, along with a scattering of his brilliant "sheep," make for a wonderful scene. Mons Pico and the highest peaks of Montes Teneriffe become intense beacons in a sea of night. I decided to try capturing that moment on the evening of October 26, 2009 starting at 10:28 p.m. PDT. I used a 35 mm Panoptic for 87x in my 12″ Meade f/10 SCT.

Suggested Materials

- Higgins Super White non-waterproof drawing ink No. 44100
- Black India ink
- Chronicle Calligraphy dip pen holder and 111EF nib
- Black 400 series Strathmore Artagain paper
- Wide, round mop brush
- Cotton swabs
- Black Conté crayon (used to cover white ink mistakes)

Step 1

My strategy for sketching starts by drawing the most prominent large features or crater(s) that form the scale of the sketch. Since I used white ink on black paper, the brightest ramparts of Plato and the bright mountains, such as Mons Pico, some of Montes Teneriffe, and two small craters, Le Verrier E and D, are drawn using Plato as the scale reference. Note the misapplied white ink mark on the right side of the floor. That will be dealt with in the final image (**Fig. 3.2.1**).

Step 2

These are the scaled features that I used to add the sizes and positions of all the other details of the sketch (**Fig. 3.2.2**).

Fig. 3.2.1

Fig. 3.2.2

3.2 Pen and White Ink on Black Paper – Mons Pico and Montes Teneriffe (by Richard Handy)

Fig. 3.2.3

Fig. 3.2.4

Step 3

In **Fig. 3.2.3**, I am applying white ink with a cotton swab, which allowed me to make opaque markings in white and black ink. You will note that I tried to cover the misapplied white mark using black India ink with the black tip of the swab. This created a shininess that contrasted with the surface of the paper. This is a new medium for me so I am learning as I sketch, including how to deal with errors!

Step 4

Depending on the duration and pressure that I applied the ink, I was able to produce a variation of grays that corresponded to the rocky terrain around Plato's rugged rim (**Fig. 3.2.4**).

Fig. 3.2.5

Fig. 3.2.6

Step 5

By use of the cotton swab, I built up the texture of the surrounding highlands. I also used a large round mop brush to add a wash of gray tint in the lit areas of the mare (**Fig. 3.2.5**).

Step 6

The large round mop brush is a great tool for adding repeated washes to the mare south of Plato (**Fig. 3.2.6**).

Step 7

I used a black Conté crayon to darken the white ink line and reduce the glare off the black ink that I applied in Step 3. Although it still is visible, the Conté really helped reduce the shine of the dried ink.

This is the final result (**Fig. 3.2.7**).

3.3 Graphite Pencil – Montes Harbinger (by Thomas McCague)

Fig. 3.2.7

3.3 Graphite Pencil – Montes Harbinger (by Thomas McCague)

Suggested Materials

- Graphite pencils: 2H, HB, 2B, 6B
- Paper: acid-free, lignin-free paper of medium weight in a 9″ × 12″ size
- Erasers: gum, plastic and shaped pencil erasers
- Clipboard
- Bright light
- Blending stumps
- Sanding block for sharpening the pencils and generating graphite dust
- Pieces of paper toweling or facial tissue
- Small brush
- An eraser shield may be useful but was not used here

46 3 Sketching Mons (Mountains)

Fig. 3.3.1

Fig. 3.3.2

Step 1

We begin this graphite sketch of the Harbinger mountains near Prinz by making a faint outline of the brightly illuminated features using a 2H pencil. This scene is close to the terminator, and for that reason, we choose a simple mountain range that can be sketched quickly before the rising sun changes the view (**Fig. 3.3.1**).

You will frequently find that when sketching equatorial features on the terminator, the features change in appearance much faster than you might expect. The small irregular shapes outlined in this sketch correspond to the brightly illuminated features such as mountains, crater rims, and ridges.

Fig. 3.3.3

Step 2

Sharpen your pencils with a sanding block and save the powdered graphite. With a piece of paper toweling, apply the powdered graphite to the paper to create the darker areas (**Fig. 3.3.2**). This method will save you time when used in conjunction with a blending stump. It would be difficult, if not impossible, to blend all of the background with this method alone; however, it is very useful for the larger uniformly dark areas of the Moon as seen at the eyepiece.

Step 3

In those small, tight areas that must be darkened, a pencil used directly or a blending stump loaded with graphite works well (**Fig. 3.3.3**).

Fig. 3.3.4

Fig. 3.3.5

Step 4

Beyond the terminator in the regions of total darkness, the graphite dust of a 6B pencil applied with paper towel provides a sketcher the means for a very dark application (**Fig. 3.3.4**).

Step 5

When you need to get in close to low light areas that are adjacent to bright areas, you cannot beat a blending stump for evening up and blending your markings. Using a graphite-loaded blending stump, carefully move in close to define brightly illuminated crater walls.

A softer pencil, such as 6B, is used for darker shadowed areas, followed by 6B graphite dust using a loaded blending stump.

Step 6

As we continue with this sketch, most of what remains to be done is to adjust the darkness of the intermediate and darkest regions while maintaining the untouched, brightest regions.

If graphite finds its way onto the lightest and brightest areas of the sketch, those areas will get "clean up" attention at the conclusion of the sketch using shaped erasers. It may be useful to keep another eraser (gum type) within reach that can be cleaned off with sanding paper in the event that you need to lighten shadow regions that have received too much graphite.

Step 7

Long shadows are visible beyond most of the mountain peaks. You can outline these shadows where they fall on the lunar surface with a 2B pencil (**Fig. 3.3.5**).

Fig. 3.3.6

Step 8

Other shadow features projecting across crater floors, or out beyond crater rims, hills, and ridges, will also be outlined and then shaded in at this time as shown in **Fig. 3.3.6**.

Before moving to the final clean-up step, compare the eyepiece view to the sketch to see if any additional lightening, darkening, erasing and blending are required.

Step 9

Finally in the last step, the very darkest regions that are beyond the terminator may have suffered from smudging and can now be cleaned up and darkened fully. Smudges along the perimeter of the sketch are removed with a shaped plastic eraser and carefully brushed away. It is perhaps good practice to use a cross-hatching technique with the 6B pencil to darken the unlit regions, since it gives the best-looking results – as has been convincingly shown to me by other sketchers including one of the co-authors of this work. Following these treatments, the sketch is complete (**Fig. 3.3.7**).

Supplementary Sketch Information

Graphite Sketch of the Harbinger Mountains on white sketching paper
Telescope used: 10″ f/5.7 Dobsonian telescope riding on an equatorial platform and with a 6 mm eyepiece for 241x
Date and Time: June 23, 2010, 01:30–02:30 UT
Weather clear, calm, 56°F (13°C)
Seeing: Antoniadi III
Lunation: 10.6 days
Phase: Waxing Gibbous
Moon 88% illuminated

Fig. 3.3.7

3.4 Pastels on Black Paper – Mons Pico and Montes Teneriffe (by Sally Russell)

Lunar mountains are seen at their most spectacular when they are near the terminator, casting long shadows under early morning or late evening grazing illumination. Though these scenes can be transitory, you will most likely have an hour or so to try capturing this kind of view before the shadows change considerably. Isolated peaks Mons Pico and the Montes Teneriffe provided an interesting target area at lunar sunrise for this tutorial.

Note: The tutorial sketch is a mirror image view as the refractor used for the observation was fitted with a mirror diagonal. The finished sketch can be scanned and flipped electronically to the correct orientation if desired.

Suggested Materials

- Drawing board (plus masking tape to fix the paper in place)
- Black paper, 12″ × 16½″ in size (90 lb weight Daler-Rowney 'Canford' paper was used in this tutorial)
- White pastel pencil
- White chalk pastel
- Craft knife for sharpening both pastel and pastel pencil
- Kneadable eraser

Step 1

Fix your paper onto the drawing board using small pieces of masking tape applied at the paper's corners. Then take a while to study and enjoy your chosen lunar area properly before you begin drawing. When you are ready to start your sketch, take the (sharpened) pastel pencil and very lightly sketch in the outlines and relative positions of the mountains and other critical features of the scene (**Fig. 3.4.1**). I find that I can draw a much-finer line using a pastel pencil compared to when using a pastel stick. To find out what works best for you, consider experimenting with techniques and media using photographs of the lunar surface in place of an eyepiece view. That way you won't be worried about shadows changing while you work and will be better prepared for sketching the "real thing."

You may find that you will want to add more features later on as the sketch evolves and as you expand on the initial chosen area (this frequently happens to me!); however, these first marks will be the backbone of the final sketch, so it is worth spending time getting their relative placements correct. To help me transfer what I am seeing through the eyepiece onto this basic outline sketch on the paper, I look for simple relationships and alignments between the various features and then try to imagine them as being on a grid to help me visualize their relative top/bottom, left/right placements. If you are not happy with your initial outline sketch, now is the time to erase and re-draw!

Step 2

Block in the brilliantly lit isolated mountain peaks with the pastel pencil. Then pick up some pastel dust onto your fingertip by rubbing it directly onto the side of a pastel stick. Begin gently applying it to the paper leaving the main shadow areas untouched. Blend the pastel (still using your fingertip) to give a soft and even background (**Fig. 3.4.2**). This method will give a much softer and more uniform background before being blended than if the pastel were to be applied directly to the paper with the pastel stick.

For large background areas, it often helps to use a small piece of dry natural sponge or soft, lint-free cloth for blending. But if your sketch is small (like the example sketch in **Fig. 3.4.3**), then a fingertip gives you the best control for placing and blending the pastel just where you want it without disturbing the surrounding drawing. Extend the blended area as necessary to best frame your composition.

Fig. 3.4.1

Fig. 3.4.2

3.4 Pastels on Black Paper – Mons Pico and Montes Teneriffe (by Sally Russell)

Fig. 3.4.3

Fig. 3.4.4

Fig. 3.4.5

Fig. 3.4.6

Step 3

Using the pastel pencil again, continue adding in the outlines of any additional features you wish to capture, then add and strengthen any highlights as necessary. Now shape a kneadable eraser into a point and carefully remove blended background pastel to start defining the terminator (on the right in **Fig. 3.4.4**).

If you need to further extend the blended background of your sketch (as I did in **Fig. 3.4.5**), then use the same technique as in Step 2, loading pastel dust onto your finger and gently applying it to the paper until you have covered the required area.

Step 4

Add in any final feature outlines that you wish to include such as craters and wrinkle ridges (dorsa). Then, with a slightly pointed kneadable eraser, carefully rub out areas of pastel to show the remaining long shadows being cast by the mons plus those of the wrinkle ridges and the crater rims (**Fig. 3.4.6**).

Fig. 3.4.7

Some further light infilling and blending of the mare regions may be necessary to help define each feature. The larger areas of soft shadow on the mare are defined using a soft dabbing motion with the pointed eraser – this lifts out small spots of pastel, leaving behind a slightly mottled darker region.

Step 5

Tidy up your work by erasing any stray pastel marks, and your sketch is complete (**Fig. 3.4.7**).

Supplementary Sketch Information

The tutorial sketch was completed on June 1, 2009 at 21:09–21:55 UT with the Moon at 8.4 days old (69% illuminated) under clear and calm conditions (seeing: Antoniadi II). I used a 105 mm f/5.8 refractor on a driven mount, with a 3.5 mm eyepiece giving a magnification of around 175x.

Chapter 4

Sketching Rilles (Lava Channels)

Whether they are straight, arcuate, or sinuous, rimae (rilles) appear to be channels, which may be the result of faulting, lava flows, collapsed lava tubes, or extensional tectonic processes such as occurrences when basin-forming impacts were later filled with dense basaltic lavas. Straight rilles are frequently grabens, a collapsed floor between two parallel faults that can extend for hundreds of kilometers. Arcuate rilles are often found around the margins of maria when the stress of the cooling mass of basalt lava faulted the crust in concentric arcs. Sinuous rilles resulted when flowing lava formed channels or tubes that, when emptied or collapsed, revealed the snaking path of the lava caused by the differential velocity of the flow.

4.1 Charcoal – Rima Hyginus (by Erika Rix)

Rima Hyginus is featured in this tutorial and was approximately 25° away from the terminator during the waning Moon. The view would have been exceptional for this area had I waited another night to observe it, but sometimes a person has to answer the door when opportunity knocks. I had a clean view of the flat floor of Hyginus and near-perfect seeing conditions.

You may find it easier to start your sketch with a nearby reference object, such as a crater, to help you with proportions and angles of the rille.

Suggested Materials

- 8½″ × 11″ sheet of white sketching paper on a clipboard (Rite in the Rain paper was used for this tutorial)
- Assorted blending stumps and tortillons
- Chamois for blending large areas (I used my fingertips for this tutorial)
- Charcoal pencil (6B soft was used in this tutorial)
- Flat piece of compressed charcoal

- Pencil sharpener
- Sandpaper for sharpening blending stumps and tortillons
- Cloth rag to wipe your fingertips

Step 1

Create a rough outline of your reference object with a charcoal pencil. I selected crater Hyginus for mine in this tutorial for its central location on the rille. Next, lightly add the outline of the rille, concentrating on shape and direction as well as general width and length proportions. Anchor markings, such as hints of crater shadows within or around the rille, are included next (**Fig. 4.1.1**).

Step 2

Draw the outlines of main contrast areas with your charcoal pencil. These are used as anchors to assist positioning other craters that will soon be included in the sketch. Imagine triangle sizes and shapes connecting two reference markings with a third new marking on the sketch. This will help with correct positioning and is termed "triangulation." Blend the shadows with a fine-tipped tortillon or blending stump. At this stage, your sketch should vaguely resemble **Fig. 4.1.2**.

Fig. 4.1.1

Fig. 4.1.2

4.1 Charcoal – Rima Hyginus (by Erika Rix)

Fig. 4.1.3

Fig. 4.1.5

Fig. 4.1.4

Step 3

Create a faint background by rubbing your fingertip across the flat piece of compressed charcoal and then applying the charcoal directly to the paper with your fingertip as shown in **Fig. 4.1.3**. Alternatively, you could directly apply charcoal to the paper with a round stick of compressed charcoal and then blend with a chamois. Be careful that there are no rough edges to the charcoal beforehand or it may leave harsh streaks across your paper that are difficult to rub out.

Step 4

Rub a large blending stump across the flat piece of charcoal. This technique is referred to as "loading your blending stump" (**Fig. 4.1.4**). Concentrating on the subtle contrast around your target, begin adding the darker areas with your loaded blending stump (**Fig. 4.1.5**).

If you concentrate on sketching the darker areas, the lighter areas will automatically come to life on your paper. A broader blending stump will cover a larger area in less time as well as provide you with better control when creating smooth transitions between contrasted areas.

Fig. 4.1.6

Fig. 4.1.7

Step 5

Use a fine-tipped tortillon to blend inside, and around, the edges of the craters and rille (**Fig. 4.1.6**). They work very well for accurately blending precision areas without smudging outside the "lines."

I added a few of the darkest shadows inside the rille with my charcoal pencil. Notice that in **Fig. 4.1.7**, I actually used a tortillon to drag charcoal out of the darker areas in order to create softer, lighter shadows around the rimless collapsed craters that were scattered along the rille.

Step 6

A new layer of contrast is added directly with a charcoal pencil to create depth (**Fig. 4.1.8**).

Fig. 4.1.8

4.1 Charcoal – Rima Hyginus (by Erika Rix)

Fig. 4.1.9

Step 7

A final gentle blending with your fingertip or a variety of blending stumps completes the sketch (**Fig. 4.1.9**).

Supplementary Sketch Information

August 29, 2010, 08:20 UT
PCW Memorial Observatory, OH, USA
Zhumell 16″ Truss-Dobsonian (f/4.5), 20 mm Tele Vue Plossl, 5x Barlow, 450x magnification, 13%
 T moon filter. Temperature: 12.8°C (55°F). Humidity: >90%. Seeing: Antoniadi I.

Phase: 309.2°, Lunation: 19.22d, Illumination: 81.6%
Libration in Latitude: −05:58, Libration in Longitude: −05:17
Altitude: 64:25, Azimuth: 175:15

4.2 Conté Crayon on Black Paper – Rima Ariadaeus, Hyginus and Rimae Triesnecker (by Richard Handy)

I like to look up and study the stars as I walk to the observatory. I noted that this evening there was only an occasional flicker. That meant the possibility of very steady seeing on this late spring evening, and I was excited to see what views the telescope would deliver. The weather conditions resulted in an almost perfect Antoniadi II.

My lunar target this evening was a nice wide-field view of Rima Ariadaeus, Hyginus and Rimae Triesnecker with its complex intersections of rilles. This area was close to the Moon's center within the eastern shores of Sinus Medii, the Central Bay, and the western shores of Mare Tranquillitatis. I chose a 20 mm Pentax XW wide-angle eyepiece, giving me about 152x power. I was anxious to try catching all three rimae in the same sketch.

Suggested Materials

- White and black Conté crayons
- White and black Conté pencils
- Strathmore Artagain black paper 400 series
- Pink Pearl eraser
- Art gum eraser
- Plastic eraser
- Synthetic and natural sponges
- Blending stumps
- Pencil sharpener

Step 1

I started sketching about 10:22 p.m. PST on May 1, 2009. One of the questions that I often hear from novice sketchers is, "How does one position and size the craters and other features in the selected field of the drawing?" My approach is to outline the largest crater or prominent feature first at a size and position that will allow me to draw all the intended craters and features that are to be included in the sketch. If I am focusing on one feature, such as a large crater, I sketch its outline close to the center of the paper, again at a size that allows me to represent all of its features.

There were plenty of medium- and small-sized craters in the Sinus Medii area. First, I sketched the outline of the largest craters. Then, by referring to their size and position, I added more craters or features to the sketch. This is much like drawing star clusters by sketching several "anchor" stars that supply a framework for the addition of other stars (**Fig. 4.2.1**).

Step 2

Besides adding smaller crater outlines in the sketch for this tutorial (**Fig. 4.2.2**), I noted that a rather swampy area, at a higher elevation between Sinus Medii and Mare Tranquillitatis, was brighter in tone than its surroundings. I decided to outline the zone so that I could brighten the swampland by adding more white Conté crayon to delineate the tonal difference.

4.2 Conté Crayon on Black Paper – Rima Ariadaeus, Hyginus and Rimae Triesnecker (by Richard Handy)

Fig. 4.2.1

Fig. 4.2.2

Fig. 4.2.3

Fig. 4.2.4

Step 3

By holding the white Conté crayon so that it rested flat on the paper, I loaded the paper with Conté using "to and fro" strokes while using light pressure (**Fig. 4.2.3**).

Step 4

A synthetic, closed-cell sponge was used with light to moderate pressure in random circular motions to blend smooth the Conté strokes in the swampland zone. This provided a lighter tone throughout the area (**Fig. 4.2.4**).

Fig. 4.2.5

Fig. 4.2.6

Step 5

Here I added the lines of the rimae less the Triesnecker rilles, which will be addressed in the next step. Please note the light application of Conté on the left side of the sketch (**Fig. 4.2.5**).

Step 6

I used the sponge again to represent the smooth Sinus Medii basalts on the left side of the sketch resulting in the appearance of these darker plains. I then refined the drawing by adding as many small details as I could observe, including the shadows in the craters, mountains, and the rilles to the east of crater Triesnecker. At this point, I recorded the time of completion as 11:37 p.m. PST (**Fig. 4.2.6**).

Step 7

This is the completed sketch. In order to prevent accidental smearing, the finished sketch was sprayed with fixative. When dry, it was stored in a portfolio with acid-free tissue paper to separate it from other drawings (**Fig. 4.2.7**).

Fig. 4.2.7

4.3 Graphite Pencil – Rimae Triesnecker (by Thomas McCague)

Suggested Materials

- Graphite pencils: 2H, HB, 4B
- Paper: acid-free, lignin-free paper of medium weight, 9″ × 12″
- Erasers: gum, plastic and shaped pencil erasers
- Clipboard
- Bright light
- Paper towels or facial tissues for wiping graphite from fingers
- Pieces of paper toweling for blending
- Blending stumps
- Sanding blocks and emery boards for sharpening pencils and creating graphite dust
- Small brush
- An eraser shield may be useful but was not used here

When sketching rilles, use moderate to high magnification at a time of grazing illumination for the best view. Many of these features occur across the lunar surface, and the ones near crater Triesnecker are my very favorite to capture in both morning and evening light. They form a complex of narrow grooves visible in one field of view at the telescope.

Fig. 4.3.1

Fig. 4.3.2

Fig. 4.3.3

Step 1

Sharpen the 2H pencil using a fine grit emery board. The graphite dust generated after sharpening is applied to the paper with fingertips in correspondence to the eyepiece view of the crater Triesnecker and the rilles to the east (**Fig. 4.3.1**). Attempt to produce a smooth, pale gray tone.

Step 2

Lightly outline the craters and rilles using the 2H pencil. As shown in **Fig. 4.3.2**, use the shaped eraser to subtract graphite from the bright crater rims and rilles. Repeat Steps 1 and 2 until the rilles and crater features match the eyepiece view for position, shape, and tone.

Step 3

Use the HB pencil to shade the crater floors and other low shadowed areas.

Step 4

The gray-toned background may have suffered from the actions of the previous steps. To correct this, use a piece of paper towel (or facial tissue) lightly loaded with graphite dust from an HB pencil to re-blend the background, including the larger, darker shaded regions previously made with the 2H pencil. You can maintain good control over the blending by shaping the towel piece around your fingertip (**Fig. 4.3.3**).

4.3 Graphite Pencil – Rimae Triesnecker (by Thomas McCague)

Fig. 4.3.4

Fig. 4.3.5

Step 5

For those regions smaller than a couple of millimeters, a blending stump works best to accurately darken the tight spots (**Fig. 4.3.4**). Although a blending stump can be used, a paper towel loaded with a little graphite dust is much faster for a large sketch and produces an equally nice and even blend. The basic sketch is on paper. You can now turn your undivided attention to darken all those features that appear too light compared to the eyepiece view.

Step 6

Using a sharpened 4B pencil, add another layer of graphite over the shaded regions just inside and outside the craters and rilles. Take your time and work carefully.

Step 7

After you have completed this darkening process, more blending will be needed with the blending stump and/or paper towel piece until the background around the craters and rilles looks properly adjusted. Be sure to shade the rilles as precisely as you can. These are small features and may disappear from eyepiece view from time to time under less than average seeing conditions. Just be patient and you will capture them (**Fig. 4.3.5**).

With the rilles and craters shaded as needed, it is time for the final phase.

Fig. 4.3.6

Step 8

Lighten the brightest areas using shaped erasers. With blending stumps, remove the unevenness that was created by the pencils during shading. **Figure 4.3.6** is the final view of the rilles after all the blending and erasing is completed.

Supplementary Sketch Information

Triesnecker crater and the adjacent rimae sketched on white paper using graphite pencils
10″ f/5.7 Newtonian riding on an equatorial platform and a 6 mm eyepiece for 241x
Date and Time: July 3, 2010, 06:50–09:00 UT
Weather: clear, calm, 60°F (16°C)
Seeing: Antoniadi I-II
Lunation: 20.8 days
Moon 62% illuminated

4.4 Black Felt-Tipped Pen on White Paper, Stippling – Rima Cauchy (by Erika Rix)

Typically a pen and ink sketch is created as a pencil outline, and then a legend is created to indicate shading gradients. After the observing session, the sketch is completed inside with pen and ink at the observer's leisure.

4.4 Black Felt-Tipped Pen on White Paper, Stippling – Rima Cauchy (by Erika Rix)

My goal for this tutorial was to complete the sketch entirely at the eyepiece. By doing so, I would eliminate the need for a legend. More importantly, I would be sketching live views instead of running the risk of inadvertently "adding detail" to the sketch after the session was over. Having a bottle of ink near a telescope at night is not a risk most of us are willing to take. Thankfully, there are felt-tipped artists' pens available with a range of precision tips made specifically for drawing. I opted to use a common ultra-fine point permanent marker for this tutorial.

When stippling, try to keep the marker perpendicular to the paper so that your dots are small and tight instead of elongated. It can be a tricky process sketching outside at night with your light source casting shadows from your pen across the paper. In fact, the technique for stippling with a marker is very similar to sketching stars…many, many stars!

Cauchy and its companions are featured in this tutorial, sporting Rupes Cauchy and Rima Cauchy on either side of it. I observed this area 4 days after new moon, which made for exceptional views. The two domes located southwest of Cauchy were what brought me to that area, and even Omega Cauchy's little summit crater was visible as seeing conditions improved.

Suggested Materials

- 8½″ × 11″ sheet of white sketching paper on a clipboard (Rite in the Rain paper was used for this tutorial)
- Ultra-fine point permanent marker or felt-tipped artist's pens
- Pencil and vinyl eraser (if desired for the initial anchor markings)

Step 1

You may use a pencil to softly sketch anchors (reference points) and then draw over them with the marker. Pencil markings can be erased after the sketch is completed. Since I wanted to eliminate unnecessary steps, I directly drew the anchors without the use of a pencil. Be careful with the placements of your markings if you choose not to use a pencil first. Once the ink is on the paper, it cannot be easily removed.

Notice, in **Fig. 4.4.1**, that I began to outline an area to the lower right of Cauchy that was to be left highlighted. Cauchy's shadow and a few of the smaller craters were also added.

Fig. 4.4.1

Step 2

Concentrate on the darkest features. Start off with just a few small dots and then build up around them. If you discover your dot placements are in error, simply leave them and start

Fig. 4.4.2

Fig. 4.4.3

building up new ones in the proper location. A few small dots placed in error can easily be intermingled in the background as the sketch progresses.

The domes were added in **Fig. 4.4.2** using triangulation for proper placements between the domes themselves, crater Cauchy, and the rille. The same technique can be used for the features you wish to add in your own sketch.

Step 3

In **Fig. 4.4.3**, areas to the left of Rupes Cauchy and Rima Cauchy were cordoned off with outlines consisting of dots placed a little further apart from each other. These cordoned sections indicated areas that will remain lighter. Darker albedo and the lightened slopes of the two domes were added next.

Step 4

Working in small sections, outline areas for specific shadings with your marker and then fill in one outlined area at a time. This is where completing the entire ink sketch at the eyepiece is beneficial; when you fill in outlined areas, you can add more dots as needed to smoothen the transition between areas true to your live observation. If you were to attempt it later by memory, it would not be as accurate.

More highlighted areas to remain lighter should be outlined at this time (**Fig. 4.4.4**).

4.4 Black Felt-Tipped Pen on White Paper, Stippling – Rima Cauchy (by Erika Rix)

Fig. 4.4.4

Fig. 4.4.5

Step 5

Continue working in sections to fill in shade gradients (**Fig. 4.4.5**).

Step 6

Notice how the scene forms right before your eyes when working in sections. Your eyes might become very tired, as the endless number of dots appears to run together. Keep concentrating so that your dots remain tight and concise. You will be glad that you hung in there when the session has ended (**Fig. 4.4.6**).

Step 7

To complete the sketch, make final adjustments to shadings. Notice that in **Fig. 4.4.7**, most of the lighter areas had at least *some* shading.

Fig. 4.4.6

Add any pertinent information for your session and then rest those eyes!

Fig. 4.4.7

Supplementary Sketch Information

June 30, 2010, 05:33–08:39 UT
PCW Memorial Observatory, OH, USA
Zhumell 16″ Truss-Dobsonian (f/4.5), 12 mm Burgess, 2x Barlow, 300x Magnification. Temperature: 11.2–9.7°C (52–49°F). Humidity: >90%. Seeing: Antoniadi III increasing to II-I.

Phase: 318°, Lunation: 17.77d, Illumination: 87.2%
Libration in Latitude: −03:28, Libration in Longitude: +00:33
Altitude: 25:44, Azimuth: 135:22

Chapter 5

Sketching Dorsa (Wrinkle Ridges)

Some of the subtlest, yet most easily observed features on the Moon are the mare wrinkle ridges, or dorsa. These sinuous ridges, seen in virtually all maria, are the result of the submergence of basin structures, buried crater rims, and compression effects caused by the cooling and shrinking of basaltic mare lavas. They are generally positive relief features; most are between 100- and 300-m high. Despite the low height, the ridges may be hundreds of kilometers long. Wrinkle ridges are best seen close to the terminator when the Sun is near the lunar horizon.

The Serpentine Ridge, along the eastern side of Mare Serenitatis, is perhaps the best-known wrinkle ridge system. It was named hundreds of years ago by the early selenographers who likened the ridge to a sinuous snake. A careful examination of the ridge will reveal ghost craters whose interiors are totally inundated by mare basalts leaving only the highest rims to indicate their presence.

5.1 Carbon Pencils – Dorsa Smirnov (by Richard Handy)

Undulating Dorsa Smirnov and Dorsa Lister, which together form the Serpentine Ridge, seem to slither across the eastern side of Mare Serenitatis. I had been waiting for the chance to draw the area when the Sun's grazing light showed the wrinkle ridge at its best. Floor-fractured Posidonius, almost inundated completely by mare basalts, appears to keep a lonely vigil between Lacus Somniorum (Lake of Dreams) and Mare Serenitatis (the Sea of Serenity).

On March 31, 2009 at 9:33 p.m. PDT, I took the opportunity to sketch these beautiful dorsa. I decided to use carbon pencils to draw the scene because they have a wide range of gray tones and are easily blended.

Suggested Materials

- Wolff's carbon pencil set (B, 2B, 4B, 6B)
- Kneaded eraser

Fig. 5.1.1

Fig. 5.1.2

- Pink Pearl eraser
- Pencil sharpener
- Synthetic sponge for blending

Step 1

I like to sketch many of the prominent craters or features in the area first. A simple outline of these with the "B" carbon pencil is fine at this stage, as it provides a framework for adding other features (**Fig. 5.1.1**).

Step 2

Using the "6B" pencil, I fill in the deepest shadows of the mare. I want this area very dark as it represents the terminator blending into the dark basalts of Mare Serenitatis (**Fig. 5.1.2**).

Fig. 5.1.3

Step 3

I am applying the synthetic sponge to blend the "6B" carbon pencil into a single tone. It is a good idea to repeat Steps 1 and 2 in order to produce a nice even, dark tone (**Fig. 5.1.3**).

Fig. 5.1.4

Fig. 5.1.5

Step 4

At this point, I use the "4B" carbon pencil and then blend again with the synthetic sponge to match the gray tone of the lit mare (**Fig. 5.1.4**).

Step 5

Like in the previous steps, the rest of the eastern mare is built up with the "4B" strokes (**Fig. 5.1.5**).

Step 6

A circular motion with moderate pressure on the sponge seems to be ideal for blending the carbon pencil (**Fig. 5.1.6**).

Fig. 5.1.6

Step 7

I finish the sketch by adding detail to the highland on the eastern side of Mare Serenitatis using the "2B" and "4B" carbon pencils (**Fig. 5.1.7**).
 Here is the completed sketch (**Fig. 5.1.8**).

Fig. 5.1.7

Fig. 5.1.8

5.2 Graphite Pencil – Dorsa Smirnov (by Thomas McCague)

Suggested Materials

- Graphite pencils: 2H, HB, B, 2B, 4B
- Paper: acid-free, lignin-free paper of medium weight, 9″ × 12″
- Erasers: gum, plastic and shaped pencil erasers
- Clipboard
- Bright light
- Paper towels or facial tissues for wiping graphite from fingers
- Blending stumps
- Eraser shield may be useful but not used here

This tutorial covers a series of wrinkle ridges, or dorsa, on the floor of Mare Serenitatis. Because of the manner in which these features meander across the Moon, they are known as the Serpentine Ridge by many lunar observers. The sketch centers on a segment known as Dorsa Smirnov along the eastern floor of the mare. You can think of these features as being a long series of low mountain ridges while sketching them. With the region of interest more than half a day past the sunrise terminator, there is no need to rush in completing this sketch before shadows change. However, if too much additional time passes (such as another evening) the ridges will be increasingly difficult to see because of the loss of shadow lengths. It is the shadows that help set the ridges apart from the background surface of the mare.

Step 1

You begin by faintly drawing the principle features using a 2H pencil. Try not to press too firmly because you may need to erase and redraw until the ridges, craters, and other features that you can see at the eyepiece are properly positioned on the paper. Create faint outlines that are easy to erase and adjust. If you are somewhat heavy handed, you may want to use a softer graphite pencil, such as HB or B, so as not to indent or groove the paper. Other sketchers, including myself, have encountered this problem when sketching quickly near the terminator where speed becomes important. You will learn with practice how to create intermediate shades by using a sequence of several pencils or by using increased pressure with fewer pencil selections, both achieving the same result.

Step 2

In this step, we begin to darken the narrow shadow features using a B pencil while examining the eyepiece view and then returning to the sketch paper (**Fig. 5.2.1**).

Erasing and repositioning the ridge shadows may be a trial and error event for a few rounds, but with patience you will sketch the light and dark regions correctly to the satisfaction of your critical eye.

Fig. 5.2.1

Fig. 5.2.2

Fig. 5.2.3

Step 3

Shade in a few of the main visible craters before shading the mare floor (**Fig. 5.2.2**). Do not use excessive pressure, and if you need a darker shade, use a softer graphite pencil such as 2B.

Step 4

Holding the sharpened B (or softer 2B) pencil nearly parallel to the paper while moving it back and forth with even pressure, create an initial application of graphite, concentrating on

Fig. 5.2.4

differences in darkness as you shade the floor away from the dorsa. Continue applying back and forth strokes to make an even, gray tone across the floor up to the wrinkled ridges. Most of the lunar sea floors are relatively dark. It may be necessary to re-work the floor with a softer pencil to produce the required dark gray of the lava-flooded floor (**Fig. 5.2.3**).

Step 5

Moving closer to the sunrise terminator, the lunar surface noticeably darkens. Once again, switch to a softer, darker pencil (4B or 6B). The way to think of this process is that you can easily darken, but you must erase to go lighter.

Step 6

You may be able to see stroke marks on your sketch from the assortment of pencils used in the previous steps. Now is the time to remove them by blending and smoothing. To achieve a nice, even blend of the correct darkness, use different blending stumps that have been loaded with soft graphite (**Fig. 5.2.4**). You may want to test their darknesses on a scrap piece of paper prior to blending your sketch.

5.2 Graphite Pencil – Dorsa Smirnov (by Thomas McCague)

Fig. 5.2.5

Step 7

It is now time to assess the overall appearance of the sketch. Use the pencils, erasers, and blending stumps that were used earlier to bring the work to a conclusion in terms of brightness and shadow. Getting the light and shadow features correct is the key to making any lunar sketch realistic looking when compared to the eyepiece view.

When the sketch closely matches the view you were striving to capture, you can consider the sketch completed (**Fig. 5.2.5**).

Supplementary Sketch Information

This graphite pencil sketch of Dorsa Smirnov was completed using a 10″ f/5.7 Dobsonian telescope and a 6 mm eyepiece working at 241x. The telescope was riding on an equatorial platform.
Date and Time: May 30, 2009, 02:30–04:00 UT
Seeing: Antoniadi III
Weather: partly cloudy, clear, calm, mild
Lunation: 5.6 days
Moon: 38.8% illuminated

5.3 Conté Crayons on Black Paper – Environs of Arago (by Sally Russell)

Dorsa are very low topographical features best seen under grazing illumination at lunar sunrise or sunset when they cast significant shadows. They are perfect subjects for showcasing a version of negative drawing where the previously applied medium is erased from the paper leaving a darker area behind. It is often simpler to apply and blend a large area of relatively uniform mare region first and remove the Conté crayon afterwards in a defined way than it is to sketch around these long, narrow shadows. This tutorial illustrates some well-illuminated dorsa viewed at the terminator in the region of the crater Arago in Mare Tranquillitatis.

Note: The sketch in this example was made from a high power telescopic view using a refractor with a mirror diagonal giving a mirror image at the eyepiece.

Suggested Materials

- Drawing board (plus masking tape to fix the paper in place)
- Smooth black Daler-Rowney 'Canford' paper (90 lb weight – paper size 12″ × 16 ½″ was used for this tutorial)
- White Conté crayon
- Craft knife for sharpening Conté crayon
- Natural sponge
- Kneadable eraser

Step 1

Before you begin sketching, either clip or tape down your paper onto a suitable drawing board (**Fig. 5.3.1**). In this example, the sketchpad is being used on a lightweight drawing board that has a built-in clip. There will be a cushioning effect if you use the whole sketching pad rather than a single sheet of paper, preventing small dents and texture on the board from being transferred through the paper onto your sketch. I learned this technique the hard way, having worked with natural wood drawing boards in the past, and found the grain of the wood echoed in my sketches! If your board is very smooth, of course, a single sheet of paper should be enough.

Fig. 5.3.1

Step 2

Sharpen your Conté crayon to a rounded point using a craft knife (**Fig. 5.3.2**), then very lightly sketch the outlines of the main dorsa and craters (**Fig. 5.3.3**). Conté crayons cannot be fully erased as easily as chalk pastels because they are slightly waxy. As long as you keep the outlines light, any faint lines

5.3 Conté Crayons on Black Paper – Environs of Arago (by Sally Russell)

Fig. 5.3.2

Fig. 5.3.4

Fig. 5.3.3

left after erasing (if needed) should be easily incorporated into the background as you apply additional layers of Conté.

Step 3

Add the main highlights on the crater rims and along the dorsa with a heavier application of Conté crayon over the original lines. Then, with a short piece of Conté crayon held on its side (flat to the paper), begin to fill in the strongly lit mare region area with broad, overlapping strokes (**Figs. 5.3.4** and **5.3.5**).

Blend the area with your fingertip or a small piece of dry natural sponge to produce the effect of the smooth, bright mare surface (**Fig. 5.3.6**).

Step 4

Build up the remaining mare region in a similar fashion with the Conté crayon held on its side and add in further major highlights showing the sunlit slopes of the domes (Arago Alpha and Arago Beta).

Fig. 5.3.5

Fig. 5.3.6

If you can, try to leave narrow, blank areas along the dorsa to represent the shadows being cast there, as this will save a bit of time later when you come to erase the Conté background to define the shadow areas.

As before, blend the area with your fingertip or a sponge, keeping the line of the terminator (along the left of the sketch) soft. Then add the remaining lighter features visible on the mare surface – the isolated highlight at the top of the sketch area (the rim of crater Arago B, just catching the sunlight under these lighting conditions) and further hints of dorsa running from the main crater (**Fig. 5.3.7**).

Step 5

Shape a kneadable eraser into a fine point, then use it to carefully remove some of the background to produce the shadow cast by Arago B (**Fig. 5.3.8**). Similarly, 'draw' in the shadows cast by the dome, crater Arago, and the small dorsa attached to the main crater. You will probably need to go over the shadow areas with the eraser a few times until you achieve the desired effect. In a similar way,

5.3 Conté Crayons on Black Paper – Environs of Arago (by Sally Russell)

Fig. 5.3.8

Fig. 5.3.7

strengthen the shadows along the main dorsa and remove a curve of background to suggest the inner, shadowed side of the large ghost crater 'Lamont.'

To tidy up, erase any stray smudges of Conté from around the periphery of your sketch.

Figure 5.3.9 is the completed sketch.

Supplementary Sketch Information

For this observation, I used a 105 mm f/5.8 refractor on a driven mount with a 2.5 mm eyepiece, giving a magnification of around 245x. The drawing was completed on January 31, 2009 at 18:35–19:45 UT with the Moon at 5.5 days old (27% illuminated) under calm, slightly hazy conditions (seeing: Antoniadi II-III).

Fig. 5.3.9

Chapter 6

Sketching Crater and Sunlight Rays

Crater rays are bright ejecta from relatively recent impacts. Rays surround Copernicus, Kepler, and Tycho, and some of them are spread over nearly half of the Moon's globe. Over the course of millions of years, they gradually fade away during a process called micro-meteoritic gardening. The Moon has no appreciable atmosphere, so that even the smallest meteorite impacts the surface with enough force to create a small pit or crater in the regolith. This constant bombardment effectively mixes the surface breccias, resulting in a gradual homogeneity that obscures the bright rays.

Sunlight rays (which can occur at sunrise or sunset), result from the Sun shining through a gap in a crater wall or massif, causing a bright ray of sunshine to fall across the lunar surface. They have no physical presence.

6.1 Charcoal – Kepler (by Erika Rix)

Sketching ejecta rays can be difficult, especially complex crater ray systems. The easiest technique for me is to actually draw the bright primary crater first (as well as most of the surrounding companions) and then fill in the gaps with the ray system. Rarely do I end up with accurate crater placements if I attempt drawing the rays at the beginning of the sketch.

Here are a few tips for using white paper when sketching rays: draw your craters first so that you have anchors for ray placements, concentrate solely on the dark areas, work in layers after your craters have been added (light to dark), work in wedges around the bright primary crater, and finally…patience is the key. The craters are the easiest part of the sketch!

You may want to start off with an easier crater ray system if this is your first attempt at sketching such a target. Or, if you are like me, just dive right in. Kepler was too irresistible to pass up for this tutorial. A friend told me (when she thought I was getting in over my head once…or twice) that there's nothing like jumping in with both feet. Well, sometimes that is exactly what is needed to keep from being intimidated by the task at hand. When you patiently plug away at a difficult sketch, you usually end up being pleasantly surprised with the results.

Suggested Materials

- 8½″ × 11″ sheet of white sketching paper on a clipboard (Rite in the Rain paper was used for this tutorial)
- Chamois for blending
- Assorted blending stumps and tortillons
- Charcoal pencil (6B soft was used in this tutorial)
- Both a flat and a round piece of compressed charcoal
- Pencil sharpener
- Sandpaper for sharpening/cleaning blending stumps and tortillons
- Cloth rag to wipe your fingertips

Step 1

A round stick of compressed charcoal is used flat against the paper to create a light background to the sketch (**Fig. 6.1.1**). Make sure there are no rough or sharp edges to the charcoal stick or you may end up with unwanted dark streaks that are difficult to erase without damaging the tooth of your paper. Blend with a chamois. Repeat if necessary.

Fig. 6.1.1

Fig. 6.1.2

6.1 Charcoal – Kepler (by Erika Rix)

Fig. 6.1.3

Fig. 6.1.4

Step 2

Add craters using your charcoal pencil, starting with the crater that the rays originate from (**Fig. 6.1.2**). Envision triangular patterns between the craters to help with proper crater placements. Concentrate on crater sizes, positions, shadows, and accurate shapes.

Step 3

Add details inside the craters with a charcoal-loaded blending stump or tortillon (**Fig. 6.1.3**). To do this, simply rub the tip of your blending stump against a piece of charcoal and then use the tip to add the markings to your paper. This technique actually blends your markings in the process.

I find it handy to clip a flattened piece of charcoal on my sketching clipboard so that I can easily rub my blending stumps across it without having to reach for my sketch kit.

Step 4

Redistribute excess charcoal from the crater rims with a clean, slender tortillon to create details on the outer edges of the craters. You may need to add more charcoal by loading your tortillon as described in Step 3 (**Fig. 6.1.4**).

Fig. 6.1.5

Fig. 6.1.6

Step 5

Working in sections, softly begin adding the darkened areas that surround the rays. Use either a stick of charcoal directly on the sketch or a soft charcoal pencil as shown in **Fig. 6.1.5**.

Step 6

Blend the new markings with a clean blending stump while being careful not to smudge the craters (**Fig. 6.1.6**).

If you notice the blending is uneven or that you have little control over the blending results, you should clean the tip of your stump with a block of sandpaper before continuing (**Fig. 6.1.7**).

Fig. 6.1.7

6.1 Charcoal – Kepler (by Erika Rix)

Fig. 6.1.8

Fig. 6.1.9

Step 7

Notice how the ray system forms itself when you concentrate on the darker areas that surround it (**Fig. 6.1.8**).

Step 8

More layers are added for depth and additional detail. At this stage, I added another layer to the outer background edges of the sketch as well as within the main feature. After blending again, final details were added directly with a rounded stick of charcoal (**Fig. 6.1.9**).

Careful blending and additional layers will eliminate the need for an eraser to create the highlighted rays; however, if you do need to use an eraser, I would suggest using either a kneadable eraser (to lift the excess charcoal) or a white vinyl eraser. You may find it a little difficult to erase cleanly if you use Rite in the Rain paper. The vinyl eraser seems to work best with that brand.

Fig. 6.1.10

Step 9

A final blending is completed, and then one last review through the eyepiece for any finer details to be added. In **Fig. 6.1.10**, a white vinyl eraser was used to create Reiner Gamma just below the crater Reiner. Hints of the crater Encke and ridges near the crater Kepler were added using a sharpened charcoal pencil.

Supplementary Sketch Information

October 21, 2010, 05:45 UT
 PCW Memorial Observatory, OH, USA
Zhumell 16″ Truss-Dobsonian (f/4.5), 8 mm Tele Vue Plossl, 225x Magnification, no filters.
 Temperature: 12°C (53.6°F). Humidity: 45%. Seeing: Antoniadi III.

Phase: 20.4°, Lunation: 13.46d, Illumination: 96.9%
Libration in Latitude: −06:15, Libration in Longitude: −02:16
Altitude: 47:19, Azimuth: 227:28

6.2 Conté Crayons on Black Paper – Kepler (by Thomas McCague)

Suggested Materials

- Conté crayons and Conté pastel pencils, white and black, several of each, sharpened
- Black Strathmore Artagain paper (large sheet 19″ × 25″)
- Art gum and Pink Pearl erasers
- Small clean brush
- Blending stumps
- X-Acto knife
- Sand paper block and/or emery boards for sharpening and maintaining pencils
- Clipboard
- Bright light

Some of the most enjoyable observations that can be made when the Moon is illuminated at a high sun angle are of the bright ejecta rays surrounding the youngest, large lunar craters. For this sketch, I chose the crater Kepler, which has magnificent ejecta rays that can be seen with the smallest of telescopes.

Step 1

To begin, cut a section (12″ × 14″) from a large piece of black Strathmore Artagain paper. After attaching it to the clipboard, lightly use a white Conté pastel pencil to begin drawing the central crater, its rays, and selected visible features. Examine the rays and other visible features at the eyepiece as you outline them and adjust the dimensions for proper placement on the paper. The sketch should now resemble **Fig. 6.2.1**.

Fig. 6.2.1

Fig. 6.2.2

Fig. 6.2.3

Step 2

We now direct our attention to the treatment of the rays. Using only the weight of the pencil with a back and forth motion, fill in the regions representing where the rays are located. We do not want to make the rays too bright, so applying no pressure on the white pencil will produce a good representation that matches the gray color viewed (**Fig. 6.2.2**). Look very carefully and frequently through the eyepiece when making adjustments to the width, length, number, and positions of these rays.

Step 3

Once you are satisfied that the rays look correct, you can move on to the craters and other features visible in the field of view. Make sure you have several sharpened white pastel pencils nearby. If you have too few, you will find yourself sharpening pencils instead of sketching. Four to six seems to be the right number of pastel pencils for a sketch of this size.

Step 4

While sketching with Conté crayon chalk sticks, we end up with small broken pieces over time. Keep these in a small container, as they are very useful (as shown in **Fig. 6.2.3**).

Draw the background between the rays with the chalk. Some of the other tutorials that use Conté in this book suggest adding the background first before drawing the outline. The method described here is just another technique you can use and is just as effective.

Fig. 6.2.4

Fig. 6.2.5

Step 5

Blending the background will require the use of blending stumps, or even just your fingers, as shown in **Fig. 6.2.4**. The bright features of the sketch are now in place and it is time to turn our attention to the darker shaded regions.

Step 6

Since the Moon is a few days before full, dark shadows are present at the bases of the craters and mountains. Carefully using a black Conté pastel pencil, add a subtle dark shading to the features that are too bright – this will tone them down. As in Step 2, when using the white pencil, it is often enough to use the weight of the black pencil to make adjustments for a darker appearance.

Step 7

Blend to a gray after shading is completed. It may be necessary to redefine and brighten the crater rims and rays using the white Conté chalk or pencil until they match the eyepiece view (**Fig. 6.2.5**).

Fig. 6.2.6

Step 8

Use art gum and shaped Pink Pearl erasers if any corrections need to be made. A small brush is carefully used to remove the eraser crumbs.

If you find no other features that need attention, you can consider your sketch finished (**Fig. 6.2.6**).

Supplementary Sketch Information

Crater Kepler ejecta rays on black Artagain paper with white Conté pencil and crayon
Sketch created on May 8, 2009 using a 10-in. f/5.7 Dobsonian telescope riding on an equatorial platform and a 9 mm eyepiece for 161x at 03:00–04:45 UT.
Seeing: Antoniadi II
Weather clear, calm, 45°F (7°C)
Lunation: 11 days
Moon 90% illuminated

6.3 Conté Pastel Pencil on Black Paper – Maginus (by Thomas McCague)

Suggested Materials

- Conté crayons, Conté pastel pencils, white and black, several of each, sharpened
- Black Strathmore paper (large sheet 19″ × 25″)
- Art gum and Pink Pearl erasers
- Small clean brush
- Blending stumps
- X-Acto knife
- Sanding block and/or emery boards for sharpening and maintaining pencils
- Clipboard
- Bright light

As a target for this sunlight ray sketch, I selected the 168-km large complex crater Maginus at the sunrise terminator. With sunlight spraying across the shadowed floor, this dramatic view begged to be captured on paper.

Bright sunlight rays illuminating crater floors or regions in the shadows beyond a crater are remarkable sights to witness at the eyepiece of a telescope. More than 80 examples of sunlight rays are known to occur. These are tabulated at The Robinson Lunar Observatory website: http://www.lunar-occultations.com/rlo/rays/rays.htm.

Step 1

Due to the shorter than ephemeral window of this sunlight ray phenomenon, speed was of the essence from beginning to end. A sheet of black sketching paper measuring about 10″ × 12″ was cut from a large sheet of Strathmore Artagain paper.

Step 2

Using a sharpened white Conté pastel pencil, a quick outline of the bright high rim of the crater was positioned onto the paper after looking into the eyepiece. Several attempts may be required to get a good match (**Fig. 6.3.1**). It is very important to get the shape correct quickly and accurately, because you will not likely have time to go back and redo the sketch if you are not satisfied with the results.

Fig. 6.3.1

Fig. 6.3.2

Fig. 6.3.3

Step 3

Beyond the crater rim, to the left in this sketch, sunlight was falling across the lunar surface. Since I used a sanding block to sharpen and shape the pencil points, pastel dust collected on the sanding block was available to create this part of the illuminated lunar surface. Fingertips worked well for applying and spreading pastel powder (**Fig. 6.3.2**).

Fig. 6.3.4

Step 4

More of the sun-illuminated features were drawn using the pastel pencil (**Fig. 6.3.3**).

Step 5

Before the scene changed too much, I started drawing the bright, light ray that was illuminating a wedge of the crater floor. After shaping the ray on the floor and adding bright highlights (**Fig. 6.3.4**), it was necessary to clean up smudges with a plastic eraser.

6.3 Conté Pastel Pencil on Black Paper – Maginus (by Thomas McCague)

Fig. 6.3.5

Step 6

Attention was then directed to completing the regions beyond the crater floor. Using the white Conté crayon, additional chalk was added and blended where needed while comparing the eyepiece view to the sketch.

Step 7

If there are persistent problem areas that do not respond well to erasure, one solution is adding coverage with a black Conté pastel pencil, and then blending with fingers or a blending stump tool (**Fig. 6.3.5**).

Step 8

Using all the tools mentioned above, it is just a matter of examining the eyepiece view and making the final corrections until you are satisfied that you have successfully captured the event.

Here is the final sketch (**Fig. 6.3.6**).

Supplementary Sketch Information

Crater Maginus with bright ray on black Artagain paper
Sketch date: February 3, 2009 using a 10-in. f/5.7 Dobsonian telescope riding on an equatorial platform and a 6 mm eyepiece for 241x at 00:00–01:00 UT
Seeing: Antoniadi III

Fig. 6.3.6

Weather: clear, calm, 20°F (−7°C)
Lunation: 7.7 days
Moon: 51% illuminated

6.4 Mixed Media – Tycho (by Deirdre Kelleghan)

Suggested Materials

- Mungyo soft pastels (grays, black, white)
- Liquidtex super-heavy body acrylic paints (Titanium white and Mars black)
- Liquidtex slow dry gel retarder
- Galeria structure gel
- Sennelier soft pastel
- Brushes, various sizes
- Palette knives, various sizes
- Windsor and Newton matte varnish spray
- 3′3″ × 3′3″ canvas

The original, massive, Tycho-forming impactor created the large bright crater with a defining, explosive ray pattern. These long, finger-like rays spread out in all directions, dramatically appearing to hold the Moon as if they were rooted to a giant supporting hand. It is indeed fortuitous from a

6.4 Mixed Media – Tycho (by Deirdre Kelleghan)

painting point of view that the material from the impact fell as it did, giving so much visual curvature to this magnificent gray orb. These rays stretch out over 1,000 miles of lunar surface. The rays shoot out from beyond the ejecta blanket and pierce through many other crater walls, floors and maria. Tycho is an enormous expansive feature with a very dramatic profile.

Many smaller and shallower impact craters surround Tycho. They collectively create scalloped patterns below the crowning rim. Raised sections between scattered craters stand out like walkways between the almost meeting edges. The colossal power of the original baptismal bombardment still remains visually evident after 108 million years.

After observing and sketching Tycho over several years, I finally came to the conclusion that this crater, impact melts, and rays would best be expressed in a painting. It was difficult to decide how to tackle Tycho on canvas. Do I fill the canvas with the crater rim and immediate surroundings, or take it really wide and include as many rays as possible? Two rays in particular interested me – one that seems to reach almost as far as Kepler and which is side-by-side with another ray that seems to truncate at Bullialdus. A wide groove separates them both and several craters pit these rays, creating diamond-like sparkle points when the Moon is almost full.

Previous pastel sketches have invited me to use my little finger to recreate this groove. On canvas, I wanted the impact to happen again in paint with energy oozing from every stroke. This painting gave me the opportunity to use a palette knife to gouge out the area between the major rays.

Paintings do not just happen out of nothing – this one has been bubbling up inside me for some time. Elements of it floated around in my head – my thoughts were constantly drifting toward its creation. Paintings develop differently to sketches – they build up to explode onto the canvas. The nature of the materials being used seems to alter the way you treat the subject. The ergonomics of wielding a palette knife loaded with paint is so satisfying and exciting. Sketches are in certain ways a more passive, restrained process for me.

With great delight, I surrounded myself with the instruments of Tycho-making: hefty palette knives, fine palette knives, thick, heavy-duty acrylic paints, and retardant gel to slow the paint drying. Pots of lovely acrylics structure gels, pastels, and other delights looked at me for days and wondered what they would become (**Fig. 6.4.1**).

Fig. 6.4.1

Fig. 6.4.2

Fig. 6.4.3

Creative Process and Studies

Several weeks before I began the main canvas, I was thinking about how I would use paint to create the many radiating lines of Tycho's ejecta rays. Cloudy weather persisted for days, so I decided to have a close look at an image of Tycho that I particularly liked. In 1998, the spacecraft Galileo took false color images of this super crater. For many years I had considered that this close up image of Tycho would make a fine subject for direction to canvas, and the finished canvas would also not look out of place in an art gallery (**Fig. 6.4.2**).

Using palette knives, I began to experiment with acrylics in thick, rapidly applied lines. I added structure gel and texture gel to the paint to see how its use might help in creating thick raised areas. I used the paint as if it were plaster and was satisfied with the resulting small canvas in red, blue, white and yellow thickly applied acrylic paints. My encounter with Tycho in this way gave me latitude, and furthered my journey towards a large canvas. This I consider to be a study painting, not created at the eyepiece but a visual study of the target, which helped to inspire the larger work.

December 1, 2009, the Moon was 98% flooded in almost direct sunlight, all of the lunar diamonds were beaming their reflective light down my telescope tube. The rim of Tycho was a thin white line interspaced with knotted darker lines. The Kepler and Bullialdus rays arched their way half way down the lunar surface. The Rosse ray wrapped its way around the Moon emanating from beyond the annulus surrounding Tycho.

My study sketch at the eyepiece that night was in pastel to show the shape of the rim and the ray pattern only, with small reference to other craters (**Fig. 6.4.3**).

January 2, 2010, Tycho was flooded in sunlight on the 98% illuminated Moon, and temperatures were plummeting in the big freeze. In the early evening, I decided to try a pencil sketch to just

6.4 Mixed Media – Tycho (by Deirdre Kelleghan)

Fig. 6.4.4

Fig. 6.4.6

Fig. 6.4.5

concentrate on the rays and the darker sections in-between. I ignored almost everything else on view as, earlier, I had decided that Tycho was so complex that it had to be tackled in layers or stages. However, after 15 min of −6°C (21°F), my fingers started to turn white and I could not hold my pencil (**Fig. 6.4.4**).

Reluctantly I went indoors but was not at all happy about it. At 00:19 UT, I decided to try again. This time I was determined to have a go at painting directly from the telescope. By 01:40 UT, I had something worth the effort in paint on paper (**Fig. 6.4.5**).

I used a small palette knife and some small brushes (**Fig. 6.4.6**).

This second study painting, done directly at the eyepiece, was an invaluable exercise as it helped me to create the shape of the ejecta blanket and the fluid-like qualities of the material leading to the major rays. For the next few days, Tycho was never far from my mind, I was preoccupied with thoughts of putting it on canvas. With astronomical sketching, I take the opportunities that the sky and the weather offer to me, getting stuck in the moment, and usually choosing my targets quickly.

With paintings I tend to mull over them for days, visualizing, generating energy, thinking of details, just thinking. I tried to immerse myself in thoughts of Tycho's first creation so I could somehow capture it in paint. My study wall was covered in previous Tycho study sketches – which I used as references for the work on the large canvas.

Fig. 6.4.7

Fig. 6.4.8

Step 1

Painting Tycho began by the application of an even gray to my canvas (two coats) and then marking in the outline of the crater rim (**Fig. 6.4.7**).

Step 2

I built up the shape of the shadows surrounding the rim using my palette knife – their dramatic angles gave height and visual structure to the crater. Attention was also given to laying down a base for the major rays (**Fig. 6.4.8**).

Step 3

My painting has many raised paint lines caused by using the palette knives. These can be emphasized by rubbing brighter or darker pastel against the edges, thereby, giving the lines an extra dimension. I added a little structure gel to the paint for the raised sections of the painting, as it aided the firmness of the paint (**Fig. 6.4.9**). I often used my fingers to blend, as sometimes it gives a better result than using a brush or a knife. On days when I had hours to paint, I added a small amount of retardant gel to the paint to help it stay spreadable longer (**Fig. 6.4.10**).

6.4 Mixed Media – Tycho (by Deirdre Kelleghan)

Fig. 6.4.9

Fig. 6.4.10

Fig. 6.4.11

Fig. 6.4.12

Step 4

I over-layered inside the crater with pure white Sennelier pastel, which added a lovely quality and very bright tone to highlight its albedo nature (**Fig. 6.4.11**). Flicks of white paint with wide triangular bases at their rims shot down to tapered points, again giving height and structure (**Fig. 6.4.12**).

Pitatus, a most important feature, was again not to be over-emphasized. Nubium's varied tones, as I attempted to capture them, helped to soften the look of the mare. Most of the observations of this crater and its environs were made when the Moon was full or close to full. Black sits well in this painting, even though in my observations the Moon was very even-toned. However, I felt that the dramatic presence of bright Tycho warranted the differences in contrast with a leaning toward expressionism.

Step 5

Fig. 6.4.13

Often while observing Tycho, I had noticed that the area around Mare Nubium presented itself in the shape of a teddy bear (see base of **Fig. 6.4.14**), Crater Nicollet being the nose, Wolf the right eye, and Birt the left eye. Remember, I was looking at it upside down. When you recognize shapes or patterns that are familiar, it somehow makes them easier to reproduce. That area, the "teddy bear," proved difficult, and my solution was to use soft Mungyo gray pastels over-layered on top of the paint to soften its hard, dark look. Indeed, because the Moon has so many grays, a drawing or painting of it could be very 'samey' if definite differences between grays were not emphasized. However, I did not want that area to be too dark, as it was observed at almost full Moon.

Most of this painting was created using palette knives for spreading and working the paint into the very raised fluid-like and very dramatic rays of this lunar gem.

Tycho crater and its rays were meant to dominate this painting, so bringing an overload of detail to this area was, in my opinion, unnecessary. The dazzling white highlands to the west were to yield the most striking features – many points of brilliant light, sparkling jewels set in the lunar rims, adrift in a sea of floodlit craters. These bright albedo features were added by using white paint on the tip of a small palette knife, and then when it dried, I added a flick of white pastel against the edge of the raised paint (**Fig. 6.4.13**).

Another useful approach to painting or sketching is to keep the work balanced, i.e., work on different areas every time you paint. With sketches, balance helps you achieve a more complete sketch despite the weather that may defeat your efforts. Painting affords you the time to stand back often and see which areas are been neglected. This canvas is 3′3″ square, so standing well back from time to time helped keep a focus on the work as a whole. To seal the painting, I used about six applications of matte fixative spray applied over several days. The fixative was more concentrated in the areas where pastel was used over the paint.

This is the finished painting (**Fig. 6.4.14**). It took from December 29, 2009 – February 5, 2010 to complete the canvas.

Supplementary Sketch Information

Pastel study sketch: December 1, 2009, 21:00–21:45 UT
Study Painting at the eyepiece: January 2, 2010, 00:19–01:40 UT
200 mm Dobsonian FL 1200 mm, 8 mm Tele Vue Plossl eyepiece, 150x
Seeing: Antoniadi I in both cases
Bray, Co Wicklow, Ireland

I brought this crater and its rays from a quarter of a million miles away to my canvas on Earth. It was an exercise in extreme observation, balance, and total immersion in the subject and materials. All my study sketches were observed with south at the top so my painting was worked on from that aspect also and has not been inverted – south is on top, west to the right.

6.4 Mixed Media – Tycho (by Deirdre Kelleghan)

Fig. 6.4.14

Fig. 6.4.15 Deirdre Kelleghan with her Skywatcher 200 mm Dobsonian f/5.9 telescope

Chapter 7

Sketching Rupes (Scarps)

Escarpments on the lunar surface are often labeled with the Latin word "rupes". A number of processes created scarps on the Moon:

They were produced by basin formation that resulted in a number of uplifted concentric, or arcuate, rings whose basin-facing sides are cliffs or scarps. A prime example of this is Rupes Altai, the well-known partial ring that surrounds Mare Nectaris.

Another process included faulting, caused by a tectonic adjustment of dense, cooling lava. You can observe this type of scarp along the eastern shore of Mare Nubium between craters Thebit and Birt. Rupes Recta (the Straight Fault or Straight Wall) is the result of faulting, which mitigated the stresses induced in the mare by the uneven distribution of basalt mass.

Scarps were also formed as a result of crater degradation, where multiple impacts or lava flows destroyed sections of the inner or outer walls of a pre-existing crater leaving an arcuate scarp.

7.1 Charcoal – Rupes Recta (by Erika Rix)

Lunar faults are the perfect targets for anyone who uses the old expression "I can't even draw a straight line!" If you want to draw a realistic scarp, seek out its curves and imperfections.

Rupes Recta is featured in this tutorial and was approximately 14° away from the terminator during the waxing Moon.

Suggested Materials

- 8½″ × 11″ sheet of white sketching paper on a clipboard (Rite in the Rain paper was used for this tutorial)
- Assorted blending stumps and tortillons
- Chamois for blending large areas
- Charcoal pencil (6B soft was used in this tutorial)

- Flat piece of compressed charcoal
- Pencil sharpener
- Sandpaper for sharpening and cleaning blending stumps and tortillons
- Cloth rag to wipe your fingertips

Step 1

With your charcoal pencil, lightly create a rough outline of the largest feature that you wish to include in the sketch. In **Fig. 7.1.1**, I chose Rupes Recta. It can be easier to create accurate proportions and placements of all the other features to follow when you reference them to a larger object. You will be able to sketch over the original markings without the need to erase if your outlines are light.

Add outlines of the other main features next. In this tutorial, crater Birt was added using the scarp as a reference for proportions and placements.

Step 2

Add the background by applying charcoal to your paper with a large, clean-tipped blending stump. I chose my largest blending stump so that I could work around the main crater cleanly as well as add subtle variances in albedo straight away with minimal time involved. Blend smoothly in the process (**Fig. 7.1.2**).

Fig. 7.1.1

Fig. 7.1.2

7.1 Charcoal – Rupes Recta (by Erika Rix)

Fig. 7.1.3

Fig. 7.1.4

Step 3

Using the charcoal pencil, lightly redraw any outlines that were rubbed smooth while blending. Add shadows around the craters first, as they tend to change faster than the shallower scarp shadows. Use a sharp charcoal pencil to produce sharp, clean crater rims.

Start adding detail on the outer rims of the craters, adjusting the pressure on your charcoal pencil as needed for slight changes in the shades as you make your way outward from the craters. This will begin the process of adding depth to the sketch. Work in layers; i.e., add a light detail layer, blend, and then add the darker details over it (**Fig. 7.1.3**).

Step 4

Begin adding shadows around the scarp and the smaller craters with your charcoal pencil. Notice in **Fig. 7.1.4**, I blended inside and around the crater Birt. Then I extended the details around it to include a slight indication of Rima Birt as I saw it through the eyepiece. An additional section of lighter shadow was added inside the crater.

Fig. 7.1.5

Fig. 7.1.6

Fig. 7.1.7

Step 5

Albedo contrast and terrain, such as ridges, are added directly with the charcoal pencil. In **Fig. 7.1.5**, another small crater was added to the bottom right of Birt as well as a long ridge. It's ok to exaggerate with your markings since they will be softened during blending.

Step 6

Once the main features are near completion, add another layer of contrast in the background directly with your charcoal pencil. Blend the background with a chamois for a very smooth transition from light to dark (**Fig. 7.1.6**).

Step 7

I blended around the ridges near the scarp with a smaller blending stump for better control. A tortillon would also have worked well for this area (**Fig. 7.1.7**).

7.1 Charcoal – Rupes Recta (by Erika Rix)

Fig. 7.1.8

Step 8

Repeat Steps 5–7 for another layer of depth if needed. Concentrate on any fine details that you may have missed. You can see by comparing **Figs. 7.1.7 and 7.1.8** that I added additional albedo contrasts, fine details around the scarp and rims of the craters, and darkened ridges in the terrain at the top of the scarp.

Wait for steady seeing and take your time. These last details, that you observe and then add to your sketch, create a crisp, realistic representation of your observation.

Supplementary Sketch Information

October 16, 2010, 23:51 UT – October 17, 2010, 01:42 UT
PCW Memorial Observatory, OH, USA
Zhumell 16″ Truss-Dobsonian (f/4.5), 20mm Tele Vue Plossl, 3x Barlow, 270x Magnification, 13%
 T moon filter. Temperature: 7°C (44.6°F). Humidity: 59%. Seeing: Antoniadi II. Transparency: 2.5/6.

Phase: 65.2°, Lunation: 9.33d, Illumination: 70.9%
Libration in Latitude: −03:50, Libration in Longitude: +02:56
Altitude: 32:06, Azimuth: 209:37

7.2 Conté Crayon on Black Paper – Lacus Mortis Fault (by Thomas McCague)

Suggested Materials

- Conté crayons
- Conté pastel pencils, both white and black
- Black Strathmore Artagain paper (9″ × 12″)
- Art gum eraser
- Small clean brush
- Blending stump
- X-Acto knife
- Sanding block or emery boards for sharpening and maintaining pencils
- Small container of white pastel pencil powder

I selected the radial fault on the floor of Lacus Mortis, which runs from south to north as it reaches out towards Rimae Bürg, to illustrate sketching a lunar fault (rupes). It is the vertical white line seen near the bottom center of the finished sketch (**Fig. 7.2.6**).

This Lacus Mortis fault sketch is from a late lunar evening with crater Bürg near the terminator during a waning gibbous Moon phase (19.5 days old). Examining the fault through the eyepiece, shows it diminishes in altitude as you follow it northward until it becomes a rille. This rendering was performed generally from right to left using high power. Although close to the terminator, this feature is far enough to the north that sketching quickly is not a major concern.

Step 1

Before commencing your sketch, you can collect and save white Conté pastel crayon dust for spreading onto the black sketching paper with your fingertips. To do this, shape or sharpen a pastel stick and/or a pastel pencil on a sanding board (rectangular object next to the pencil) and store the dust into a small plastic film container or other clean tight-sealing container for later use (**Fig. 7.2.1**).

7.2 Conté Crayon on Black Paper – Lacus Mortis Fault (by Thomas McCague)

Fig. 7.2.1

Fig. 7.2.2

Step 2

After examining the region of interest in the eyepiece, gradually (as needed) sprinkle some of the collected dust onto the paper to correspond to the illuminated lunar region and then spread it across the paper to match the eyepiece view. This may take more than one application to achieve an adequate level of brightness (**Fig. 7.2.2**).

Step 3

Fig. 7.2.3

As soon as you are satisfied that both the gray–white tone and the shapes are correct on the paper, use the sharpened white pastel pencil to begin sketching your outline of the bright features, going back and forth between the eyepiece view and your sketch.

Continue working on the outline features, getting them well placed before applying more pressure to brighten the highlights that are the most light reflective. The bright line just above the pencil is the fault on the floor of Lacus Mortis (**Fig. 7.2.3**).

Fig. 7.2.4

Fig. 7.2.5

Step 4

As you work from region to region around the field of the sketch, use a black Conté pastel pencil to mark and shade features that are completely shaded (**Fig. 7.2.4**).

Step 5

Next, return to the white Conté and continue checking your progress by frequent glimpses into the eyepiece. Finger blending may be necessary to adjust the background. The goal is to have your sketched object match the eyepiece view.

Carefully work your way through the sketch, alternating between the white and black Conté pastel pencils (**Fig. 7.2.5**).

The final brightening of the reflective features of the sketch with white Conté brings the rendition to a close approximation of the eyepiece view. As you look over the sketch, perform any needed final erasing, brightening, darkening, and blending.

If you experience some smearing, as you can see in the lower right portion of the sketch in **Fig. 7.2.5**, it will need attention. Blending stumps may be all you need to correct this. A blending stump loaded with a little black pastel can darken those smeared regions.

Step 6

Another blending stump is prepared for those regions that need brightening by loading white pastel dust on the blending stump.

When you are finished with these final corrections, the sketch can be considered complete (**Fig. 7.2.6**). Note that Rimae Bürg was visible and included at a right angle above the Lacus Mortis fault.

7.3 Graphite Pencil – Rupes Altai (by Sally Russell) 111

Fig. 7.2.6

Supplementary Sketch Information

Lacus Mortis Fault on black Artagain paper with white Conté pencil and crayon
Sketch date: July 12, 2009 using a 10-in. f/5.7 Dobsonian riding on an equatorial platform and a 6mm eyepiece for 241x at 06:00–08:00 UT
Seeing: Antoniadi II
Weather calm, 65°F (18°C)
Lunation: 19.5 days
Moon 79.3% illuminated

7.3 Graphite Pencil – Rupes Altai (by Sally Russell)

One of the most spectacular escarpments on the Moon is Rupes Altai, which lies in the heavily cratered southern uplands and towers some 1000m over the adjacent, lower-lying area. The formation is bordered by deep shadows at local sunset, making this a dramatic scene visible on a waning Moon of around 19–20 days old. Good planning will be required to view and sketch this formation under these lighting conditions, as it will be an unsociable early hour of the morning before the waning Moon rises high enough for you to be able to observe it telescopically. If you observe at lunar late sunset you may find it will be a race to sketch the shadows before they are swallowed up by the encroaching darkness!

Note: The tutorial sketch was made from a high power telescopic view using a refractor with a mirror diagonal giving a mirror image at the eyepiece.

Suggested Materials

- Drawing board (plus masking tape to fix the paper in place)
- White cartridge paper (80 lb weight – paper size 8″ × 12″ was used in this tutorial)
- 4B graphite pencil
- Pencil sharpener
- Plastic eraser

In this tutorial, I used just one grade of graphite pencil (4B, which is medium-soft in hardness), and purposely did not blend or soften the pencil marks so that the finished sketch retained a 'raw' quality where the movements of the pencil would still be evident.

Step 1

With the sharpened pencil, lightly sketch in the outlines of the undulating sweep of the scarp plus its shadow and that of the nearby major crater (Catharina) (**Fig. 7.3.1**). This is a very intricate and complex area of the Moon, so do spend some time studying the subject well before you commit your first mark to the paper. To help get the correct scale and placement for the various features, look for similarities between them in size and shape. In this example, I could see that the right hand curve of the main crater Catharina (as drawn) is approximately the same size as (and would fit into) the left hand curve of the shadow being cast by the scarp. It is positioned approximately one crater diameter away (**Fig. 7.3.2**).

Fig. 7.3.1

Fig. 7.3.2

7.3 Graphite Pencil – Rupes Altai (by Sally Russell)

Fig. 7.3.3

Fig. 7.3.4

Step 2

Now hold the pencil so that the tip is nearly lying on its side. This enables the pencil to gain the maximum contact area between the graphite and the surface of the paper. Start blocking in the main area of deep shadow (**Fig. 7.3.3**), continuing all the way up to the terminator, which runs diagonally from top left to bottom right of the sketch (**Fig. 7.3.4**). If you use a slightly random, cross-hatching method of shading (moving the pencil just a few millimeters for each pencil stroke and changing direction every few strokes) you will produce a fairly even finish to this heavily shadowed area. I find that adding in the major area of contrast early on in a sketch helps enormously when trying to marry the eyepiece view with the paper view as I switch back and forth between them. It also serves to 'freeze' the extent of the shadows at the start time of your observation.

Fig. 7.3.5

Fig. 7.3.6

Step 3

Start adding in the outlines of the smaller craters and features surrounding the scarp, filling in the smaller shadows with your pencil as you go along. Again, this will help further with identifying the area as you switch back and forth between eyepiece and paper (**Fig. 7.3.5**). Continue this process until you have included all the relevant features along the entire length of the scarp (**Fig. 7.3.6**).

Step 4

Now add the shadow both in and around the main crater. As before, draw the outlines of additional features on the other side of the scarp (**Fig. 7.3.7**).

Fig. 7.3.7

7.3 Graphite Pencil – Rupes Altai (by Sally Russell)

Fig. 7.3.8

Step 5

To finish your sketch, add in the final few feature details in between the major crater and the shadow of the scarp. Complete the main area of shading up to the terminator (which will connect the shadow of the scarp all the way to the shadow-filled crater Catharina). Lastly, use the eraser to tidy up any stray smudges of graphite.

Figure 7.3.8 is the finished sketch.

Supplementary Sketch Information

For this observation I used a 105 mm f/5.8 refractor on a driven mount, with a 3.5 mm eyepiece giving a magnification of around 175x. The equipment was set up the evening beforehand in readiness for a *very* early morning observing and sketching session the following day! The drawing was completed August 30, 2010 at 03:09–04:32 UT with the Moon at 20 days old (75% illuminated) under clear and calm conditions (seeing: Antoniadi II).

7.4 Pastels and Conté on Black Paper – Rupes Cauchy (by Deirdre Kelleghan)

Suggested Materials

- Soft pastels
- Conté crayon
- Grated pastels
- Spray glue
- Somerset 300 g paper
- Winsor and Newton satin varnish spray

The most detailed image I have ever seen of Rupes Cauchy was taken by the crew of Apollo 8, the first human space flight to leave Earth orbit. Up to November 24, 2010 my eyeball and this lunar escarpment had not met each other. The seeing was bad at first as I observed the area, and nothing at all was coming to focus. Taruntius showed its chunky rim clearly on the edge of the terminator. Over several hours as the Moon gained height toward 55°, details on the floor of Mare Tranquillitatis slowly began to emerge.

Step 1

I began by making a foundation for the sketch by using a mid-gray pastel on its side to cover the approximate area the drawing would take up (**Fig. 7.4.1**).

The floor of the mare had two or three very distinct gray tonal areas. Crater Cauchy was almost at the edge where a darker gray met a lighter gray.

Fig. 7.4.1

Fig. 7.4.2

7.4 Pastels and Conté on Black Paper – Rupes Cauchy (by Deirdre Kelleghan)

Fig. 7.4.3

Fig. 7.4.4

Step 2

In order to give myself a visual base map in which to place all the elements in my view. I used a small piece of pastel to draw in a black shape for Taruntius and a dark gray area to mark the differences in the tonal values of the mare floor. Using a white Conté crayon, I also added an outline of the higher lunar land that edged Mare Tranquillitatis (**Fig. 7.4.2**).

Step 3

An area that seemed very shallow sat under a bay, which also looked like it bookmarked one end of the Rupes. I introduced this into the sketch with a tiny press of pastel on my little finger (**Fig. 7.4.3**).

Step 4

I continued to develop the higher land with pastel and sketched in the very circular Cauchy using Conté for the outline and pastel for the shadow (**Fig. 7.4.4**).

Step 5

My observation of Rupes Cauchy was long and careful before I began sketching it. I used a very light touch of pale gray Conté for the rupes line. This was not an easy view on the waning Moon. The lunar surface seemed to stretch out in front of my eyes, with a slight darkening of the floor around Cauchy. Beyond that, a thin pale gray line shot out from the higher area into the mare, truncating at several tiny craters, G, H, and J. I also noticed two tiny darker areas above Cauchy and in line with the tiny craters that bookmarked the other end of the rupes. These marks were included using a tiny tip of black pastel. Without realizing it I had sketched in the domes Omega and Tau Cauchy. This is one of the most precious reasons for drawing exactly what you see in your view. You can then have the fun, retrospectively, of learning about these features and being more aware of them in future drawings.

Fig. 7.4.5

Fig. 7.4.6

Step 6

The higher land was very detailed, broken, ridged and textured. I decided to try an experiment with grated pieces of pastel (**Fig. 7.4.5**).

I grated some pastel into uneven chunks and placed these pieces on the higher land area section using a small palette knife and pushed them down using a brush. I used a little bit of spray glue to hold the pieces in place (**Fig. 7.4.6**). The grated pastel was applied when the drawing was on a flat surface but close reference was continuously made to the telescope view (**Fig. 7.4.7**).

Fig. 7.4.7

The finished drawing, **Fig. 7.4.8**, is close to the view I had on the waning Moon around Cauchy and its environs. Rima Cauchy was not visible due to the fall of the light. This photograph was taken at an angle to show the three-dimensional effect created by using grated pastel. The sketch was sealed while flat using several applications of Satin Varnish spray, which is strong enough to hold the particles of pastel in position.

Increasing magnification did nothing to improve the view as the seeing was not the best it could be nor was the lighting at its best for the area. A revisit to this feature at lunar sunrise will be a very interesting and welcome challenge in the future.

Supplementary Sketch Information

200mm Dobsonian Telescope, 8 mm Tele Vue Plossl eyepiece, Magnification 150x, Seeing – Antoniadi II
November 24, 2010, 22:00–23:21 UT
Bray, Co Wicklow, Ireland

7.5 White Felt-Tipped Paint Pen on Black Paper, Cross Hatching – Rupes Altai (by Richard Handy)

Fig. 7.4.8

7.5 White Felt-Tipped Paint Pen on Black Paper, Cross Hatching – Rupes Altai (by Richard Handy)

Rupes Altai, or the Altai Scarp, surrounding Mare Nectaris is one of the most visible cliff ranges on the Moon. Semi-circular, the feature appears to arc across the southeastern quadrant, starting at the crater Piccolomini and gradually fading between battered crater Catharina and the clearly younger Tacitus. Mare Nectaris is a multi-ringed basin, and the arc of Rupes Altai is considered to be a portion of one of these rings. These concentric rings are an indication of the tremendous kinetic energy that was imparted to the lunar crust by a large asteroid. I love the appearance of these rings when the waxing terminator is on the eastern shores of the mare.

Suggested Materials

- ZIG Painty twin felt-tipped paint pen (white and black opaque) by Kuretake Co., LTD
- DecoColor fine line paint marker (white opaque) by Uchida
- Strathmore Artagain Series 400 black paper (9" × 12")

I am using a felt-tipped paint pen with white paint at one end and black paint at the other in this tutorial. These are generally used for writing on a wide variety of glass, ceramics, wood, plastics, and metal. These pens come with the brand name "ZIG Painty Twin" and are manufactured in Japan by Kuretake Company, LTD. I like having one in white and the other black. If I make an error, I can use the black paint to cover the white or vice versa. You will see several errors that occurred while sketching this scene that required adjustments to the black, gray or white tones.

Fig. 7.5.1

Fig. 7.5.2

Step 1

Generally, I enjoy spending some time at low power perusing the terminator. A Tele Vue Panoptic 35 mm gives me 97x power with my 12″ f/10 SCT. It is so nice to see the entire Moon in one field. Immediately it was apparent that my sketch target would be in dramatic lighting during this apparition.

When I set the scale of my drawings, I try to use the largest crater in the field of view as my measuring rod. Piccolomini at the bottom right is my first outlined crater. Next, I start placing other smaller craters at various distances based on the size and position of Piccolomini. Once I have laid down the crater positions (this is very similar to establishing the scale of star clusters by use of a set of bright stars in a pattern in order to position all the other stars in the field), I have a reference frame to finish adding details to my sketch.

Using the white pen, I create the outline of the edge of the scarp (**Fig. 7.5.1**).

Step 2

In order to sketch the mid-tone grays over most of the basin rings, I use another white paint pen called the Fine Line DecoColor Opaque Paint Marker 200-S White, manufactured in Japan and distributed by Uchida Corporation, Torrance CA. This paint marker works great when sketching the grays because the intensity of the white paint has a lot to do with the speed and pressure on the pen.

I create the surface albedo features around the mare by cross-hatching. Here I am sketching the glacis (outer slope) of Piccolomini and some of the areas adjacent to the terminator. Along with the crater floors and shadows, I am also adding some of the smaller craters and other small features at this stage (**Fig. 7.5.2**).

7.5 White Felt-Tipped Paint Pen on Black Paper, Cross Hatching – Rupes Altai (by Richard Handy) 121

Fig. 7.5.3

Fig. 7.5.4

Step 3

I start by laying down the hatching and cross-hatching that will allow me to represent the gray of the basin steps (**Fig. 7.5.3**).

Step 4

I keep working on the hatching and decide to make the hatch lines radial to Mare Nectaris to simulate the terrain of the ejector's path (**Fig. 7.5.4**).

Fig. 7.5.5

Step 5

Here you can see how I have hatched the step terrain adjacent to the Altai Scarp (**Fig. 7.5.5**).

Step 6

I continue applying the hatching to the lower step at the base of the scarp, sketching in as many details as I can in the area, again by reference to other features already drawn (**Fig. 7.5.6**).

Step 7

You can see I am nearly finished. I have been carefully observing the shadow line of the scarp so that my hatch lines define the shadow edge at the base of the step (**Fig. 7.5.7**).

The finished sketch shows the outcome of my observation (**Fig. 7.5.8**).

Fig. 7.5.6

Fig. 7.5.7

Fig. 7.5.8

Chapter 8

Sketching the Phases

Due to the Moon's revolution around the Earth and Sun, the Moon cycles through changes in light and shadow as seen from the perspective of an earthbound observer. The change in the Moon's appearance from waxing to waning, New Moon to New Moon, provides the observer with a fascinating array of possibilities for representing these phases. Lunar sketchers can use their naked eye, binoculars or telescopes while documenting their observations.

8.1 Conté on Black Paper – Full Phase (by Erika Rix)

Shortly after drawing an outline of the Moon, I always feel a bit overwhelmed. It does not take long to remember just how difficult it can be to get the shapes, sizes, and placements correct for all the predominant features. Even the borders of maria become elusive when you try to set boundaries for them on paper. Yet, there always seems to be that magic point in a sketch where everything starts to come together…usually just after the sense of despair when it takes sheer willpower not to toss the sketch in the trash and start over again. So be patient and persistent. Not only will you have a wonderful opportunity to deeply study the entire moon phase, your sketch afterward will be a terrific recording of your session.

At 99.5% illumination of the Moon during my observation, a filter was needed for not only bringing out details on the lunar surface but also to cut down the bright glare that can cause eyestrain.

Suggested Materials

- 9″ × 12″ sheet of black sketching paper on a clipboard (Strathmore Artagain 400 Series paper was used for this tutorial)
- Compass for drawing your initial circle
- White vinyl eraser, sharpened with a craft/utility knife to resemble a flat-headed screwdriver
- Light-gray charcoal pencil (Rexel Derwent – Light was used for this tutorial)

- Stick of white pastel (Conté crayon was used for this tutorial)
- White pastel pencil (Conté was used for this tutorial)
- White colored pencil (Prang was used for this tutorial)
- Black oil/wax pencil
- Pencil sharpener
- Exacto knife and/or pencil sharpener for sharpening pencils/pastels

Pastels tend to be a little powdery, and in my opinion, even more so than compressed charcoal. During the course of your sketch, you might find powdery residue on your sketch. You can gently blow on your sketch to remove this residue or use a rubber bulb air dust blower. Make sure you are downwind and well clear of your optics before blowing the dust off your sketch. I'm pretty fond of my Giottos Rocket Air Blaster, both for my eyepieces and for my sketches (if for no other reason, it compliments my Stealth Bomber pencil sharpener).

Step 1

Create a 5- to 6-in. circle using the white colored pencil and compass. The larger the circle, the easier it will be for you to add more details to the sketch **(Fig. 8.1.1)**. A color pencil leaves a slightly waxy, faint marking that creates a sharp, well-defined boundary.

Step 2

Rub your finger across the flat surface of the pastel stick to ensure that it is smooth and gritless. Rough sticks of pastels have the potential to leave streaks or gouges in your paper. Evenly apply a coat of pastel inside the circle with the flat edge of your pastel stick **(Fig. 8.1.2)**.

Fig. 8.1.1

Fig. 8.1.2

8.1 Conté on Black Paper – Full Phase (by Erika Rix)

Fig. 8.1.3

Fig. 8.1.4

Step 3

Gently blend with a clean fingertip **(Fig. 8.1.3)**. Paper with little tooth, such as Artagain, can be difficult to blend with a chamois, fanned paint brushes, or blending stumps without removing too much of your pastel. In fact, I actually use a blending stump with Artagain paper if I *want* to remove a layer of pastel! I would suggest practicing with various blending tools on a separate sheet of paper first until you find what works best for you.

Erase any stray markings outside of the circle with the flattened edge of the vinyl eraser.

Step 4

Add anchors with the pastel pencil. The pastel pencil will leave a brighter, more visible marking than a colored pencil. These anchors are the predominant markings that you can use to guide correct placement of all the other features in your sketch. In **Fig. 8.1.4**, I used anchors such as Tycho and one of its rays near the top of the sketch, Aristarchus near the left, and Montes Apenninus just below center.

Fig. 8.1.5

Fig. 8.1.6

Step 5

Using the charcoal pencil with light to medium pressure, draw in the maria and shadowed regions (**Fig. 8.1.5**). It may be easier if you sketch the larger maria first, and then work your way down to the larger crater shadows. I used a light-gray charcoal pencil instead of a darker one for subtleness during this step. You can use a stick of compressed charcoal if desired but may find it difficult and a bit cumbersome for the finer details.

Step 6

Use the pastel pencil to add a layer of bright features (**Fig. 8.1.6**).

Step 7

The terminator is to the right of my sketch. Since shadows are more defined and darker along the terminator, a black charcoal pencil or a black oil/wax pencil is good to use for this step of your sketch. I find that the oil pencil (mine is woodless) works best for me as it leaves a distinct, smooth marking over the pastel, whereas the charcoal might bleed a little into the white pastel because of its powdery consistency.

Using your oil/wax pencil, sketch the darker shadows along the terminator as well as any areas on the entire sketch that would require deep-black, defined markings (**Fig. 8.1.7**).

8.1 Conté on Black Paper – Full Phase (by Erika Rix)

Fig. 8.1.7

Fig. 8.1.8

Step 8

Add a final layer of detail with your pastel pencil if needed. This is the moment you can breathe a sigh of relief for such an undertaking and soak in the views through the eyepiece, trying to catch any details that were previously missed **(Fig. 8.1.8)**.

Step 9

Clean up stray markings with the vinyl eraser and the sketch is complete **(Fig. 8.1.9)**.

Supplementary Sketch Information

July 8, 2009, 02:40–05:35 UT
PCW Memorial Observatory, OH, USA
Orion ED80, William Optics dielectric diagonal, LXD75, 21–7 mm Zhumell, 28–85x Magnification, 13% T moon filter. Temperature: 17.6–11.7°C (63.7–53.1°F). Humidity: 59–86%. Seeing: Antoniadi II. Transparency: 3/6. Light cirrus, calm.

Phase: 352.2–350.9°, Lunation: 15.3–15.42d, Illumination: 70.9%
Libration in Latitude: +01:32 to +01:24, Libration in Longitude: −00:00 to −00:37
Altitude: 11:02–27:10, Azimuth: 132:18–170:38

Fig. 8.1.9

8.2 Graphite Pencil – Waxing Crescent, First Quarter, Full and Waning Gibbous Phases (by Thomas McCague)

Suggested Materials

- Graphite pencils: HB, B, 2B, 4B, 6B
- Paper: ordinary cartridge or copy paper (8½″ × 11″ size)
- Erasers: including gum, plastic and shaped pencil erasers
- Clipboard
- Bright light
- Paper towels or facial tissues for wiping graphite from fingers and also blending pencil marks
- Blending stumps
- Circular protractor

All sketches here were made using a 4.25″ (108 mm) f/5 Dobsonian reflector along with 24 mm and 12 mm eyepieces for 22x and 45x magnification respectively.

8.2 Graphite Pencil – Waxing Crescent, First Quarter, Full and Waning Gibbous Phases (by Thomas McCague)

Fig. 8.2.1

Fig. 8.2.2

Although an entire lunation (cycle of lunar phases) takes place in a little less than a month, weather conditions can make sketching a sequence of different phases a long-term project. If you are at a location where you have many clear nights in sequence, this type of study can be completed in as little as 4 weeks. The following Moon phase sketches, however, took the first half of 2009 to complete.

Step 1

As with most types of lunar sketching, the Moon needs to appear large enough to allow details to be captured. When using graphite, you should also remember that the larger the sketch, the more time it would consume at the eyepiece. With some practice on smaller sized renderings, you should find that sketching the whole Moon within a circle of about 6 in. (150 mm) in diameter is completely manageable. For this lunar circle size, you can use a circle protractor template tool.

Since the outside diameter of this tool is 8 in., the same protractor can be used to form a 1-in. outer boundary representing the dark sky beyond the sketch. You have the options of adding the dark sky background at the start, during, or after you finish the lunar drawing. You can also do as I did with most of these sketches, adding some shading before starting and then the remainder of the sky shading upon completion.

Using the circle protractor, we outline the limb of the Moon (**Fig. 8.2.1**).

Step 2

The terminator of the illuminated crescent region of the Moon is estimated and sketched freehand using the light touch of an HB pencil.

At this point, we will add some shading to represent the dark sky, as it will aid in producing correct contrast for features visible in the illuminated crescent. Thus far, you have only looked through the eyepiece to get the terminator line, but now we are ready to begin drawing the lunar features in the illuminated crescent. The narrow crescent phase is relatively easy to sketch because only a limited number of features are visible. The full Moon, for example, is much more challenging and takes longer to complete.

Sketch an outline around the dominant craters, seas and other features visible in the sunlight on the Moon using the HB pencil (**Fig. 8.2.2**).

Fig. 8.2.3

Fig. 8.2.4

Step 3

With the HB pencil, followed by the B pencil, the darker features and shadows are added leaving the brightest regions untouched.

It is now time to turn our attention to the Earthshine – something that can often be seen during crescent phase if the transparency is good and light from the Earth's gibbous-phase (as seen from the Moon) cloud top is reflecting off the 'non-illuminated part' of the Moon. Within the Earthshine, discernable features can be viewed in the telescope. Begin sketching these and then shade the darkest features using a 4B pencil **(Fig. 8.2.3)**.

Step 4

After you are satisfied with darkening the Earthshine features, start sketching the brighter earth-illuminated features while attempting to match them to the eyepiece view. This may require going back to an HB graphite pencil.

Blend away the uneven pencil strokes with your fingertips, a blending stump, or pieces of paper towel. As with the example in **Fig. 8.2.4**, a blending stump loaded directly with graphite from the pencil works well. Adjusting the depth of gray can be accomplished with a few looks back and forth between the eyepiece and the sketch. When you can see no further need for adjustments, the work at the eyepiece is finished.

Step 5

Next, we need to shade in the outer perimeter that represents the dark background sky. To accomplish this, the circle protractor is used to generate an outer circle, which can be subsequently shaded with a 4B or 6B pencil. Crosshatch with the pencil throughout the background sky. Then, erasing any smudges and stray marks brings us to the end.

8.2 Graphite Pencil – Waxing Crescent, First Quarter, Full and Waning Gibbous Phases (by Thomas McCague)

Fig. 8.2.5

With the work now completed, here is the final sketch (**Fig. 8.2.5**).

Similar sequences to the one described above were used in all of the following graphite Moon phase sketches. The waxing and waning gibbous phases, as well as the full Moon sketch, were the most challenging because of all the visible features seen. Additional time was needed to layer the darker features with softer pencils and to erase smudges and brighten features. Eraser shaping with the use of a sanding block made it possible to clean up features such as bright crater rays (**Fig. 8.2.6**).

Fig. 8.2.6

Final Graphite Phase Sketches

These, along with the two already depicted (**Figs. 8.2.5** and **8.2.6**), are graphite sketches of the Moon phases completed between February and May of 2009.

Fig. 8.2.7

Fig. 8.2.8

Fig. 8.2.9 Thomas McCague with the telescopes and materials used in his tutorials

Seven days old, nearly a first quarter Moon, sketched on March 3, 2009 (**Fig. 8.2.7**).
Eighteen day old waning gibbous Moon, sketched on April 13, 2009 (**Fig. 8.2.8**).

8.3 Ink Wash – Waxing Gibbous Phase (by Sally Russell)

During late spring in the northern hemisphere, the Moon rarely gets above an altitude of 35°. By the time the evening gets dark enough for a decent amount of contrast to be visible on the lunar disk, the Moon is slipping rapidly from view. As a result, available sketching time is often limited in this situation, especially if you do not have a good southwestern horizon. Use of a small 'grab and go' telescope on a simple manual mount with a low-power view will help you make the most of such a short-lived scene.

This tutorial illustrates a phase sketch of the waxing gibbous Moon that was completed in two stages – a simple, fairly quick graphite pencil sketch created scope-side, followed by a relaxed ink wash completed indoors later on. The latter was done using mainly the 'wet on dry' watercolor technique where layers of ink are applied and allowed to dry completely before more layers are added. Though it is relatively time consuming to paint in this way, it gives a great degree of control over the finished image.

8.3 Ink Wash – Waxing Gibbous Phase (by Sally Russell)

Certain features really stood out on the Moon's disk during the observation – the bright splash of Tycho and its crater rays; brilliant craters Proclus, Menelaus, Dionysius and Censorinus as glowing points of light; the Montes Jura arcing out into blackness; almost parallel above it, the rim of J. Herschel; and Plato, Philolaus and the lunar mare were darkly present.

Suggested Materials

- Drawing board
- White 140 lb weight 'Bockingford' rough watercolor paper – a sheet 10″ × 14″ was used in this tutorial
- Masking tape
- 2B graphite pencil
- Compass (or suitable circular template)
- Plastic eraser
- Masking fluid
- Black India ink
- Round paintbrushes – sizes 1, 4, and 8
- An artist's palette with deep wells

Step 1

First of all you will need to tape down your paper onto a suitable, water-resistant board using masking tape. The paper needs to be sturdy enough to take fairly wet washes of ink. Watercolor paper of 140 lb weight will work well for this. I like using a medium or rough watercolor paper, as the texture really adds to the finished effect (and will give your sketch a slightly 'Galileo' look!). Smooth paper can be used if preferred. Use a full-length piece of tape for each paper edge and overlap the tape at the corners. Though taping the paper down is not strictly necessary for the drawing stage of your sketch, it is absolutely necessary for the ink wash stage; the paper becomes wet and might start to buckle unless held flat onto the board.

Step 2

Lightly draw the whole circular outline of the Moon using a compass fitted with a 2B pencil – in this example the circle is 13 cm in diameter. Alternatively, a suitably sized small plate or saucer will work just as well. The pencil line can be erased after the ink wash has been applied (and has dried), but it is best to keep the line light to avoid having to rub the paper too hard thus damaging the paper surface (and the ink wash) when you remove it later. Lay your pencil nearly on its side (I find this gives greater control when trying to draw curves by eye) and lightly draw the approximate line of the terminator using soft, light pencil strokes to show the gibbous phase outline (**Fig. 8.3.1**).

Fig. 8.3.1

Fig. 8.3.2

Fig. 8.3.3

Step 3

Draw the outlines of the main lunar features starting with the larger mare regions, as these will act as guides for the placement of the smaller features **(Fig. 8.3.2)**. Take your time to get these placed as accurately as you can, and do not be afraid to erase and re-draw incorrect pencil lines if needed. Try to keep your pencil lines very light so that the surface of the paper will not be damaged if erasing is necessary (which would also affect the way that the ink-wash bonds).

Placement of features may be easier if you liken the Moon to a clock face, visualizing that a feature is at, say, the 8-o'clock position and extends about 20% of the way into the disk. This is how I transfer onto my drawn disk what I am seeing on the lunar disk. Gradually add the smaller features (such as individual craters, crater rays, and deep crater shadows on the terminator) until you are satisfied you have captured all of the main visible details.

Step 4

Holding your pencil on its side (as you did for drawing in the line of the terminator), lightly shade the mare regions and other dark areas to represent the relative tones using light, parallel strokes. You now have a complete tonal sketch as a template ready for the ink wash stage **(Fig. 8.3.3)**.

Painting with diluted ink is very similar to painting with watercolor and many of the same techniques are used. Pure white highlights that you wish to keep pristine can be protected with masking fluid (a quick-drying latex solution) before painting starts – ink washes can then be applied freely, the masking being removed once the ink has dried. It is important to remove the masking within 24 h of it having been applied, though, and preferably as soon as the paper is dry. If it is left on the paper for too long, it can bond permanently and ruin your work! As an alternative, you can just leave the small highlight areas as blank paper and paint around them when applying your ink washes; however, this is quite difficult to do accurately, and I would not recommend you try this on your first attempt.

When choosing your brushes for the wash stages, it is advisable to use a medium-sized brush (such as the No. 8 used here), so that washes can be applied fairly quickly and evenly, with less likelihood

8.3 Ink Wash – Waxing Gibbous Phase (by Sally Russell)

Fig. 8.3.4

Fig. 8.3.5

of giving a streaky finish. Very small brushes, though good for adding fine detail, are not able to hold much liquid and hence can only be used to cover relatively small areas.

Step 5

Begin by making up ~10 mL (approx. two teaspoons) of a *very* dilute ink solution in one palette well: approx. one part ink to about 15–20 parts of water (let's call this ink wash "A"). Test its tone on a scrap piece of the same type of paper as you used for your sketch. Further dilute if necessary to give a very pale gray tone, but remember that the washed area will become lighter in color as it dries. Water-soluble ink will behave differently on different paper types, so it is important that you use the same type of paper for the testing as that on which you made your eyepiece sketch.

Step 6

Use masking fluid loaded sparingly onto the No. 1 (smallest) round brush and apply a spot of fluid onto each of the craters that you wish to retain as bright highlights **(Fig. 8.3.4)**. Again, with a very sparingly loaded brush, very lightly and carefully draw the visible crater rays (around Tycho and Proclus) with the masking fluid. Wash your brush immediately afterwards with soapy water to remove the very sticky residues – masking fluid dries extremely quickly and can easily ruin brushes.

I like to apply the first wash of diluted ink onto very slightly damp paper, as this aids the ink wash to flow evenly over the entire area. This method significantly reduces the likelihood of any hard lines appearing between ink applications, and the diluted ink will flow up to, and then stop at, the natural boundary between the damp and dry paper.

Step 7

Once the masking fluid has dried, use clean water and a No. 8 round brush to carefully wet the entire gibbous-phase area of the disk (but not the crescent shaped, shadowed area) **(Fig. 8.3.5)**. Let this dry until there is no visible sheen of water on the paper and any slight buckling of the paper

Fig. 8.3.6

Fig. 8.3.7

has straightened out. This will probably take at least 10–15 min depending on your working conditions, temperature, etc. The paper should still feel very slightly damp to the touch.

Now dip your brush into ink wash "A" (you might need to give it a quick stir beforehand) and carefully brush an even, thin wash of color over the damp paper, re-loading your brush with ink wash as necessary **(Fig. 8.3.6)**. Leave this to dry completely. Try not to touch the painted area while it is drying, as any apparent small blemishes within the ink wash will almost disappear once it is dry, whereas if you fiddle with them while damp, they might spread and 'bloom' into something quite ugly!

Fig. 8.3.8

Step 8

Now it is time to deepen the tones by adding extra layers of ink wash to pick out the disk detail. Before you start, mix up ~5 mL (approx. one teaspoon) of additional, slightly deeper-toned ink wash in another palette well: approx. 1 part ink to about 10 parts of water (ink wash "B"). Remember to check the tone by first testing it on the scrap paper as before.

Still using ink wash solution "A", load your brush and paint the individual mare regions and dark craters – your underlying sketch will act as a guide for both position and tone **(Fig. 8.3.7)**. For the mare regions that include the terminator, load your brush lightly with the deeper-toned ink wash "B" and *just* touch the brush onto the paper along the terminator edge while the newly painted area is still visibly wet. This will allow the ink to flow into, and then gradually spread across, the wet area, giving a gradient of tone that represents the way the disk darkens near the terminator **(Fig. 8.3.8)**. Repeat this 'wet in wet' watercolor procedure as required along the terminator, then leave to dry completely **(Fig. 8.3.9)**.

Fig. 8.3.9

Fig. 8.3.10

Step 9

Once the piece is completely dry, remove the previously applied masking from the crater rays by rubbing the surface gently with your fingertip. The dry masking film should roll up into easily removed small rubber balls. Now, further dilute ink solution "A" by adding an equal amount of water to the palette well, and then paint this wash between the crater rays to narrow them slightly and give them extra definition **(Fig. 8.3.10)**. Allow the ink wash to dry. Repeat if necessary until the required level of tone is reached, again, allowing the ink wash to dry after each application.

Step 10

Using a smaller brush (e.g., No. 4 round) and ink wash "B", paint in any remaining individual dark features on the disk over your previously drawn pencil marks and, again, allow to dry completely.

In order to show the Montes Jura and the rim of J. Herschel, as well as to emphasize the bright gibbous phase, we must now darken the unlit portion of the disk with a much deeper toned (almost black) ink wash, leaving behind narrow white highlights of untouched paper to represent them. Make absolutely sure that the previously painted ink washes are completely dry before attempting this last stage, because if the paper is still damp within the previously painted region, this new, deeper colored ink wash will bleed into it and make a mess, ruining all your careful work so far.

Step 11

Mix up ~5 mL (approx. one teaspoon) of a very deeply toned ink wash in another palette well: approx. 1 part ink to 1 part water (ink wash "C") and test its tone on the scrap paper as before. Though

Fig. 8.3.11

Fig. 8.3.12

this ink wash needs to appear almost black, do not be tempted to use undiluted ink as this would dry to give a shiny finish, whereas the slightly diluted ink will give a matte finish when dry. Using clean water and the No. 8 round brush, lightly dampen the unlit crescent portion of the disk, leaving dry paper where the highlights occur on the mountains and crater rims. When doing this, it helps to look along your board at an angle so that you can see the light reflecting off the wet paper, hence showing where you are painting and where the dry paper highlights are.

Allow this to dry until it is slightly damp to the touch. Then load your brush with ink wash "C" and begin to carefully paint in the entire shadowed crescent, turning your board as necessary to produce the best painting angle as you progress (**Figs. 8.3.11** and **8.3.12**). Try to work fairly quickly, keeping the painted area fluid to avoid hard edges from forming while you apply further brush loads of ink. Again, let this wash dry completely and try not to be tempted to touch the wash while it is drying, as this will damage the uniform finish.

The ink wash sketch is almost done!

Step 12

Now for the finishing touches. Remove the masking film from the craters, as before, by gently rubbing with your fingertip. Next, very lightly erase the pencil template line from around the edge of the disk with a plastic eraser. Gently rub out any strongly visible pencil lines from within the area of the disk. Provided you are gentle and do not scrub too hard, it is possible to easily remove the graphite without disturbing the ink or spoiling the paper surface in any way.

Figure 8.3.13 is the finished ink wash sketch.

Supplementary Sketch Information

The drawing for this tutorial sketch was completed on May 23, 2010 at 21:05–22:00 UT with the Moon at 9.8 days old (81% illuminated) under clear and calm conditions (seeing: Antoniadi II). I used a 70 mm f/6.8 refractor on an un-driven mount, with a 9 mm eyepiece giving a magnification

8.4 Pastels on Colored Paper – Waxing Crescent Phase (by Sally Russell)　139

Fig. 8.3.13

of around 53x. The ink wash painting stage was carried out a few days later, taking a number of hours from start to finish.

8.4 Pastels on Colored Paper – Waxing Crescent Phase (by Sally Russell)

Sometimes we are presented with a very limited window of sketching opportunity such as a glimpse of the Moon seen through a fleeting gap in the clouds or, as in this example, where the setting crescent Moon is rapidly sinking out of view from the local surroundings. It is best to adopt a simple approach under such circumstances, using a quick telescopic set-up and media that permit catching the essence of the view rather than ultra-fine detail. Use of colored paper can add extra interest to the finished sketch. The deep purple paper used in this tutorial echoed the rich color of the early evening sky.

Note: This tutorial sketch was made from a low-power telescopic view using a refractor with a mirror diagonal giving a mirror image at the eyepiece.

Fig. 8.4.1

Fig. 8.4.2

Suggested Materials

- Drawing board (plus masking tape to fix the paper in place)
- 12½″ × 16½″ sheet of dark purple Daler-Rowney 'Canford' paper (90 lb weight)
- White, plus light, medium and dark gray chalk pastels
- Craft knife for sharpening pastels
- Kneadable eraser
- Circle template

In this tutorial as opposed to sketching with white pastel on black paper, there are parts of the lunar surface that appear barely darker than the sky background. Using a full range of gray toned pastels, including a very dark gray (**Fig. 8.4.1**), will enable you to capture this effect.

Fig. 8.4.3

Step 1

Firstly, either clip your paper onto the drawing board or tape it down with masking tape applied lightly at the paper corners. Lightly draw the arc of the crescent Moon using a slightly sharpened white pastel and a suitable circular template. A medium-sized tea plate 7½ in. in diameter was used in **Fig. 8.4.2**. Depending on whether you are right- or left-handed you may find it easier to turn the board around (as I did here) to enable you to easily draw the crescent arc – the board can then be turned back, before starting the sketch proper, so that the crescent matches up with the eyepiece view.

Step 2

Now lay a small piece (about 1-in. long) of white pastel on its side and fill in the sunlit crescent area with light strokes (**Fig. 8.4.3**). Lightly blend with your fingertip for a smooth finish (**Fig. 8.4.4**).

8.4 Pastels on Colored Paper – Waxing Crescent Phase (by Sally Russell)

Fig. 8.4.4

Fig. 8.4.5

Step 3

Select the pale gray pastel and add in the slightly darker oval mare regions over the blended crescent area, again blending these areas using a fingertip to soften the overall effect **(Fig. 8.4.5)**.

Step 4

Using the slightly sharpened white pastel, add the narrow line of the curved highlight defining the mare ramparts near the terminator. Then add a slightly broader line of pastel to accentuate the bright limb **(Fig. 8.4.6)**.

Fig. 8.4.6

142 8 Sketching the Phases

Fig. 8.4.7

Fig. 8.4.8

Step 5

Using the medium gray pastel, add any smaller details visible on the sunlit crescent to further define the textures in this region. Then, with the dark gray pastel, add more definition to the terminator region to capture the effect of the partially lit craters (**Fig. 8.4.7**).

Now it is time to capture the Earthlight effect (Earthshine) on the shadowed portion of the lunar disk. The earthlit region is very subtle when seen through the eyepiece, with minimal disk detail being visible in a low-power view. The most important effect to portray is the contrast between the crisp bulk of the dark disk and the surrounding sky background.

Step 6

Re-apply the circular template over the sketch, but this time, lightly draw in the rest of the lunar limb using the slightly sharpened dark gray pastel (**Fig. 8.4.8**).

Step 7

Rub your finger directly onto the broad side of the medium gray pastel to pick up a small amount of powder onto your fingertip – this will enable you to apply the pastel very softly and uniformly. Then lightly fill in the whole earthlit region (re-loading pastel onto your fingertip as many times as you need) and blend this evenly using your fingertip, making sure to blend in the drawn line of the limb (**Fig. 8.4.9**). Carefully blow excess pastel off the sketch every so often to help minimize smudging and to keep the sketch clean.

8.4 Pastels on Colored Paper – Waxing Crescent Phase (by Sally Russell) 143

Step 8

In a similar fashion, apply a second light banded layer (about 2–3 cm wide) of dark gray pastel to just the limb region of the earthlit area. Keep the outer limb edge of this band slightly crisper and soften the inner edge towards center disk by further blending.

Step 9

Tidy your sketch by erasing any stray pastel marks using the kneadable eraser and sweeping the debris from the paper either by gentle blowing or with light strokes from a wide, soft paintbrush.

Figure 8.4.10 is the completed sketch.

Fig. 8.4.9

Fig. 8.4.10

Supplementary Sketch Information

The tutorial sketch was completed on February 28, 2009 at 19:27–20:00 UT with the Moon at 3.7 days old (15% illuminated) under clear and calm conditions (seeing: Antoniadi II). I used a 70 mm f/6.8 refractor on an un-driven mount, with a 9 mm eyepiece giving a magnification of around 50x.

8.5 Pastel and Conté on Black Paper – Waxing Crescent and Waxing Gibbous Phases (by Deirdre Kelleghan)

It was December 31, 2008, the last day of the year when Venus, the sparkling planet, and our own crescent Moon were to be visually within 2.5° of each other. Two bodies, so different, shining by the light of our Sun, were set to give us a final hurrah to the year. Achill Sound, Co Mayo, Ireland, close to the Atlantic rush of wind and wave, was my viewing place for the show.

15 × 70 mm binoculars, mounted on a multi-tasking photographic tripod, was my instrument of choice for viewing that evening. The tripod was fitted with a pan and tilt quick-release head, which was perfect for moving the Moon into my field of view. I forgot to pack my blending sticks so used a piece of driftwood that I found earlier that day while walking the beach. It would work just as well and be "of the land". A clipboard, A4 black card, Conté, pastels, and driftwood stick were commissioned into action for my first phase sketch **(Fig. 8.5.1)**.

Fig. 8.5.1

Suggested Materials

- Soft, mid-gray Mungyo pastel
- White Conté crayon
- Gray/blue Schmincke soft pastel
- Soft, black Mungyo pastel

Before starting my next sketch, I added a kitchen roll to my tripod set-up to minimize vibrations from the strong wind **(Fig. 8.5.2)**.

In order to achieve an early evening sketch (a factor to be taken into account), you must first observe the sky. What color is it? Blue? Blue–gray? Blue–white? Black, gray, gray–black? Decide and then use your pastels to blend a tone as close to the sky color as you can manage.

Fig. 8.5.2

8.5 Pastel and Conté on Black Paper – Waxing Crescent...

Fig. 8.5.3

Fig. 8.5.4

Step 1

First, I laid down a layer of black pastel on the black card using a pastel stick on its side. Black paper, or card, is not really as black as it could be; so black pastel gives that extra shading kick to your sky.

In **Fig. 8.5.3**, I blended a layer of blue over the black until the merging of the two represented the sky as I saw it, although, perhaps, a few tones darker to compensate ahead for the darkening sky over time.

Observe the shape of the crescent Moon against the whole disk, which is visible due to Earthshine. This wonderful phenomenon is produced by sunlight shining on (and reflecting from) our oceans, land, and clouds back to the dark part of the Moon's disk. This borrowed light, in the right conditions, can illuminate details of our Moon's features that are usually hidden in the lunar night.

Fig. 8.5.5

Observe the horns of the Moon – where do they start and end in relation to the complete circle of the Moon? I noticed that the southern horn was just left of the 6-o'clock position and that the northern horn was just right of the 12-o'clock position. I also made a mental note of how slim the horns were.

I observed the visible mare, craters, terminator and the limb. Any lunar features that stood out along the terminator were noted in my mind as were any albedo features.

Step 2

A tea mug (**Fig. 8.5.4**) became my circle template as I began my sketch – which turned out to be a series because of the unusual luck of having five relatively clear evenings in a row. I used a slimmed down Conté stick to inscribe the visible lunar limb onto my page and a pencil to finish the circle (**Fig. 8.5.5**). It is easier to cover up a pencil line with black pastel than to cover up a Conté line in white. So you must think ahead about how you will finish what you have started.

Fig. 8.5.6

Fig. 8.5.7

Step 3

I began to work more detail into the sketch using pastel along the terminator **(Fig. 8.5.6)**.

Step 4

The highlights of the sun-clipped craters and mountains along the terminator were emphasized using a white Conté crayon. A little light blending helped to give shape and tone to the sketch. The unlit side of the Moon was then filled in with black pastel **(Fig. 8.5.7)**.

Finished Sketch

January 3, 2009 **(Fig. 8.5.8)**.

This step-by-step sequence was repeated for several clear evenings resulting in a series of waxing Moons and one waning Moon. Using pastel and Conté for Moon sketches that are 65 mm in diameter can be a challenge.

January 6, 2009 **(Fig. 8.5.9)**.
January 9, 2009 **(Fig. 8.5.10)**.

There is so much detail on the Moon that using small circles will focus your attention on the most important aspects. I used a little blue for maria as it brings empathy with the early evening sky in which this sequence was assembled. Maria can often look a little blue in daytime and twilight hours.

8.5 Pastel and Conté on Black Paper – Waxing Crescent... 147

Fig. 8.5.8

Fig. 8.5.9

Fig. 8.5.10

Supplementary Sketch Information

All sketches: 15×70 mm SkyMaster Binoculars.
December 31, 2008, Venus Moon Conjunction, 16:52–17:54 UT, 0°C, breezy, hazy. Lunation: 4.19 days.
January 3, 2009, 17:29–18:10 UT, 0°C, hazy, Lunation: 7.20 days.
January 6, 2009, 17:15–18:00 UT, −2°C, strong wind, Lunation: 10.23 days.
January 9, 2009, 00:00–00:45 UT, −5°C, occasional fast cloud, Lunation: 12.52 days.
Achill Sound, Achill Island, Co Mayo, Ireland.

Chapter 9

Sketching Domes

There are few lunar features that are so subtle, intriguing, and challenging to convey than lunar domes. They come in various sizes, but most are less than 10 km in diameter. Domes are generally very gently sloped; between 1° and 5° is common. As a result, they are best seen when close to the terminator, where the dramatic light makes them easier to locate. Domes can often be found in large groups such as the Marius dome field, Mons Rümker, or the Aristarchus Plateau. Due to the rapid changes in light and shadow near the terminator, you will need to work quickly to capture them before the sun is too high when the Moon is waxing, or they are lost in shadow when it is waning. Many domes have central calderas or rilles, a testament to the igneous processes that created them.

Lunar domes are the Moon's version of a shield volcano on earth. Lunar gravity being much weaker than that on earth, coupled with the lack of an atmosphere, allowed magma to be ejected several kilometers from the vent. Subsequent eruptions built new layers until the dome formed its characteristic lens shape. Domes are made of basalts with varying mineral content depending on the temperature of the magma. There are exceptions, such as the Gruithuisen domes, which appear to have a silicate component allowing them to build a steep slope. However, most domes have such a gentle slope that we would hardly notice were we walking on their flanks. In a world dominated by craters, domes represent the endogenic processes of lunar volcanism.

9.1 Graphite Pencil – Mons Gruithuisen Gamma and Delta (by Sally Russell)

Lunar domes are generally quite small targets, so high magnifications plus illumination at a reasonably low sun angle will be advantageous if you wish to observe and sketch them in any detail. Since the seeing was only moderate (Antoniadi III) when the sketch in this tutorial was completed, very fine structures in the domes and their immediate surroundings were not visible.

The target area conveniently encompasses a small crater (Gruithuisen B) which helps to illustrate the opposite topographies – shadow being cast into the crater dip contrasts well with the shadows being cast by the raised domes (Mons Gruithuisen Gamma and Delta). This kind of sketch is all about the boundaries between the different features, and capturing the relative tonal qualities to show them off well.

Note: The tutorial sketch is a mirror image view as the refractor used for the observation was fitted with a mirror diagonal.

Suggested Materials

- Drawing board (plus masking tape to fix the paper in place)
- White cartridge paper (80 lb weight – I used a paper size of 8″×12″ in this tutorial)
- 2B and 4B graphite pencils
- Pencil sharpener
- Kneadable eraser

Step 1

Tape your paper onto the drawing board with masking tape applied lightly at the paper corners. Using a sharp 2B pencil, begin your sketch by lightly drawing the outlines of the domes, the crater (including the boundary line of its internal shadow), and the other linear features **(Fig. 9.1.1)**. Try to draw the relative layout and scale of the features as accurately as you can, as this will create a strong basis for your sketch. To help with this, try visualizing the distances between various features as being a proportion (or multiple) of the diameter of a particular dome, and consider the angles at which the features are placed relative to one another.

Step 2

With the 4B pencil, start adding the major areas of shadow, following the curves of the domes and the crater dip with your pencil lines as you draw **(Fig. 9.1.2)**.

Fig. 9.1.1

Fig. 9.1.2

9.1 Graphite Pencil – Mons Gruithuisen Gamma and Delta (by Sally Russell)

Fig. 9.1.3

Fig. 9.1.4

Step 3

Now it is time to begin connecting the features by adding the lunar mare background. Holding the 4B pencil so that the pencil tip is almost on its side (this allows a broader line to be drawn compared to when the pencil is held upright), begin lightly shading the background in between the domes **(Fig. 9.1.3)**. Small strokes applied in a random crosshatch fashion will build up the tone quite evenly. Adding another layer by shading over the same area a second time will give a deeper shadow tone. Even though the individual strokes will still be visible, the overall effect will be fairly uniform.

Though it was not done in this example, if you prefer, you can blend the shaded area using your fingertip or a blending stump to obtain an even, smooth finish. Shade up to, and then incorporate, the original lightly drawn feature outlines into this shaded background area so that they become light/dark boundaries rather than remaining as incongruous hard lines.

Step 4

Continue building up the mare background, leaving untouched white paper for the highlighted areas (such as along the dorsa, and on the sunward facing side of the domes), while building up darker tones by over-drawing the mare areas until the right depth of tone is achieved. Apply further shading in the small areas directly in front of the sunlit side of the domes to enhance the effect of the dome rising up from the flat plain **(Figs. 9.1.4** and **9.1.5)**.

Fig. 9.1.5

Fig. 9.1.6

Tidy up the boundaries between the domes and the mare region and re-define the highlights along the dorsa using a pointed kneadable eraser with a gentle dabbing motion. It will lift a tiny amount of graphite from the paper where the eraser tip touches without disturbing the surrounding drawing.

Step 5

Extend the mare background to encompass all of the initial outlines to complete the structural composition of the sketch. With the complete mare background having been drawn in, the previously drawn shadows might now appear too pale. Using the 4B pencil, strengthen shadow tones as required by applying further layers of graphite (again, with the pencil held so that the tip is nearly on its side) until you are happy with the overall effect. All that remains to be done is to add in final touches of shadow to increase the boundary contrasts of the features (**Fig. 9.1.6**).

Figure 9.1.7 is the completed sketch.

Supplementary Sketch Information

This tutorial sketch was completed on February 26, 2010 at 20:40–22:00 UT. Conditions were clear and calm (seeing: Antoniadi III) with the Moon at 12.8 days old (95% illuminated). I used a 105 mm f/5.8 refractor on a driven mount, with a 3.5 mm eyepiece plus 2x Barlow lens giving a magnification of around 350x.

9.2 Conté on Black Paper – Milichius and Hortensius Dome Fields (by Richard Handy) 153

Fig. 9.1.7

9.2 Conté on Black Paper – Milichius and Hortensius Dome Fields (by Richard Handy)

Suggested Materials

- White and black Conté crayons
- White Conté pencil
- Strathmore Artagain black paper 400 series
- Pink Pearl eraser
- Art gum eraser
- Plastic eraser
- Synthetic and natural sponges
- Blending stumps
- Pencil sharpener

Fig. 9.2.1

Fig. 9.2.2

Step 1

When beginning any sketch, I always focus on the selected target and decide how large an area I would like to include in the local environs. My target this evening is the dome field in the area of Milichius and Hortensius. This zone of domes to the west of Copernicus contains both close groups and isolated single domes. Using the white Conté pencil, I establish the scale of the sketch first by outlining the position of Hortensius, Milichius, and Copernicus C. Then I add some of the brightest hills and other prominent features in relation to these three craters (**Fig. 9.2.1**).

Step 2

Note that I have outlined the shadows of some of the hills and craters. I have also sketched some of the smaller hills using the white Conté pencil (**Fig. 9.2.2**).

Step 3

At this stage, Conté pencil is applied to highlight a large dome to the north (upper right in the sketch). You can see that I have added more details in the upper left of the sketch (**Fig. 9.2.3**).

9.2 Conté on Black Paper – Milichius and Hortensius Dome Fields (by Richard Handy)

Fig. 9.2.3

Fig. 9.2.4

Step 4

A blending stump helps me tone down the highlight on the light-facing side of the dome to match the tone I see through the telescope (**Fig. 9.2.4**).

Step 5

By using a flat side of a white Conté crayon and stroking with a light back-and-forth motion, I can apply enough Conté on the paper surface to allow me blend the crayon marks into a gray tone (**Fig. 9.2.5**).

Fig. 9.2.5

Fig. 9.2.6

Fig. 9.2.7

Step 6

After the addition of more Conté crayon to the right side of the sketch, the blending stump is used to develop a group of domes to the immediate northeast of Hortensius (**Fig. 9.2.6**).

Step 7

I continue to apply the Conté crayon on its side, providing enough Conté to blend in the gray tones in the vicinity of the crater and domes (**Fig. 9.2.7**).

Step 8

Fig. 9.2.8

This is what happens when I blend the crayon that was laid down in Steps 5 and 7 with a piece of synthetic foam. At this point I add any final highlights and then deepen the shadows with black Conté crayon (**Fig. 9.2.8**).

Figure 9.2.9 is the finished sketch.

9.2 Conté on Black Paper – Milichius and Hortensius Dome Fields (by Richard Handy)

Fig. 9.2.9

Chapter 10

Sketching Lunar Eclipses

There are several types of eclipses that can occur due to the Moon's position with respect to the Sun and Earth. The Sun and Moon just happen to have a similar angular diameter when viewed from the Earth. A total, annular, or partial solar eclipse happens when the Moon is between the Earth and the Sun. A total or partial lunar eclipse indicates that the Earth is between the Moon and the Sun. These events can produce spectacular colors and dramatic scenes, but they can be difficult to capture due to the pure awe of such a sight.

10.1 Oil Pastels on White Paper (by Thomas McCague)

Suggested Materials

- HB graphite pencil (for initial outlining of features)
- White, gray, yellow, beige, orange and brown oil pastel crayons
- Paper: ordinary cartridge or copy paper, 8½″ × 11″
- Black paper, 8½″ × 11″ with a 6″ circle cut out
- Circular protractor
- Art gum eraser
- Small clean brush
- Pieces of paper towel for blending and cleaning
- X-Acto knife
- Coarse sanding block for shaping crayons
- Clipboard
- Brightness adjustable white light lamp

When it comes to colorful lunar views, they nearly always involve the Moon's interplay with our own atmosphere. We have all seen the red and gold moonrises and moonsets that have been recorded in sketches and photographs. Few of these compare to the colorful beauty of our Moon during totality of a bright lunar eclipse. The long wavelengths of sunlight passing from our atmosphere to the lunar

surface create a three-dimensional effect that can best be appreciated in binoculars or telescopes under low power. The view can be magical as the Moon appears to be illuminated from within.

It was just such an occasion on the night of February 20–21, 2008, when I recorded the Moon in two sketches during totality. In the first sketch, I worked from right to left applying dark colors and then finishing with light colors. In the second sketch, shown in this tutorial, I worked left to right applying light colors first. This second method worked best when it came to final results.

The steps below, with the exception of the final rendering, are a re-creation of how I made this oil pastel drawing at the telescope. At the time of the eclipse in early 2008, I did not generate a tutorial sequence. In recalling my steps this is how the sketch was made.

Step 1

The materials, gathered and shown here, to complete this oil pastel sketch include a circular protractor, graphite pencil, paper towel pieces, a coarse sanding block and eight oil pastel crayons (**Fig. 10.1.1**).

Step 2

Using the circular protractor and HB pencil, a light 6-in. diameter circle is scribed on the paper. Selected features of the full Moon (visible at the eyepiece prior to first umbral contact) are lightly drawn on the paper. I used the shapes of the darker maria, crater Tycho, and its light rays to anchor this sketch (**Fig. 10.1.2**).

Step 3

Working from the left, the lightest colors are applied. It is important not to draw or smudge the darker shades where you need lighter ones, because even careful scraping with the X-Acto knife will not completely remove darker colors (**Fig. 10.1.3**).

Fig. 10.1.1

Fig. 10.1.2

Fig. 10.1.3

10.1 Oil Pastels on White Paper (by Thomas McCague)

Fig. 10.1.4

Fig. 10.1.5

Step 4

Blending with the paper towel pieces, and also directly with the oil pastels while reapplying the colors, continues until the lightest colors are reasonably rendered. In this type of sketch, you do not need to capture all the fine details because you are concentrating on the color and larger features. After blending, wipe the tips of the oil pastels clean with a piece of paper towel in order to remove any contaminating colors that may have been picked up while blending directly (**Fig. 10.1.4**).

Fig. 10.1.6

Step 5

Turn your attention to the darker colors next. These are added in the same way as the lighter colors. Generally, you build up the colors and then blend them together directly or with a piece of paper towel as needed (**Fig. 10.1.5**).

Additional careful blending at the margins of the differing colors eliminates the bare areas of paper. Flakes of pigment may be present across the sketch. If they need to be removed rather than blended, they can be lifted with the X-Acto knife.

Step 6

Upon completion of the original sketch, I found a substantial amount of smearing around the margins from blending at the edges as well as dark flakes that marked up the paper beyond the Moon's limb. To improve the look of the sketch, I made a black paper mask with a 6-in. cut out to use as a mat (**Fig. 10.1.6**). This worked well, but as an alternative, it would be possible to do the entire sketch on black paper and use a black pastel crayon to cover stray marks beyond the lunar limb.

Fig. 10.1.7

Step 7

The final sketch is in **Fig. 10.1.7**. Minor clean up of this sketch was completed indoors the morning after the eclipse using the X-Acto knife to remove small flakes and crumbs as described earlier.

The Danjon Scale

I rated this eclipse at the time of mid-totality at 3.5 on the Danjon Scale. This scale ranges from 0 to 4 for darkest (0) to brightest (4) during totality of the eclipse. Among those I have observed, this was a very bright total lunar eclipse.

Supplementary Sketch Information

The telescope used was a 4.25″ f/5 Dobsonian-mounted reflector riding on an equatorial platform, with a 12 mm eyepiece giving 45x magnification.

10.2 Pastels, Conté, Grated Pastels on Black Paper (by Deirdre Kelleghan)

Suggested Materials

- Black paper, size 8½"×12"
- Clipboard
- Soft pastels
- Conté crayons
- White paper, 8½"×12"
- Graphite pencil
- Quilling needle or craft needle
- Scissors
- Black card, size 8½"×12"
- Pastel sticks (yellow, orange, brick red)
- Small, fine grater
- Sponge
- Fixative spray

On the eve of the 2010 winter solstice, snow was falling and accumulating in unprecedented amounts. Temperatures were plummeting to record lows. The following morning's total lunar eclipse looked like it would be an impossible observation. The Moon's predicted position for the eclipse meant that it would be too low for the telescope view from my garden, and the icy conditions at the time made driving impossible. My plan was to sketch the full Moon on the evening of December 20th and follow up the next morning with as much eclipse detail as I could manage. A gap in the chilly precipitation gave me an opportunity to try for a sketch.

Fig. 10.2.1

Step 1

As it was very cold (−7°C), my Moon sketch had to be physically small to save time. I used a compact disc and a stick of white Conté crayon to outline the lunar disk onto black paper attached to a clipboard (**Fig. 10.2.1**).

Step 2

I used a white pastel on its side to fill in the circle (**Fig. 10.2.2**).

Fig. 10.2.2

Fig. 10.2.3

Fig. 10.2.4

Step 3

Using a mid-gray pastel, I sketched in the approximate positions of maria (**Fig. 10.2.3**).

Step 4

I began to add Tycho and its rays, plus Copernicus and Kepler (**Fig. 10.2.4**).

Step 5

Fig. 10.2.5

Proclus, its defining rays, and Sinus Iridum were added, as well as many bright albedo features that were prominent throughout the lunar disk. My paper was getting damp, and the pastels and Conté crayons were not working as well as they usually do. Ice was forming between my paper and the clipboard. **Figure 10.2.5** is the sketch rotated ready for the binocular view the next day.

The next morning at 07:30 UT, a gap in the snow clouds revealed the lunar eclipse for a short time.

Step 6

Again, I used a CD and a pencil to make a circle on white paper. Then I took a visual note of the colors I observed and sketched the position of the Earth's shadow over the lunar terrain with the pencil. 15×70 mm binoculars showed me the wonderful brick red shadow into which the descending Moon was gliding. This white paper sketch served as a template for the Earth's shadow.

I noticed that the line of the Earth's shadow had less curvature than the terminator from the Sun. The Earth's shadow line was more upright, and to me looked immediately different. On consulting

10.2 Pastels, Conté, Grated Pastels on Black Paper (by Deirdre Kelleghan)

Fig. 10.2.6

Fig. 10.2.7

with fellow sketcher Sally Russell my observation was confirmed. This also gave affirmation to my sketching when used as a personal learning tool – 'sketch only what you see'. Heavy snow showers swallowed up the Moon and there was no further opportunity to sketch. I used my binocular eclipse observation sketch to add to my pre-drawn moon.

I cut out a CD-sized circle in the black card and placed the pencil drawing over it. Then, I punched through the paper onto the card using a craft needle to make marks so that I could draw in the line of the Earth's shadow and then cut out its shape.

The card was aligned and placed on the original Moon drawing and I sprinkled fine particles of orange–yellow grated pastel over the area not eclipsed. After removing the card, I sprayed the whole sketch with fixative to seal it (**Figs. 10.2.6** and **10.2.7**).

Fig. 10.2.8

Step 7

The remaining smaller card template was used to screen the yellow particle-covered Moon. This allowed me to firstly add tiny particles of dark gray pastel grains to simulate the shadow of the Earth. The fine grains were created by grating the pastel on a nutmeg grater and letting them drop over the lunar surface. Tiny particles of pastel (applied by using the sponge from inside a box of Conté crayons) became the red brick shadow of the Earth as I had observed it earlier. Using a sponge to apply these particles gave me more control over where they landed. The particles were sprayed with a fixative again to firmly adhere them to the lunar drawing (**Fig. 10.2.8**).

The Earth's shadow line, as I observed it, was not harsh, nor was it visually merged into the unshadowed section. It was subtle, as was the entire shadow, because even though the developing color

Fig. 10.2.9

was deep, maria and many features were still visible underneath. The shadow of the Earth was like ink-tainted gauze being dragged over the lunar surface. As the dawn approached, a brief glimpse of the Moon in the blue–black sky was my last view of the event.

The sketch was finished by applying black pastel as the background around the lunar disk, followed by spreading an overlay of blue pastel on top of the black pastel background, and then blending to give the color of the sky. The entire sketch was then sprayed with a matte fixative to hold the particles firmly on the page **(Fig. 10.2.9)**.

Supplementary Sketch Information

200 mm Dobsonian Telescope, 32 mm Tele Vue Plossl eyepiece, Focal Length 1200 mm, Magnification 37x, Seeing: Antoniadi II, December 20 and 21, 2010, 15 × 70 mm SkyMaster Binoculars
 Bray, Co Wicklow, Ireland

10.3 Colored Pastels on Black Paper (by Sally Russell)

Sketching a lunar eclipse in color gives rise to an interesting set of challenges. You will need to use a white light source to be able to see the different pastel colors, but will also need to manage the light level quite carefully to retain some level of dark adaptation such that you can still observe the finer detail on the darkened face of the eclipsed Moon. A late evening total lunar eclipse provided a good opportunity to catch a mid-totality, colored pastel sketch for this tutorial. A small hand-held,

10.3 Colored Pastels on Black Paper (by Sally Russell)

Fig. 10.3.1

Fig. 10.3.2

low-intensity white flashlight was used to see the pastel colors, which included white, black, orange, light brown, red, and blue **(Fig. 10.3.1)**.

As with any lunar drawing, you will "fix" the view of the Moon as it appears at the start of your sketch. During an eclipse, both the color and lighting of the disk change continuously and dramatically as the event progresses, so you must try to finish your sketch on a fairly short timescale before the scene changes markedly from that initial view! When choosing your template size, bear in mind that a pastel drawing will need to be done on a reasonably large scale if you wish to include fine detail, but the larger the drawing circle you use, the longer it may take to complete your sketch.

Note: The tutorial sketch is a mirror image view as the refractor used for the observation was fitted with a mirror diagonal.

Suggested Materials

- Drawing board (plus masking tape to fix the paper in place)
- Smooth black 90 lb weight Daler-Rowney 'Canford' paper (size 12″ × 16½″ was used for this tutorial)
- White and variously colored chalk pastels (black, orange, light brown, red, blue)
- Craft knife for sharpening pastels
- Kneadable eraser
- Natural sponge (or a soft, lint-free cloth)
- Blending stumps (one for each color used)
- Circle template
- A low-intensity white light

Step 1

Tape your paper onto the drawing board using small pieces of masking tape applied at the paper corners. Then, with a circular template (a 9-in. diameter dinner plate was used in the tutorial) and a slightly sharpened orange pastel, lightly draw the lunar disk **(Fig. 10.3.2)**. Choosing a color slightly

Fig. 10.3.3

Fig. 10.3.4

lighter than the deep orange–red of mid-totality will make it easier to incorporate the limb outline seamlessly into the sketch as the disk area is filled in.

Step 2

Holding a small chunk of light brown pastel on its side, use light strokes to block in the main deep-colored area of the lunar disk **(Fig. 10.3.3)**. The right limb and disk (as seen through the telescope at the start time of the sketch) were deep in a red–brown toned umbral shadow, whereas the left limb was much paler and bluer, being closer to the umbral/penumbral shadow boundary.

Blend the area using your fingertip, cloth, or a dry sponge, gently blowing away excess pastel as you go. The background color of the paper will still show through at this stage but will become covered over as more layers of pastel are added. You will find that a lot of pastel dust is generated when applying chalk pastel over large areas. Gently blow the excess pastel off your sketch regularly to keep it clean and to avoid stray pastel from smudging the sky background of your sketch.

Step 3

Using a small piece of white pastel, roughly block in the lighter toned area around the left limb and, again, blend the area for a smooth finish **(Fig. 10.3.4)**.

Step 4

Build up the background depth of color across the whole disk by adding layers of pastel to both areas, mixing in a small amount of lilac–blue pastel into the white area, and both orange and red pastel into

10.3 Colored Pastels on Black Paper (by Sally Russell)

Fig. 10.3.5

Fig. 10.3.6

Fig. 10.3.7

the brown area. Gently blend using a cloth or sponge as you progress until you have an even background with a smooth light-to-dark boundary between the two areas **(Fig. 10.3.5)**.

Step 5

Now it is time to start adding in the main lunar features. Pick up a small amount of black pastel directly onto your fingertip by running it along the side of a pastel stick. Use your fingertip to draw the dark patches of the lunar mare regions **(Fig. 10.3.6)**.

Soften and blend each area with your fingertip, or by using a cloth or a dry sponge, as you did previously for the lunar background **(Fig. 10.3.7)**.

Step 6

Add a thin band (~0.5 cm) of red pastel along the deeper-colored right limb. Overlay it with a thin layer of black pastel and then blend into the background color using your fingertip. This will both soften and darken the lunar limb, which lies deeply in the umbral shadow. Tidy up the outside of the

Fig. 10.3.8

Fig. 10.3.9

Fig. 10.3.10

limb edge by gently using a kneadable eraser held on its side (**Fig. 10.3.8**). You will be less likely to accidentally remove chunks of color from the limb edge when holding the eraser in this fashion.

Step 7

Add a band of white pastel along the pale left limb, and blend this into the background using your fingertip, keeping a clean and bright limb edge. As in Step 6, clean the outside of the limb edge afterwards using the kneadable eraser.

It is surprising just how high the contrast can be between the right and left limbs. Though this will differ for each eclipse depending on how deep into the Earth's shadow the Moon passes, in this example, the left limb (as observed) is barely immersed in the umbra, while the right limb is almost placed at the center of the Earth's shadow at the time of the eclipse sketch.

Step 8

Pick up a small amount of white pastel directly onto a clean blending stump (**Fig. 10.3.9**), and then use this to carefully add any final bright highlights; e.g., crater Aristarchus (**Fig. 10.3.10**).

10.3 Colored Pastels on Black Paper (by Sally Russell)

Fig. 10.3.11

Step 9

Load a new blending stump with orange pastel and use this to draw the highlights that are deeper in the shadowed portion of the disk (e.g., Copernicus, Kepler, and Tycho's rays). Re-load the blending stump with more pastel as necessary. It is best to use separate blending stumps for each color to avoid cross-contamination. Clean up any remaining pastel smudges from the surrounds of the lunar disk using the kneadable eraser.

Figure 10.3.11 is the finished sketch.

Supplementary Sketch Information

For this observation and sketch, I used a 105 mm f/5.8 refractor on a driven mount with 13 mm and 9 mm eyepieces, giving magnifications of around 47x and 68x. The drawing was completed at around 01:00 UT March 4, 2007 with the Moon at 14.3 days old (100% illuminated), under initially clear and calm conditions which later deteriorated to a misty fog (seeing: Antoniadi I–II).

Chapter 11

Additional Tutorials and Sketching Gallery

11.1 White and Black Charcoal on Black Stock – Crescent Moon and Earthshine (by Jeremy Perez)

The telescopic view of a delicate bubble of Earthshine resting within the thin, smiling embrace of a crescent Moon is an incredible delight to behold. The crisp, brilliant details along the crescent and broad, subtle tones within the Earthshine present an enjoyable contrast in techniques if you wish to transfer the enchanting sight to paper. White and black charcoal on black paper are ideal media for this task, allowing us to take advantage of the darker tones that dominate the majority of the view.

Suggested Materials

- Smooth, black cardstock such as Strathmore Artagain or Daler-Rowney Canford
- White and black charcoal pencils
- Blending stump and artist's chamois
- Sheet of blank copy paper
- White vinyl eraser pencil
- Craft knife
- File folder, compass and paper clips
- Spray fixative such as Winsor and Newton's Artist Fixative
- Clipboard and observing light

For those accustomed to working with graphite, white charcoal possess some unique qualities. For example, an artist's chamois tends to lift the media off the paper rather than simply blending it. Likewise, a blending stump can either add, remove or blend tones depending on how much charcoal has already been applied and how much texture the paper has. The media also requires the sketch be created at a reasonably large scale to reliably depict details.

Fig. 11.1.1

Fig. 11.1.2

Step 1

We will start by creating a softly shaded disk to represent the Earthshine effect. You don't need to be at the telescope to set this up, and can create it well ahead of time. To do this, take a manila file folder and use a compass or dinner plate to draw a circle about 18 cm in diameter on one half of the folder. Then use a craft knife to carefully cut out the circle. Next, place a sheet of black cardstock in the folder and use paper clips to hold it in place. Lay this on a flat surface with the circle side facing up and the black stock showing through.

Step 2

Scrape the craft knife against the tip of the white charcoal pencil and move it around so that the white powder drifts onto the exposed black paper. It does not need to be perfectly even but should cover the exposed surface (**Fig. 11.1.1**).

Step 3

Use your finger to blend the white charcoal dust into the paper. Start at the outside edge of the circle, following the circumference, and gradually spiral inward until you have blended all the way to the center (**Fig. 11.1.2**). If the blending appears uneven in places, use the knife to scrape some more white charcoal dust over these areas and re-blend with your finger.

11.1 White and Black Charcoal on Black Stock – Crescent Moon and Earthshine (by Jeremy Perez)

Fig. 11.1.3

Fig. 11.1.4

Step 4

To further blend and soften the effect, brush an artist's chamois around the disk, as you did with your finger **(Fig. 11.1.3)**. When finished, remove the black stock from the file folder and tap it against a hard surface to knock away any loose dust. Use a vinyl eraser to remove any stubborn white charcoal that managed to work its way outside the circle template.

Step 5

When you are at the telescope, you will feel some pressure to work quickly as the thin crescent Moon threatens to sink out of sight. To give yourself more time, you may want to begin your sketch in bright twilight, saving the Earthshine details for last as the sky darkens. Begin by using a sharpened white charcoal pencil to mark the brilliant side of the limb. Imagine a clock face superimposed over the lunar disk and use this for reference to mark a few prominent crater boundaries along the terminator. Then, lightly draw an arcing line between these features to represent the basic position of the terminator **(Fig. 11.1.4)**. As you do this, place a blank sheet of copy paper under your hand so you can rest your hand on the sketch without creating accidental smudges.

Step 6

Now that the terminator is marked, use the white charcoal pencil to lightly fill the crescent. Then get both your white and black charcoal pencils ready and begin drawing the features you see within the boundaries of the brightly lit crescent. Work from one side to the other, using the features you plotted

Fig. 11.1.5

Fig. 11.1.6

earlier as reference points. Switch back and forth between black and white to add the shadows and highlights as you observe them **(Fig. 11.1.5)**. Work on the major features, realizing that you won't be able to include every bit of detail in this crisp and rugged terrain.

Step 7

Once you have completed the sharp details, use the white charcoal pencil to further brighten the surface of the crescent. Look for albedo differences as you do this, and apply more pressure to the brighter areas, while leaving darker areas, such as flooded crater floors, alone **(Fig. 11.1.6)**.

Fig. 11.1.7

Step 8

With the crescent completed, we can move on to the subtler features that are lit by Earthshine. To block in the large maria, wrap the artist's chamois around your index finger and brush it on the sketch to lift the white charcoal away **(Fig. 11.1.7)**.

11.1 White and Black Charcoal on Black Stock – Crescent Moon and Earthshine (by Jeremy Perez)

Fig. 11.1.8

Fig. 11.1.9

Step 9

Further refining the shape of the maria is a give and take process of lifting away and re-applying the white charcoal. To re-brighten areas, scribble a patch of white charcoal on scrap paper, brush a clean blending stump in it, and use this to apply brighter tone to the sketch **(Fig. 11.1.8)**. To darken finer details, tightly wrap the chamois around the tip of a pencil and brush this against the sketch to lift away the white charcoal. Small, dark craters such as Plato and Grimaldi can be more precisely sculpted with a sharpened vinyl eraser.

Step 10

Search for other differences in albedo besides the dark maria. Bright areas around Tycho, Copernicus, and Kepler may show up first, but be sure to search for other softer regions. Brush the blending stump in a scribbled patch of white charcoal and apply it to the sketch to lighten these areas and define any rays you observe **(Fig. 11.1.9)**. Finally, jot down a few notes about your observing session – particularly the date and time – and then preserve your sketch by applying a light coat of artist's fixative.

The finished lunar crescent and Earthshine sketch was made May 17, 2010, 02:30–03:30 UT, and was observed with an Orion SkyQuest XT8 (8-inch, f/5.9 Dobsonian) at 48x **(Fig. 11.1.10)**.

Sketching the crescent Moon with Earthshine is a fascinating experience in sharp and subtle contrasts and will make an excellent addition to your collection of lunar sketches.

Fig. 11.1.10

11.2 Ink and Ink Wash – Theophilus (by Harry Roberts)

(Paraphrased by Richard Handy)

Fellow lunar sketcher Harry Roberts was deeply impressed and motivated by the work of the late Harold Hill in his book *A Portfolio of Lunar Drawings* (Cambridge University Press, 1991.) In Harry's words, "… after some trials with the C8, I too was able to make drawings this way, not as good as Hill's, but very rewarding to produce." Harry told me that he found his own sketches were a great way to study lunar features, even better than taking a photograph.

His technique is a bit different, making use of a simple cross-hair eyepiece using strands of spider web. This allowed him to map a network of key features that could serve as reference points in the field of view of the eyepiece (Ready-made cross hair eyepieces are available from a number of sources.) He mapped these reference points to quadrille paper, where he then added the features in outline. Typically this process takes him about an hour.

This outline sketch is then coded with "0" being pure white, "B" deep black shadow and numbers 1–9 for gray tones. Harry often adds notes, detail sketches, and uses a blending stump to record tonal

11.2 Ink and Ink Wash – Theophilus (by Harry Roberts)

1. Graphite image on art board

Fig. 11.2.1

Fig. 11.2.2

gradations in order to augment the outline sketch produced at the eyepiece. A day or two later he finishes the sketch using the following steps:

Step 1

The outline sketch is taped to a smooth piece of art board. After using a soft pencil rubbed on the back of the sketch, a hard pencil is applied to the outlines, transferring the sketch to the art board **(Fig. 11.2.1)**.

Step 2

With a steel nib pen and black India ink, the shadows are filled in. Larger areas are filled in using a small brush **(Fig. 11.2.2)**.

Step 3

Diluting a few drops of India ink in a small bowl of water; the tint is matched with the tone code 2–3 on the original outline sketch. This is applied to those areas on the outline sketch that have those number codes, using a "dry brush" technique. A sable watercolor brush is employed to wet the brush with pigment, and then with some tissue paper, the brush is shaped into a flat chisel edge and with

2. Outline black areas and infill by brush

Fig. 11.2.3

3. Shadows completed

Fig. 11.2.4

small circular strokes, applied to the art board. This provides better control over how much pigment is applied (**Figs. 11.2.3** and **11.2.4**).

Layers of pigment are built up to match code 5 or mid-tone gray. Dry the art board with a hair dryer between applications of the brush to prevent it from getting wet. These layers look very representative of the lunar surface albedo if you allow a slightly uneven texture to develop.

Keep the tone scale close by to verify that the ink tones match the code numbers on the original eyepiece sketch. For tones darker than code 5, simply add more ink to the diluted pigment, but use the layering technique above. If a portion of the sketch ends up darker than the code, you can use an ink eraser to lighten the tone; however, make sure the art board is completely dry before applying the eraser, otherwise there is a good chance of tearing the surface.

All of this is very satisfying and, when finished, you will have created your own miniature masterpiece that describes what you have observed through the telescope far better than a photo (**Fig. 11.2.5**).

4. Mid-tones brushed in to match greyscale nos.

Fig. 11.2.5

The crater Theophilus is the target of this tutorial. The orientation does not conform to the IAU standard and must be scanned and flipped using a computer before publication.

As Harry says "Draw the Moon – it is a great way to a better knowledge of lunar topography."

11.3 Pencil Sketching and Cybersketching – Sinus Iridum, Rima Ariadaeus, Agrippa, Delisle, Diophantus, and Parry (by Peter Grego)

Visual Lunar Observation

A telescope reveals countless features on the Moon's big, bright disk. Competing for the observer's attention, lunar impact craters and crater chains, vast dark lava plains, volcanic domes, wrinkle ridges, mountains, faults and valleys all lie within the amateur astronomer's field of view. Changing degrees of libration (the monthly oscillation of the Moon that enables us to see some 59% of the entire lunar surface), combined with the continually shifting illumination of the Moon by the Sun, produces an ever-changing visual scene with which nobody could possibly become bored. Most observers choose simply to gaze at the Moon's majestic surface every now and then, perhaps imagining that their eyepiece was the window of their very own orbiting spacecraft. But a dedicated bunch of observers enjoy nothing more than to get up close and personal with the Moon by making drawings of selected areas of the lunar surface.

Of course, these days the Moon's surface has been thoroughly mapped, and CCD imagers are capable of securing exceptionally detailed, high-resolution images. Yet despite modern advances, sketching lunar features is by no means an outmoded and arcane practice. Here are a few excellent reasons why making observational drawings at the eyepiece remains as valid now as it ever was, and why it will remain valid in the future:

- The Moon's awesome, fascinating surface is beautiful to look at 'live.'
- Sketching the Moon is a personally enjoyable and rewarding pursuit.
- Drawings provide unique records of your observations.
- Attending to detail through drawing allows you to discern finer points that might be overlooked by the cursory viewer.
- Sketching enhances every aspect of your observing skills. Detailed note-making techniques can also be learned in the process.
- The changing appearance of features under varying conditions of illumination and libration is appreciated and learned.
- Drawing the Moon is by far the most effective way of getting to know lunar topography and becoming familiar with its often tongue-twisting nomenclature.
- There is always a real chance of making a 'live' scientific discovery.
- Drawing improves visual skills, increasing your aptitude for perception and interpretation, enabling you to become a more accurate observer.
- There's a thriving community of visual lunar observers who love discussing the Moon and comparing notes. Great value is placed on visual observations by the Society for Popular Astronomy (SPA) Lunar Section and the British Astronomical Association (BAA) Lunar Section, both based in the UK, as well as the Association of Lunar & Planetary Observers (ALPO) Lunar Section in the USA.

Drawing Techniques

Even the most experienced observers sometimes get lost on the Moon, so find your bearings with a detailed map of the Moon that is easy to handle at the telescope. Identify your target, such as an individual crater or feature, and one that's preferably close to the lunar terminator where most detail is visible. It's worth preparing a light pencil outline template of the features within your chosen area, using your map, a photograph or a suitable computer program as a guide. Take care to get the orientation, proportion and arrangement of features right – this will save time and allow you to concentrate upon the

detail. Remember that features near the Moon's edge are most affected by libration, and an outline blank based on a map may not be precisely the same as how a feature is presented in the eyepiece.

It is important not to 'bite off more than you can chew' if you are aiming to make an accurate depiction of what you can see; attempting to sketch even a single crater such as Copernicus will prove to be time-consuming (it would take me around an hour or more) so select only a small portion of the lunar surface and attempt to depict its details. Drawings of larger features like entire maria can of course be attempted; a skilled observer can produce an extremely pleasant depiction of, say, Mare Crisium, over the course of a couple of hours. However, even a couple of hours are not long enough to do justice to all the detail that can be seen in and around Mare Crisium.

Pencil Sketches

Here's an outline of my own pencil sketching technique.

I use a set of soft-graphite pencils, from HB to 5B, and a small pad of smooth paper. First, the basic outlines of the most prominent lunar features visible through the eyepiece are sketched. Scale is important – a drawing of around 4 in. (100 mm) in diameter is a manageable size, quite sufficient for most lunar observations.

Next, shading is applied to the darkest areas that have been outlined. When shading, it's best not to apply a great amount of pressure on the paper; the darkest areas (lunar shadows) are ideally applied in several criss-crossing layers rather than in a frenzy of heavy pencil pressure. Once the shadows have been suitably depicted (bearing in mind that a regular graphite pencil will never produce true black), attention is then turned to the finer detail – the subtleties of tone and the intricacies of topography. This fine detail is depicted as carefully as possible. An eraser may come in handy – don't be afraid to use it!

I usually set myself about an hour for each observation. Written notes can also be made at the eyepiece, indicating any unusual or interesting features that you've observed but may not necessarily be obvious in your drawing. Note the name of the feature you have observed; if you cannot identify it in the field, note its position with respect to any nearby feature that you can identify. Also, record the observation date, start and finish times (UT), instrument and magnification used, the seeing conditions and the drawing's orientation – mark the direction of lunar north and the east-west axis, remembering that mirror diagonals will flip the image around. Finally, make a 'neat' copy of your observation as soon as possible after the observing session, while the visual information remains fresh in your mind; it's remarkable how much information your mind's eye retains immediately after an observing session, but this gradually fades as time goes by, so prepare your 'neat' copy once indoors if it's practicable **(Fig. 11.3.1)**.

Lunar Cybersketching

With their touch-screen stylus input, PDAs (Personal Digital Assistants) and tablet computers used in conjunction with suitable graphics programs offer an intuitive drawing-like experience. PDAs and tablet computers have backlit LCD screens, so there is no need to juggle a flashlight while making a drawing. Graphics programs allow the properties of the stylus stroke to be modified in terms of its thickness, shape, intensity, color, texture and transparency, so that a range of pencil, pen, brush strokes and other artistic media can easily be replicated.

Fig. 11.3.1

11.3 Pencil Sketching and Cybersketching – Sinus Iridum, Rima Ariadaeus...

Rima Ariadaeus, Agrippa
2010 April 20
19:40-20:20 (1)
Col. 351.7-352.0° (1)
20:20-20:30 (2)
Col. 352.0-352.1° (2)
Seeing: AI-II, very good, no wind, clear
200mm SCT, 250x, integrated light
Peter Grego (St Dennis, Cornwall, UK)
PDA sketch enhanced in PhotoPaint immediately after session

Fig. 11.3.2

I have called electronic drawing of celestial objects 'Astronomical Cybersketching', and my book on the subject (with the same title) was published by Springer in 2009 **(Fig. 11.3.2)**.

Cybersketching is, in many ways, an easier and more enjoyable experience – and certainly a far more forgiving one – than pencil sketching. I began making astronomical cybersketches in 2004, after more than 20 years of pencil work; electronic sketches on PDA are now my preferred medium. The techniques of outlining, filling, shading and application of detail, all proceed in the same manner as regular pencil sketching. Any mistakes made are, however, far easier to rectify, and additional techniques, such as blending and blurring, zooming-in to attend to more intricate areas, allow a more accurate sketch to be made at the eyepiece.

One area in which cybersketching excels is making sequential drawings of features as they emerge from (or are immersed into) the lunar terminator – the rapidly changing conditions of illumination under such circumstances can produce dramatically altering scenes which are often difficult and time-consuming to portray with conventional sketches. Cybersketches, however, can be saved and copied on the device, and then used as blanks upon which further detail brought up by changing illumination may be added at leisure **(Fig. 11.3.3)**.

Cybersketches made at the eyepiece can often be drawn to such a pleasing standard that they require very little 'post-editing' on a graphics program on the main computer, other than a touch of re-sampling and the details of the observation texted into the sketch. It's certain that cybersketching will be performed by a growing number of amateur astronomers in the future. It must be said that the one obvious 'downside' to cybersketching is that you don't end up with a physical artifact of your efforts – just an electronic file – something that many die-hard observers may never come to terms with! However, electronic files lose nothing in replication and can be posted on the Internet among groups and forums immediately after they are made – an advantage that, for me, makes cybersketching so alluring, addictive and enjoyable **(Fig. 11.3.4)**.

Parry
2010 April 22
22:10-22:40 UT (1)
Col. 17.0-17.3° (1)
Seeing: AII-III, no wind, clear
200mm SCT, 250x, integrated light
Peter Grego (St Dennis, Cornwall, UK)
PDA sketch enhanced in PhotoPaint immediately after session

22:55-23:05 UT (2)
Col. 17.4-17.5° (2)
Seeing: AIII, haze

Fig. 11.3.3

Delisle and Diophantus
2010 May 23
21:10-21:30 UT
Col. 34.7-34.9°
Seeing: AIII, darkening twilight
200mm SCT, 250x, integrated light
Peter Grego (St Dennis, Cornwall, UK)
PDA sketch enhanced in PhotoPaint

Delisle and Diophantus
2010 May 23
21:50-22:00 UT
Col. 35.1-35.2°
Seeing: AIII
200mm SCT, 250x, integrated light
Peter Grego (St Dennis, Cornwall, UK)
PDA sketch enhanced in PhotoPaint

Delisle and Diophantus
2010 May 23
22:20-22:30 UT
Col. 35.3-35.4°
Seeing: AIII, darkening twilight
200mm SCT, 250x, integrated light
Peter Grego (St Dennis, Cornwall, UK)
PDA sketch enhanced in PhotoPaint

Fig. 11.3.4

11.4 Sketching Gallery

Petavius, by Carlos Hernandez **(Fig. 11.4.1)**
Mare Orientale, by Michael Rosolina **(Fig. 11.4.2)**
Crescent Moon, by Thomas McCague **(Fig. 11.4.3)**
Mare Imbrium near Aristillus and Autolycus, by Leonor Ana Hernandez **(Fig. 11.4.4)**
Alpine Valley including the craters Aristillus, Eudoxus and Cassini; by Alexander Massey **(Fig. 11.4.5)**
Theophilus, Cyrillus and Catharina; by Peter Mayhew **(Fig. 11.4.6)**
Aristarchus and Prinz, by Sally Russell **(Fig. 11.4.7)**
Theophilus, by Eric Graff **(Fig. 11.4.8)**
Clavius, by Chris Lee **(Fig. 11.4.9)**
Rima Ariadaeus, by Dale Holt **(Fig. 11.4.10)**
Petavius, by Richard Handy **(Fig. 11.4.11)**
Maurolycus, by Carlos Hernandez **(Fig. 11.4.12)**
Schiller compilation; by Sally Russell, Michael Rosolina, Richard Handy, Eric Graff, Jeremy Perez, Erika Rix **(Fig. 11.4.13)**
Anaxagoras, by Deirdre Kelleghan **(Fig. 11.4.14)**
Schiller, by Dale Holt **(Fig. 11.4.15)**
Ptolemaeus, by Leonor Ana Hernandez **(Fig. 11.4.16)**
Bullialdus, by Erika Rix **(Fig. 11.4.17)**
J. Herschel, by Harry Roberts **(Fig. 11.4.18)**
Copernicus, by Chris Lee **(Fig. 11.4.19)**
Plato, by Carlos Hernandez **(Fig. 11.4.20)**

Fig. 11.4.1 Petavius – February 12, 2009 (06:00 UT), 9″ (23 cm) f/13.5 Maksutov-Cassegrain at 359x, Pickering: 5–7/10. Digital sketch using Photoshop (Courtesy of Carlos E. Hernandez)

186 11 Additional Tutorials and Sketching Gallery

Fig. 11.4.2 Mare Orientale – graphite pencil on white paper (Courtesy of Michael Rosolina)

11.4 Sketching Gallery

Fig. 11.4.3 Crescent Moon – September 3, 2010 (12:45 UT), 4.25″ f/5 Dobsonian telescope, equatorial platform, 12 mm wide-field eyepiece at 45x. Blue craft paper, white pastel and blue color pencils. By Thomas McCague

Fig. 11.4.4 Mare Imbrium near Aristillus and Autolycus – 31 May, 2009, Guadalajara, Spain. Sketch and tutorial courtesy of Leonor Ana Hernandez.(1) Select a sharp feature such as a crater, or a contrasted shadow area (mountain). Position it with an H graphite pencil and draw it gently. Just paint the shadows (edges), not the light areas. (2) Do the same but with less prominent features that are close to the main target. (3) Only draw the shadows, so start to fill in the light areas gently and then increase the black color in the darker areas. It is important to identify the different areas of gray for this, so with an HB pencil start to darken the shadows accordingly. (4) After this, draw the most intense shadows with a B or 2B pencil. The large gray areas are filled with a blending stump, paying attention to changes in light (if the bottom of a crater is concave or convex). Apply increased intensity of gray in the darker areas to give the illusion of a curved floor. "This drawing took me approximately 30 min. I consider it a simply quick sketch finished completely in situ"

11.4 Sketching Gallery

Fig. 11.4.6 Theophilus, Cyrillus and Catharina and environs – graphite pencil on white paper (Courtesy of Peter Mayhew)

Fig. 11.4.5 Alpine Valley including the craters Aristillus, Eudoxus and Cassini – December 13, 2010, backyard in Sydney, Celestron C5 (5″ SCT), TMB Planetary Type II 6 mm at 200X. Pencil, white paint and ink on white paper (Courtesy of Alexander Massey). "I found depicting the terminator quite a challenge. First, the shadows are just so dominatingly black. In contrast, the highlights are so white, like the peaks that soar above the still blackened moonscape that capture the first rays of the sun making them appear like floating, attendant pups of the Moon. It's almost like the Moon is breaking up and pieces are falling off it. Another challenge was finding the best balance of pencil grades to reproduce the shades of gray this time. The contrast is much more intense along the terminator."

Fig. 11.4.7 Aristarchus and Prinz – February 17, 2008 (21:40–22:35 UT), 105 mm f/5.8 refractor with diagonal on a driven mount, 2.5 mm eyepiece at ~245x, lunation 10.71 days (87.6% illumination), clear, calm, sub-zero conditions (seeing: Antoniadi II). Conté crayon on black paper. By Sally Russell

190 11 Additional Tutorials and Sketching Gallery

Fig. 11.4.8 Theophilus, Cyrillus and Catharina – September 14, 2010 (03:45–05:15 UT), 6″ f/6 Newtonian reflector at 240x. #2 pencil, blending stump, and ink (for the deep shadows) (Courtesy of Eric Graff)

Fig. 11.4.9 Clavius – graphics pad drawing based on a graphite pencil sketch completed at the telescope (Courtesy of Chris Lee)

Fig. 11.4.10 Rima Ariadaeus – April 1, 2009 (20:15–21:00 UT) at 337x. White and black Conté pencils on black paper (Courtesy of Dale Holt)

Fig. 11.4.11 Petavius in waning light – October 28, 2007 (20:47–21:34 PDT), 12″ SCT f/10, 12.5 mm eyepiece at 244x. White Conté crayon on black paper. By Richard Handy

11.4 Sketching Gallery

Fig. 11.4.12 Maurolycus – April 2, 2009 (02:00 UT), 9″ (23-cm) f/13.5 Maksutov-Cassegrain at 253x, Pickering: 5–7/10 (Courtesy of Carlos Hernandez)

Fig. 11.4.13 Six astronomical artists from across the USA and England individually sketched the strange, footprint-shaped crater Schiller over a period of nearly 3 years. Schiller is seen most dramatically at or around days 10–12 of a lunation – this is reflected in the days annotated on each individual sketch. A variety of media and techniques (including white pastel or Conté crayon on black paper, and graphite pencil or charcoal on white paper), an array of telescopes, and a wide range of magnifications were used for these renderings. Though individually unique they are complementary to each other, and as a group have captured much subtle detail in this feature under the various librations and fractional lighting differences. (This compilation was originally published on the Lunar Photo of the Day website, May 5, 2007)Sally Russell (England), 105 mm f/5.8 refractor, 480x; Michael Rosolina (West Virginia), 8″ f/10 SCT, 200-170x; Richard Handy (California), 12″ SCT, 639x; Eric Graff (California), 6″ f/6 reflector, 240x; Jeremy Perez (Arizona), 6″ f/8 Newtonian, 240x; Erika Rix (Ohio), 70 mm ETX, 88x

Fig. 11.4.14 Anaxagoras, its rays, and the Moon's north limb – February 28/March 1, 2010 (23:20–00:35 UT), 200 mm Dobsonian, FL 1,200, 8 mm TVP eyepiece at 150x. Pastels and Conté on black paper. By Deirdre Kelleghan

Fig. 11.4.15 Schiller – December 28, 2009 (21:30 UT) at 220x. Conté pencils on black paper (Courtesy of Dale Holt)

Fig. 11.4.16 Ptolemaeus – May 31, 2009, Guadalajara, Spain (Courtesy of Leonor Ana Hernandez)

Fig. 11.4.17 Bullialdus – November 12, 2005 (01:00–03:00 UT), 10″ LX200 Classic, diagonal, 8 mm Tele Vue Plossl, Ohio, USA. By Erika Rix (*Astronomical Sketching: A Step by Step Introduction*, Springer Science+Business Media, LLC, 2007)

11.4 Sketching Gallery

Fig. 11.4.18 J. Herschel – India ink and ink washes on art board from a graphite pencil study sketch (Courtesy of Harry Roberts)

Fig. 11.4.19 Copernicus – graphics pad drawing from a graphite pencil sketch completed at the telescope (Courtesy of Chris Lee)

Fig. 11.4.20 Plato and the surrounding region – May 3, 2009 (02:00–04:00 UT), 9″ (23-cm) f/13.5 Maksutov-Cassegrain at 352x, Pickering: 5/10, with brief moments of 6–7/10 (Courtesy of Carlos Hernandez)

Chapter 12

General Hints and Tips

Now that you have made the exciting decision to sketch the Moon, your thoughts will no doubt be turning towards the practicalities – which art materials should you use, what about observing equipment, and how will you see what you are drawing if you are outside in the dark, and so on. Everyone new to astronomical sketching goes through this process. We hope this section of practical hints and tips will help to answer those questions for you and ensure a successful start to your lunar sketching journey.

The main aspects we will consider are as follows:

12.1 Art Equipment – Media, Paper, Supports, Fixing and Preservation, Hard Copy Storage, Digital Archiving

12.2 Observing Equipment – Telescopes, Mounts, Eyepiece Viewing Comfort, Accessories

12.3 General Comfort – Seating, Lighting, Clothing, Central Heating!

12.4 Miscellaneous – Planning Your Sketching Session, Identification, General Tips

12.1 Art Equipment

Lunar sketching can be as simple a process as using a standard graphite pencil on a sheet of white copy paper, right through to mixed media painting on canvas, and pretty much anything else in between! Most people will have had some experience drawing with graphite pencils but there are many other media that are well suited to outdoor use at the eyepiece. If you have ever walked into an art store, you would have seen the wonderful array of drawing and painting materials on display. For the inexperienced sketcher this can be a completely overwhelming experience when it comes to choosing media for getting started. General information on media can be found in Appendix B: Glossary.

The following media overviews offer additional, practical advice:

12.1.1 Media Overviews

12.1.1.1 Charcoal

Pros

- Flat (matte) finish
- Easy to apply and remove
- Has a broad range of dynamics
- Good when working in layers and requires minimum use of an eraser
- Comes in all shapes and sizes

Cons

- Powdery/dusty, though not quite as powdery as pastels
- Leaves black residue on fingertips – keep a rag (or baby wipes) nearby to wipe your hands before touching eyepieces/astronomy equipment

12.1.1.2 Conté Crayons

Pros

- Intense pigments – white gives brilliant highlights; black gives the deepest of shadows
- Easy to apply
- Produces crisp, tight lines
- Gives a flat (matte) finish
- Blends well with other colors

Cons

- Erasing strong lines completely can be difficult

Additional Information

- Save fractured pieces of Conté crayon in a small container. The sharp fragments are ideal to use when adding fine detail.
- Save Conté crayon and pastel pencil dust into small, sealable containers when sharpening with a sanding block or a craft knife. The powder can then be used for application with the fingertips.

12.1.1.3 Conté Pencils

Pros

- Have similar characteristics to Conté crayons on paper, but are much cleaner to use
- Easily sharpened with a craft knife – Conté cores are too fragile for an ordinary pencil sharpener

Cons

- Very slightly waxy, so erasing strong lines completely can be difficult
- If thickly applied, it cannot be easily overlaid with a different color due to its slight waxiness
- Tips blunt very quickly – the bulk of the pencil can be lost through frequent sharpening rather than through drawing use

12.1.1.4 Graphite Pencils

Pros

- Very convenient, clean, and easy to use
- Easily sharpened with an ordinary pencil sharpener
- Good for small scale drawings

Cons

- Gives a shiny finish, which can reflect the glare of flashlight/headlamp making it hard to see fine detail during sketching

Additional Information

- Graphite pencils are available in a range of hardness grades, usually from 9H (**H**ardest) to 9B (softest or **B**lackest). Grades from the mid-range HB, the standard writing pencil, up to 6B are ideal for general lunar sketching.
- Save graphite powder into containers when using sanding blocks to sharpen compressed graphite sticks or solid graphite pencils. The powdery graphite by-product can be applied with pieces of paper towel or fingertips to create large, uniform background areas.

12.1.1.5 Carbon Pencils

Pros

- Gives a wide range of matte gray tones
- Produces a fuller black than graphite pencils and a smoother finish than charcoal
- Easily blended

Cons

- Extremely difficult to erase

12.1.1.6 Watercolor Pencils

Pros

- Intense pigments transfer easily onto paper
- Very convenient, clean, and easy to use
- Good for small scale drawings and highlights

Cons

- Difficult to erase completely
- Leads are brittle so tips snap easily – the bulk of the pencil can be lost through frequent sharpening using an ordinary pencil sharpener rather than through drawing use

12.1.1.7 Soft Pastels

Pros

- Easy to apply and remove
- Very soft and easy to blend and manipulate on the paper – good for layering
- Gives a flat (matte) finish
- Works well in combination with Conté crayons
- Overall, a very forgiving medium

Cons

- Very dusty, so can be messy – keep baby wipes and/or paper towels beside your work space to keep hands clean

Additional Information

- Keep white and gray pastels clean by storing them in a jar or tray filled with rice.
- Try etching pastel with a craft tool or a quilling needle to scrape away pastel thereby creating different effects.
- Placing a pastel stick onto its side when laying down pigment into an area gives a thinner layer and a more even, easily blendable finish.
- Breaking a stick often creates lovely pointed edges on the broken part, very useful if you need a sharp edge like the terracing on crater rims.
- Pastels can be finely grated to add texture to areas that are very complex and rugged, e.g., when simulating the slopes of lunar mountains.

12.1.1.8 Pastel Pencils

Pros

- Have the same characteristics as soft pastels on paper, but are much cleaner to use
- Easily sharpened with a craft knife – the pastel cores are too fragile for an ordinary pencil sharpener

Cons

- Tips blunt very quickly – the bulk of the pencil can be lost through frequent sharpening rather than through drawing use

12.1.1.9 Oil Pastels

Pros

- Vibrant pigments

Cons

- Less blendable than chalk pastels
- Difficult to erase

12.1　Art Equipment

12.1.1.10　India Ink

Pros

- A wide range of tones are possible by simple dilution when used for ink wash
- Ideal for very fine, detailed work when used for cross-hatching or stippling because of the assortment of nibs available for application

Cons

- Tricky to use at the eyepiece because of the need for paintbrushes and pots of water when used for ink wash
- Risk of ink splatters or spillage near astronomy equipment

12.1.1.11　Permanent Marker/Felt Tip Pens

Pros

- Ideal for outdoor stippling sketching
- Easy to use
- Marker ink does not freeze even after prolonged use at −5°C/23°F
- Available in a small range of tip thicknesses that are useful for shading gradients

Cons

- Be careful with your markings – once the ink is on the paper it cannot be easily removed
- Filling in all the dots outside can make eyestrain worse – illuminate the sketch well to help relieve this
- Completing the sketch scope-side means a longer session outside compared to the comfort of being indoors while filling in the dots

Additional Information

- When used outside directly (as opposed to making a pencil sketch first followed by completing a traditional India ink drawing inside after the observing session), it eliminates the unnecessary steps of creating a shading legend, drawing an outline, and then essentially redrawing the object inside by infilling in with all the dots.
- If you discover your placements are in error, you can easily leave them there – a few misplaced small dots can easily be intermingled into the background.
- Completing the sketch entirely outside eliminates the risk of inadvertently adding detail to the sketch after the fact by trying to fill in the shading away from the eyepiece. This is where completing the entire ink sketch at the eyepiece is beneficial – when you fill in outlined areas, you can smooth the transition between two areas by adding more markings according to your live observation at that moment, whereas if you were to attempt it by memory later on, your sketch would not be as accurate.

12.1.1.12　Blending Stumps

Pros

- Enables accurate blending of very small areas
- Good for drawing delicate lines – rub blending stumps directly on pastels, charcoal or graphite, or onto an area of paper where the medium has already been applied in order to pick up pigment to use for drawing

Cons

- Become dirty very quickly, so need regular sharpening or cleaning using sandpaper or a sanding block

12.1.1.13 Acrylic Paints

Pros

- Good for use with palette knives, especially when working on a large scale
- The whipped cream texture of this paint allows it to be used like plaster, to layer on thickness as required or to be scraped away to emphasize or lower the perception of an area

Cons

- Dries extremely quickly

Additional Information

- Wash brushes immediately after use as acrylic paint sets like plastic. It is impossible to restore brushes to their original state if paint has dried on them, though it *can* be peeled off palette knives and mixing palettes. Spraying a fine mist of water onto the area you are working on helps prevent the paint drying out too quickly. Using a stay-wet palette helps, as does a slow dry retarder gel mixed with the paint.
- Black lava textured gel, glass bead gels, and structure gels can be added to acrylic paint to produce textured effects.
- In a similar fashion, rough, crushed, or finely grated pastel can be mixed with acrylic paint to add a three-dimensional aspect to a painting.
- Use a spray varnish to finish and seal paintings, applied in layers over the course of a few days. Matte or satin varnishes give good results. Remember to sign the painting before spraying, as it is difficult to sign on top of the varnish finish.

12.1.2 Paper

The main considerations when choosing paper for sketching purposes are:

- Thickness or weight, usually given as pounds (lbs) or grams per square meter (gsm or g/m^2)
- Smoothness or roughness ('tooth')
- Durability under outdoor conditions
- Color and size

Your primary choice of paper will depend on the medium you intend to use for your sketch. For instance, a paper with a fine to medium tooth or roughness would be ideal for a pastel or a charcoal sketch that includes large areas of smooth, blended background, whereas a smooth white cartridge paper would be suitable for graphite. Thicker paper (>80lbs) is recommended, as it is less likely to crumple when being erased and generally provides a more robust support. If you live in a part of the world that frequently experiences very humid conditions, then the durability of your paper towards dampness will also be a major consideration in your selection.

What size of paper should you use? This is a very personal choice and will be dictated by considerations as varied as your own sketching confidence (a large, blank piece of paper can be a daunting

prospect if you are inexperienced at sketching), or the amount of time you have available (a thumbnail sketch in a small notebook can be completed in minutes, whereas a large and detailed sketch could take up to 2 hours to complete). Media known for making fine marks (e.g., sharp graphite, watercolor, or sharpened Conté pencils) will be better able to deliver a detailed sketch on a small scale, whereas those known for thick or heavy marks (e.g., soft pastel sticks or chunks of Conté crayon) will be better suited to larger scale sketching. If you are completely new to sketching, then it is advisable to start with a small paper size as you will be far more likely to finish a small sketch than a large one. You will soon learn what works best for your own level of experience.

The following papers are generally useful for lunar sketching:

12.1.2.1 White Papers

Rite in the Rain Paper (www.riteintherain.com)

Pros

- Very durable, water resistant paper that holds integrity in the highest humidity
- The Rite in the Rain company will print templates on the paper for you when you order and are very accommodating to your needs

Cons

- It is not easy to erase without smudging this paper – the recommend way to lift your markings off is either with a kneadable eraser or using a vinyl eraser. If you use charcoal, this shouldn't be a problem
- It is a little more expensive than ordinary sketching paper, but WELL worth it if you live in high humidity areas that leave you with damp paper while observing

Cartridge Paper

Pros

- A general purpose paper which is particularly good for graphite or ink sketching
- Widely available in a range of weights and sizes

Cons

- Not very durable in damp conditions

White Art Paper

Pros

- Widely available in a range of weights and sizes
- Specifically made for sketching
- Comes in an assortment created for specific media

Cons

- Some may not be very durable in damp conditions

White Card Stock

Pros

- Widely available in a range of weights and sizes
- Fairly durable in damp conditions

Cons

- Generally has a very smooth tooth

12.1.2.2 Black Papers

Daler-Rowney 'Canford' and Strathmore 'Artagain'

Pros

- Both papers are ideal for large blended areas of pastels and Conté crayon
- Both papers are fairly durable in slightly damp conditions

Cons

- Neither paper is intensely black

Additional Information

- The 400 series Strathmore 'Artagain' paper is very similar in weight and smooth texture to the Daler-Rowney 'Canford' paper.
- Strathmore 400 series Pastel paper has a heavier texture that holds the pastel well and is ideal for larger scale pastel and Conté crayon sketches.

12.1.3 Supports

Lightweight drawing boards can be used to provide extra support for sketchpads or as primary support for individual sheets of paper. A variety of styles are available from art suppliers. The thin cardboard on the back of a drawing pad is not usually firm enough to provide proper support to sketch on, especially when using a large paper size. Some boards have integrated clips to hold the paper or sketchpad in place, but masking tape applied at the paper corners works equally well to hold a single sheet of paper onto the board. One advantage of using the whole sketchpad rather than just a single sheet is that the paper bulk provides a cushioning effect. If the drawing board has any imperfections on the surface, these will usually show through onto a single piece of paper.

Field easels are useful for larger scale drawings or paintings. Use a sheet of smooth cardboard on top of the field easel surface to prevent any gaps or grain in the timber from indenting on your sketch.

12.1.4 Fixing and Preservation of Sketches

Finished pastel, Conté, charcoal, and graphite sketches are quite fragile and can easily be smudged and smeared if they are not carefully protected and stored.

Art fixative aerosol sprays, of which there are many different brands available, can be used to permanently fix your sketch on the paper. A good example is Winsor & Newton Fixative for Pastel, Charcoal & Pen. Un-perfumed extra-hold hairspray can also work quite well and is generally cheaper, but be sure to use one that is free of any oily conditioner additives as these could leave greasy spots on your sketch. Art quality spray is specific for the purpose and should give reliable results, whereas the hairspray might not. You can also purchase "workable" fixatives that allow you to add to the sketch after it has already been sprayed.

A thin layer of fixative is applied by spraying across the sketch from a distance of at least 15″ and then you should allow the sketch to dry completely before you store it. Be sure to follow the directions on the container and use in a well-ventilated place, preferably outdoors. This definitely helps reduce the possibility of smudging or smearing the finished sketch, but be warned – some of the fine detail of your sketch, particularly the bright areas, can easily be lost into the paper when the aerosol mist is absorbed, especially if you apply more than one layer of fixative. For this reason many sketchers prefer to use alternative storage methods so that the original sketch is preserved in its entirety.

Another problem with fixative sprays is that they can clog or burst large droplets onto the paper, which can remove pastel and leave bare dots on the sketch. To help avoid this, before you begin the fixing procedure, spray into an area well away from your sketch to clear all the liquefied fixative from the nozzle. Then, before storing the fixative spray, repeat the procedure to clear the nozzle, only this time turn the fixative can upside down while spraying. This should keep it from clogging and then bursting out large droplets when you next use it.

A less invasive method of protecting sketches drawn on individual sheets of paper is to place a full sized layer of tracing paper over the sketch and use paper clips to hold it in place. Insert the whole thing into a protective sleeve and store in a folder or portfolio (see below). Another option is to place the sketch in a singly folded piece of acid-free layout paper, in sandwich fashion, before storing.

If you are using a bound sketchbook, it is advisable to only draw on one side of each page so that the blank, facing page acts as protection. Tracing or layout paper cut to the appropriate sizes can also be interleaved between the pages of a sketchbook and clipped in place as for individual sheets of paper.

12.1.5 *Hard Copy Storage of Sketches*

Once you begin sketching the Moon, it does not take long to build up a collection of sketches that will need archiving. Try to develop good storage habits from the outset, as this will pay dividends later on as your collection grows, enabling you to easily find your way back to any sketch!

Assuming that you will have already fixed or protected your sketches using your chosen method as detailed above, it is time to consider the various options for longer-term storage of your hard copy sketches.

12.1.5.1 **Sketchbooks or Sketchpads**

Sketches made in bound sketchbooks or sketchpads can be stored with little additional intervention. Label the exterior of the sketchbook with the date range of when it was completed to help in locating sketches later on.

12.1.5.2 Individual Sheets of Paper

Sketches on individual sheets of paper can be stored in:

Smaller sketches

- Plastic sleeves stored in ring binders
- Display books containing built-in clear polypropylene pockets
- Cardboard wallet folders, separated by single sheets of acid-free layout or tracing paper
- Accordion-style folders, which allow for alphabetical storage of a large number of sketches, again separated by single sheets of acid-free layout or tracing paper

Larger Sketches

- Plastic sleeves stored in suitably sized portfolios
- Sandwiched between mount boards and stored in portfolios

In all cases, even for sketches that have been sprayed with a fixative, continually flipping through the pages of a sketchbook, ring binder, or portfolio may still lead to some smearing and degradation of the sketches.

The ultimate storage solution is to frame your sketches and hang them on your wall (but keep them away from direct sunlight!). Pastel sketches need to be mounted such that the sketch is kept well away from the glass. Acrylic paintings on block canvas are simple to hang, as they do not need hanging strings.

12.1.6 Digital Archiving of Sketches

Creating a database of your sketches will provide a useful and permanent record. In addition, your sketches will be readily available if you ever need to show your work or create presentations.

Firstly, scan or take the highest possible resolution photographs (or both) of your sketches, and name them in a way that will enable you to easily keep track of them. A good method is to use the date (year: month: day) followed by the universal time of the observation (00:00UT) and then the name of the feature, adding any supplementary information at the end such as telescope used and magnification, e.g.:

20080528_21:40UT_Copernicus_105mmF6_175x

Set up a folder system on your computer hard drive that will allow you to intuitively find your sketches again! Folders can be listed by descriptors such as:

- Type of feature – enables you to home in on specific craters, mountains, maria, etc.
- Alphabetically – search by the feature name.
- By date only – may make it slightly harder to locate an individual sketch unless you have a particularly good memory!

Viewing your folder contents using the 'thumbnails' option will also help you find your sketches.

It is a very good idea to make a copy of your data to provide a back up. There are many methods available but the following are useful:

- External hard drives
- USB Memory sticks/flash drives
- CDs

- Free online photo-editing software such as Picasa 3 or Photobucket – You can upload images to a remote server and will be able to control the visibility of the online albums. Though the displayed images will be compressed versions, the full size of the original file will be available to you if you choose to export an image to your computer. This free software also allows a small amount of editing, slideshow and movie making.

12.2 Observing Equipment

Nowadays, a vast range of astronomical equipment is readily available to the amateur observer. With many factors to consider such as budget, practicality, preferred observational targets, and so on, the choice is very personal, so this is not the right place for a detailed discussion of equipment pros and cons. It *is*, however, an opportunity to consider various aspects in particular relation to lunar sketching. If you have read this far, then you are probably already a visual observer owning a telescope or binoculars. The good news is that from a sketching point of view, whatever equipment you already own will be just fine for getting started with lunar sketching.

One often-overlooked aspect of the sketching process is that the observational element is crucial! To be able to accurately draw what you are seeing, you have to *really* look at your subject first. So spend a reasonable length of time at the eyepiece studying your chosen target well before and throughout the sketching session. One of the bonuses of sketching is that it will eventually make you a better visual observer, and during the process you will quickly learn your way around the Moon.

12.2.1 Telescopes

The equipment used to observe the Moon for sketching purposes can be as simple as your naked eye or hand-held small binoculars, through to refractors, reflectors, and Catadioptric telescopes of any size. In general, the longer your telescope's focal length and the larger the size of its aperture, then the higher the useful power you will be able to employ. What this means in practice is that binoculars and small aperture telescopes on simple mounts are an ideal choice for full disk and low power lunar views for sketching, whereas larger aperture scopes will be better able to deliver higher powers and therefore very detailed views for sketching purposes.

Remember that the configuration of the equipment you are using will affect the view at the eyepiece. Newtonian reflectors give an inverted view, as do straight through views with a refractor. Using a mirror diagonal with a refractor will make viewing more comfortable, but the price paid for this comfort is an upright but mirror image view. Though this won't affect the enjoyment of your lunar observing, it might affect your ability to identify what you have drawn.

Most lunar maps and atlases are printed with the maps in the normal (naked eye) view format, but there are some very good maps and atlases which cater specifically for the mirror-image view, such as Sky & Telescope's laminated *Mirror Image Field Map of the Moon*, and the Hatfield *SCT Lunar Atlas*. There are also several choices available for lunar atlas computer software that allows you to change the settings not only for your time and location, but for your specific equipment as well. Some are freeware such as *The Virtual Moon Atlas* by Christian Legrand and Patrick Chevalley (see Appendix C).

12.2.2 Mounts

If you are viewing with *large* binoculars, it is advisable to use a strong tripod to minimize vibrations as much as possible. As a general rule, an absolute maximum of 10x magnification should be used for hand held binoculars. We recommend that you use a tripod for support for anything greater than that.

When viewing with a telescope, use of a driven mount (such as a German equatorial or an equatorial platform for a Dobsonian telescope) will make it possible to keep your subject centered in the eyepiece for considerable lengths of time allowing you to sketch at leisure. By comparison, an undriven mount will require frequent manual pointing adjustments to hold the subject in your field of view; however, with practice, this does not have to be an obstacle even when sketching at high power, as described here by Erika Rix:

> Sketching with a Dobsonian Mount Without Tracking
>
> My main nighttime telescope is a Zhumell 16″ Truss-Dobsonian (f/4.5) without a tracking platform. I've adjusted to the constant pushing and nudging of the telescope for those long lunar sessions and believe it takes perhaps more time to constantly push the scope than it does to actually sketch the target. I've gotten pretty good about nudging it with my forehead, side of my face, shoulder, nose, back of my sketching hand…
>
> It is helpful to use an eyepiece with a wide field of view as it allows more time between nudges; although, I still only have time for a few markings on the sketchpad before it becomes necessary to nudge again. Another trick is to use lower magnification for the albedo features and then increase for the finer details.
>
> My sketches really suffer if I feel pressed for time, such as clouds coming in or the Moon moving close to the tree line. The results are far better when I can allow several hours to relax, study the target, and sketch with no time constraints.
>
> I have an adjustable, easy-to-move, lightweight chair that I scoot along the observatory floor during the duration of the session. Comfort is very important, and I prefer to sit so that my back and neck are straight. Of course, this means that the chair must be adjusted often, but you quickly get used to it to the point where you don't realize you're doing it. The same holds true for nudging the scope.

12.2.3 Eyepiece Viewing Comfort

If the view in your scope is too bright, use either a higher power or a polarizing or neutral density filter to help tame the glare.

Binoviewers (or an eye patch on your non-viewing eye) work well to relax your eyes so that your attention can be fully focused on the features you are observing and sketching rather than on fighting muscular fatigue.

12.2.4 Accessories

- Small folding tables are useful for keeping your sketching implements/eyepieces, etc. conveniently to hand.
- A shallow plastic box works well as safe storage for an assortment of the softer media, such as Conté and pastels, yet makes it easy to see and select individual items when it is in use scope-side.
- If you build up a large collection of different pencil types, a pencil wrap (available from all good art suppliers) will keep pencils secure but immediately accessible when opened out.
- Using a small tea plate or circular protractor as a template for the lunar disk makes it easy to sketch a series of whole disk drawings at exactly the same scale. A compass is also useful.

12.3 General Comfort

If you are warm and comfortable and can see what you are doing, you will enjoy your observing session and be able to put all your efforts into completing your sketch.

12.3.1 Seating

A comfortable and height adjustable observing chair or stool can make longer sketching sessions easier to endure. Of the many options available a 'Catsperch' style observing chair is particularly flexible, with a wide seat height range plus an in built height adjustable foot rest. (**Fig. 12.3.1**).

Whichever seating arrangement you choose, it will still be necessary to adjust the height and floor position frequently during an observing/sketching session as the Moon traverses the sky at a considerable rate and your binoculars or telescope will need to move with it!

12.3.2 Lighting

A battery powered headlamp or a low wattage electric lamp fixed to your drawing board is ideal for most lunar sketching, giving the advantage of leaving both hands free to work with the materials and the scope. Alternatively, hang a headlamp or a hand held lamp by a string from the eyepiece holder of your telescope, adjusting the length such that the light hangs several inches above the clipboard/sketchpad. This avoids the potential problem of banging your headlamp into your eyepiece each time you look down at your drawing or of creating extra glare around the eyepiece due to reflected light from your headlamp. If you are sitting and can lay the clipboard/sketchpad on your lap, you may even prefer to hold a small flashlight in your hand while drawing with the other hand.

Given that the Moon is so bright, it is fine to use a white light, particularly if you are sketching on white paper. The light level will be similar at the eyepiece and the sketchpad, and your eyes will not need to adjust very much when moving between them.

A red or blue light will provide softer lighting conditions to work by and is preferred by some lunar sketchers when drawing on black paper.

12.3.3 Clothing

Always wear clothing appropriate for the season to keep you cozy at the eyepiece. You will rapidly lose your concentration when sketching if you

Fig. 12.3.1

are cold. For observers living in a cold climate, the same advice applies as is general for outdoor living. Wear thin layers, a warm and windproof jacket or coat, sturdy footwear, plus a hat and gloves. Thermal base layers are recommended if the outside temperatures are sub-zero.

Depending on how cold your hands usually get, there are various glove options available. Fingerless gloves (or mittens where the entire finger region can be flipped back) work well for some folk. An alternative is to wear close fitting, thin Polartec fleece gloves. These still allow great dexterity when sketching and also act as a built in cloth for blending! Large pockets in your coat or jacket are not only good for holding hand-warmers (see below), but also for temporarily storing pencils/erasers, etc., as well as eyepieces and other astronomical paraphernalia.

12.3.4 Central Heating!

No, not the indoor variety; but if conditions are really extreme, it might be worth investing in some heated garments as used by motor bikers. Heated vests, gloves, and socks are all readily available, even if a little expensive! Another trick is to put a hot water bottle inside your jacket or coat. Reusable or chemical hand warmer heat packs can be bought from most good camping and outdoor stores and are very good for giving cold fingers a boost of heat.

If you suffer from neck problems, a chemical heat pack works wonders tucked in a muffler around your neck. You can even purchase mufflers with pockets specifically created to hold the chemical packs! You may also want to try the heat packs tucked in your boots or near your kidneys as a trick to keep your whole body a little warmer on those damp, cold nights.

Hot drinks are comforting and warming, but keep them well away from your sketch! Use a covered insulated travel or camping mug to keep drinks warmer for longer.

12.4 Miscellaneous

12.4.1 Planning Your Sketching Session

What will be on view on the Moon on any given night? When planning ahead for an observing and sketching session, a great tool to use is the free, downloadable Virtual Moon Atlas (VMA). This will show you the current lunar phase on a zoom-able and highly detailed lunar map for any given date and time. Among its myriad functions, it displays a list of the features that will be visible along the terminator with their detailed descriptions, and it has a search option if you wish to locate a specific target.

There are iPod apps that are useful for planning such as Moon Globe HD by Michael Howard. It uses Moon image data from the Clementine spacecraft, and the topography data is from the laser altimeter instrument on the Lunar Reconnaissance Orbiter. If you have an iPad, you can move the terminator with a swipe of your fingertip, change the telescope mode, zoom in or out, search features, and change the time/date as well as countless other features to explore.

Other useful sources of current information include monthly astronomy magazines, general planetarium software (some are freely downloadable), plus there are many useful astronomical websites (see Appendix C).

You are probably already aware of the general sky areas where the Moon is visible from your favorite observing site. However, before starting a sketch, it is worth checking that you know the path of the moon for the few hours ahead so that you won't have to move your equipment during the sketch because of trees or buildings, etc. that might obscure your view.

If you are after a specific target which is only visible at or around last quarter Moon, then provided that the weather forecast is good (and you are not lucky enough to have the use of an observatory), it is worth considering setting up your astronomical equipment the evening beforehand. This lunar phase is only observable during the early hours of the morning, which is a particularly unsociable hour to be setting up when you might prefer to invest the time solely in the sketch itself!

12.4.2 *Identification*

A good lunar atlas is a very useful aid when trying to identify what you have drawn. It is not always obvious what your chosen target is at the time of the observation as the ever-changing light on the lunar surface can play many tricks on you! Of particular use when at the eyepiece is Sky & Telescope's laminated *Field Maps of the Moon*, available in both normal and mirror image versions. As an *aide memoire* at the end of your session, it is worth taking a moment to zoom right out by putting in a really low power eyepiece and draw a 2″ circle for the lunar disk using an eyepiece cover as a crude circular template. Add the terminator as seen (remember that you might have a mirror image view), and then mark the approximate position of the feature you have been drawing. The lunar observing templates in Appendix A have ready-made finder Moons at the top left of the forms specifically for this.

12.4.3 *General Tips*

- To establish the scale of your sketch, outline the size of the most prominent feature first and then make reference to its size and position to compare and place all the other features in your sketch.
- A CCD framing eyepiece with various rectangular grids can be used to define the area of your sketch.
- Balance your sketch by working on different areas for a few minutes at a time. This helps the strength of the overall drawing and means that you should have something worthwhile if the weather suddenly changes and ends the observing session.
- If you are left-handed you may find it useful to sketch from right to left whenever possible to minimize smearing, and vice versa if right-handed.
- It is a good idea to record your observational data such as subject, start and stop times, optical equipment used, weather conditions, Antoniadi or Pickering numbers to characterize the seeing, transparency, as well as general notes about the sketch. You may find it helpful to use a template that can be filled out with all the pertinent data and attached to the back of your sketch (see Appendix A).

A Final Note from the Authors

We hope that you enjoyed these tutorials and that they have encouraged you to take up the satisfying adventure of lunar sketching in the media of your choice. The road to reaching and then surpassing your expectations might occasionally be a challenging one; however, the time you invest will amply repay you by increasing your visual observing skills as well as the quality of your sketches.

No matter how well you achieve mastery of media or technique, Selene will inevitably present new sights and challenges through her ever-changing dichotomy of shadow and light. Changes in light angles produced by the 18-year Saros cycle mean that no two nights will ever be exactly the same, so even if you sketch every night that the Moon's phase and weather permit, you can be assured that you will never run short of sights that inspire the lunar artist in you.

Richard Handy, Deirdre Kelleghan, Thomas McCague, Erika Rix, and Sally Russell

Appendix A

Observing Forms

Lunar Observation Record

Target Location

Date:
Time:

Target(s):

Rukl Map #	Phase:	Lunation:	Illumination %:
Libration Lat:	Libration Lon:	Altitude:	Azimuth:

Observing Location:

Observing Instrument:	Focal Length:

Eyepieces:	Barlow:	Filters:	Magnification:	
Temperature:	Humidity:	Wind/Clouds:	Seeing:	Transparency:

Notes:

Template design by Erika Rix - PCW Memorial Observatory (2010)

Observing Forms

Lunar Observation Record

Target Location

Date:
Time:

Target(s):

| Rukl Map # | Phase: | Lunation: | Illumination %: |
| Libration Lat: | Libration Lon: | Altitude: | Azimuth: |

Observing Location:

| Observing Instrument: | | Focal Length: |

| Eyepieces: | Barlow: | Filters: | Magnification: |
| Temperature: | Humidity: | Wind/Clouds: | Seeing: | Transparency: |

Notes:

Template design by Erika Rix - PCW Memorial Observatory (2010)

Appendix B

Glossary

Acrylic paint Fast-drying water-based paint that contains pigment suspension in acrylic polymer emulsion. This paint can be diluted in water during application but will become water resistant after drying.

Anchor marks Points of a sketch in which all additional markings are referenced to for sizes and positions.

Antoniadi scale Scale used to record atmospheric turbulence, devised by E. M. Antoniadi.
I Perfect seeing with no quivering
II Slight quivering with moments of calm
III Moderate seeing
IV Poor seeing with constant tremors
V Very poor seeing to the point that it is near impossible to create a sketch

Art gum eraser Soft, coarse rubber eraser that is useful for erasing large areas without damaging the paper. It tends to crumble and leave residue as it is used, so care must be given while removing the residue off your sketch.

Artist's palette (with deep wells) Container with multiple wells (mixing areas) for paint or ink. Glazed ceramic flower palettes are recommended as they do not stain and are easily rinsed clean. Because they are heavy, they stay firmly in place when in use so are less prone to spillage. Lightweight plastic palettes may stain during use but they are far cheaper and will otherwise work just as well.

Bulb air blower Rubber device used to manually blow contaminates off lenses or paper. Can be found in photography shops.

Blending stump Tool used for blending markings made by graphite, charcoal, or pastels. Similar to a tortillon, it is made of tightly wrapped paper, felt, or leather and is pointed at both ends. It generally produces a softer blend and has a broader stroke than a tortillon. Various sizes are available.

Carbon pencil Made from clay and lamp black (sometimes blended with charcoal or graphite). It has a fine, smooth grain with a matte finish.

Carpentry pencil sharpener Plastic sharpener that has a wide opening allowing flattened lead carpentry pencils to easily be sharpened. Some have multiple blades for both the vertical and horizontal edges of the pencil and work very well for sharpening Conté crayons.

Chamois Soft leather cloth used for blending graphite, charcoal, or pastels. Especially useful for large areas or where very smooth blending is required.

Charcoal (artist's) Dark gray/black carbon substance made from heating wood in a kiln without air. It is available in a broad range of dynamic tones and is particularly useful for nighttime astronomical sketching because of its matte, non-glare appearance while illuminating sketches with artificial lights. A fixative should be used to preserve the completed sketch.

Glossary 219

Charcoal (compressed) Charcoal powder mixed with a gum binder to produce flat or round compressed sticks.

Charcoal holder Wood-handled mechanism used to insert and hold round sticks of charcoal for drawing.

Charcoal pencils Round pieces of compressed charcoal wrapped with paper or wood sheaths.

Charcoal powder Charcoal dust/powder that can be used over large areas of the sketch to tone the background or used to draw smoother areas of the sketch by means of a loaded blending stump. Charcoal powder can be purchased in artist-grade or you can gently shave the sides of compressed charcoal with a utility knife to form small piles of powder.

Charcoal (vine) Round sticks of charcoal created by burning sticks or twigs of wood in a kiln without air. Willow is the preferred wood because of its even, fine consistency. Grades of hardness are available in soft, medium, and hard.

Charcoal (willow) Vine charcoal made from willow. Preferred for its even, fine consistency.

Circle protractor Template tool that is useful for drawing circles on paper.

Colored pencils Pencils that have wax-like bases with added pigments to produce a variety of colors. They are easily blended with each other and waterproof.

Compass Technical tool used to draw circles and arcs.

Conté crayons/pencils Chalk and pencils consisting of graphite powder combined with clay. They come in an assorted range of hardness and color, producing rich textured markings. Both Conté crayons and pencils are softer than ordinary pencils and chalk and tend to smudge easily. They retain their rich color and adhere to the paper much better than ordinary chalk. Use of a fixative is recommended to preserve the finished sketch.

Cosmetic brush Soft-bristled brush that is normally used for cosmetics but that can be useful for brushing debris off of sketches.

Craft knife Short, sharp blade mounted on a pencil-shaped holder that can be used for sharpening pencils and erasers.

Craft needle Steel tool with various tip attachments that is intended for use with card crafting. When using with pastels, the needle attachment is useful for etching, while the other attachments can make interesting marks. The craft needle is thicker and stronger than a quilling needle and produces a thicker marking.

Cross-hatching Technique of shading by making a set of small repetitive parallel lines, then repeating the process with an additional intersecting set of parallel lines. This results in a textured, yet overall fairly uniform shaded area. Cross-hatching is particularly useful in graphite pencil sketching when shading broad areas.

Daler-Rowney Bockingford watercolor paper An acid-free, fine-grain watercolor paper made from wood pulp, available in a variety of sizes and weights.

Daler-Rowney Canford paper Smooth medium-weight (150 g/m^2) paper with a matte finish, ideal for pastels and Conté crayons.

Danjon scale Method used to rate the darkness of a lunar eclipse during the time of totality. This scale ranges from 0–4 (darkest to brightest) during totality of the eclipse.

Drawing board A smooth surfaced board usually made from wood, hardboard or MDF, used as a support for single sheets or pads of paper. (Fig. 5.3.1 in Chap. 5) Many sizes and variations are available, some having in-built spring clips to hold the paper in place. Ideally drawing boards should be lightweight to remain comfortable in use.

Dry cleaning pad Bag filled with fine grit-free powder that absorbs dirt and particles off sketching paper without abrading the surface.

Easel Frame made of wood or plastic that holds paper or art boards in place while sketching.

Easel, field Small wooden or metal easel that can be used outside.

Easel, gallery (studio) Large wooden or metal easel that would be too heavy or cumbersome to easily set up or use outside.

Eraser shield Thin metal sheet with various opening sizes and shapes that is used to make precision erasures without smearing.

Etching Technique of creating marks on a hard surface by cutting into it with a sharp tool; the technique of using acid on a hard surface to create etched marks.

Felt tipped (artist's) pens Fade-resistant, acid-free, felt-tipped pens with an India ink pigmented formula. Most are water resistant when dry and are available in assorted precision tip diameters. These can be used in lieu of India ink with quills and are especially useful for stippling an entire sketch directly at the eyepiece.

Fixative Spray agent used to preserve charcoal, pastel, and graphite sketches, preventing them from flaking and smearing. Workable fixatives are available that allow you to add additional layers to your sketch, spraying after each layer.

Gradation Transition of tone or color value.

Graphite pencils Pencils that are made from a combination of clay and graphite encased in wood. Graphite typically lacks the dynamic range of charcoal, but because of its finer grain, has the ability to create smooth, finer detail. Graphite markings tend to be shiny, especially compared to the matte finish of charcoal. This may create difficulty seeing the details of the drawing when sketching under the glare of brighter lights, whether artificial or in direct sunlight.

Graphite pencils (solid) Solid graphite pencils that are made entirely of woodless graphite but are otherwise similar to regular graphite pencils regarding consistency and dynamic range.

India ink Intense black ink used on absorbable media by dipping a brush or a quill into the ink to create broad strokes, washes and precise details.

Kneadable (kneaded) eraser Soft putty-like eraser that absorbs and lifts graphite and charcoal off paper. It can be kneaded and shaped for precision erasing and is best used for smaller areas.

Glossary 223

Liquidtex Brand of mediums that work well on porous surfaces with a variety of effects.

Loaded blending stump Process of rubbing or dipping the tip of a blending stump in graphite, charcoal, or pastels, and then drawing directly with the blending stump.

Masking fluid Quick-drying latex solution used to block out areas of watercolor paint or ink while washes are applied, thereby retaining the white (or previously painted) paper surface underneath. Once the paint or ink has dried, the masking can easily be removed by gently rubbing it with an eraser or fingertip.

Masking tape Low tack sticky tape used for lightly securing paper onto a board. For many paper types, it can easily be removed without damaging the surface of the paper or leaving sticky residues.

Oil paint Slow-drying paint consisting of pigment and drying oil such as linseed oil. Can be mixed with solvents to change its viscosity.

Oil pastels Waxy drawing sticks comprised of pigments mixed with a non-drying oils and wax binders. They are less powdery and have harder edges than soft pastels making them less likely to smudge and more difficult to blend in comparison.

Paintbrush (round) All-purpose traditional paintbrush available in a wide range of sizes. The most commonly used sizes are 0–20, where size 0 is the smallest. The natural or synthetic hairs usually taper to fine points making these brushes suitable for precise strokes and detail work. Natural sable hair-type brushes, which are prized by watercolorists, are supple and have excellent paint-carrying capacities but are generally very expensive. Modern synthetic fiber brushes are far more economical yet still have moderate-to-good paint-handling qualities and are equally suitable for ink wash sketching.

Painting knife Blunt knife with a flexible, non-sharpened blade that is used in place of a paintbrush. Comes in assorted styles, shapes, and sizes. There is usually a large crank between the blade and the handle to prevent the artist's hand from touching the canvas.

Palette knife Blunt knife with a flexible, non-sharpened blade that is used for mixing paint colors and other mediums on a palette before applying them to the canvas. Unlike a painting knife, the palette knife is symmetrical with a shallower crank between the blade and the handle.

Pastels (soft), Mungyo Sophisticated chalk with wonderful rich gray tones, and pure black and white tones, that are excellent for lunar work.

Pastels (soft) Chalk-like sticks comprised of rich pigments plus binders. The softer varieties, which generally have higher pigment content, are wrapped in paper to retain their integrity during the drawing process. Drawn pastel is very easily smudged and blended giving a smooth, matte finish but create a lot of dust in the process. Pastels are softer than Conté crayon and are readily erased; so finished sketches should be protected with a spray fixative or carefully covered when stored to minimize smudging.

Pencil grade Classification for the hardness of pencils such as charcoal, graphite, and carbon. H=hardness (hard grade, lighter markings). F=fine point (medium markings). B=blackness (soft grade, darker markings). …5B-4B-3B-2B-B-HB-F-H-2 H-3 H-4 H-5 H…

Pickering scale Scale used to record atmospheric turbulence, devised by W. H. Pickering, Harvard Observatory: 1 (very poor) through 10 (excellent).

Quill Writing tool originally made from a feather. Ink traveled up the shaft of the quill when dipped into an inkwell allowing several lines of script to be written before reloading the shaft. Today, it is more common to use a dip (nib) pen that consists of a metal nib mounted on a holder usually made of wood or plastic. Most dip pens do not have shafts and the ink is held solely in the curvature of the metal nib allowing only a few words to be written before the need to reload with ink. Nibs come in assorted tip points and are very useful for stippling as well as cross-hatching and calligraphy.

Quilling needle Long, thin pointed needle on a wooden handle that is mostly used in creative card making. It is also useful to for etching fine lines while using pastels. (Fig. 2.1.7 in Chap. 2)

Rite in the Rain paper All-weather writing or sketching paper that remains durable under extremely damp conditions. This paper is excellent for high-humidity areas where normal sketching paper loses its integrity. *www.riteintherain.com*

Glossary

Sandpaper block Layers of fine sandpaper on a flat stick that is used for sharpening and cleaning tools such as blending stumps, tortillons, pencils, charcoal, and pastels.

Sponge Man-made or sea sponges that have a variety of art uses such as blending, creating textures or patterns, and stenciling. They can be cut into various sizes and shapes specific to your needs.

Strathmore paper Acid-free recycled paper that comes in a variety of textures and weights.

Stippling Technique of producing degrees of shading by drawing small dots with a pen or paintbrush.

Tortillon Tool made of tightly wrapped paper that is especially useful for precision blending of graphite, charcoal, or pastels. The tip can be sharpened to a fine point with sandpaper. Various sizes are available.

Triangulation Process of envisioning a triangle that connects two reference markings on a sketch that assists the proper placement of a third marking.

Vinyl (plastic) eraser Soft non-abrasive eraser that is suited for lighter marked precision areas and can be sculpted with a utility knife specific to your needs. Smearing tends to occur if you try to erase darker markings or large areas.

Watercolor paper Paper that is treated or sized so that it can accept color yet withstands repeated application of washes without the surface deteriorating.

Watercolor pencils Pencils that are designed to create strokes on paper, be saturated with water, and then the markings spread with brushes; however, they can also be used without water to create fine, soft markings.

X-Acto knife (craft knife) Short, sharp blade mounted on a pencil-shaped holder that can be used for sharpening pencils and erasers.

Appendix C

Resources

Online Resources

Astronomical Sketching

http://www.asod.info/	ASOD – Astronomy Sketch of the Day
http://www.cloudynights.com/ubbthreads/postlist.php/Cat/0/Board/Sketching	Cloudy Nights Telescope Reviews – Sketching Forum: friendly community of astro-sketchers discussing techniques, tools, and advice
http://groups.yahoo.com/group/astrosketch/	Yahoo Astrosketch – sketching forum

Lunar

http://www.cloudynights.com/ubbthreads/postlist.php/Cat/0/Board/lunar	Cloudy Nights Telescope Reviews – lunar forum dedicated to the observation and appreciation of our Moon
http://aa.usno.navy.mil/data/docs/RS_OneDay.html	Complete Sun and Moon Data for 1 day
http://www.inconstantmoon.com/	Inconstant Moon
http://lpod.wikispaces.com/	LPOD – Lunar Photo of the Day
http://www.lpi.usra.edu/lunar/	Lunar and Planetary Institute – research institute that provides support services to NASA and the planetary science community
http://www.stargazing.net/David/moon/atlasindex.html	Moon Image Atlas by David Haworth
http://nssdc.gsfc.nasa.gov/planetary/planets/moonpage.html	NASA – Lunar and Planetary Science: The Moon
http://www.psrd.hawaii.edu/Aug00/newMoon.html	PSRD: A New Moon for the Twenty-First Century, by G. Jeffrey Taylor: geological study
http://the-moon.wikispaces.com/Rukl+Index+Map	Rukl-Based Index to the Moon, by Jim Mosher

(continued)

Appendix C (continued)

http://www.lunar-occultations.com/rlo/rays/rays.htm	The Robinson Lunar Observatory – Lunar Sunrise/Sunset Rays
http://www.astrosurf.com/avl/UK_index.html	VMA – Virtual Moon Atlas by Christian Legrand and Patrick Chevalley: freeware for all levels of lunar study and observation planning
http://www.cloudynights.com/item.php?item_id=1273	VMA Tutorial – Virtual Moon Atlas Tutorial for beginners on Cloudy Nights by Erika Rix
http://cityastronomy.com/	Whitepeak Observatory – superb amateur site devoted to lunar geologic studies by Mardi Clark
http://tech.groups.yahoo.com/group/lunar-observing/	Yahoo Lunar Observing Forum

General Astronomy

http://www.astrosociety.org/index.html	Astronomical Society of the Pacific
http://www.astronomytogo.com/	Astronomy to Go, education outreach organizations and home of the Yard Scope
http://www.cloudynights.com/	Cloudy Nights Telescope Reviews – comprehensive, friendly community of amateur astronomers
http://cleardarksky.com/csk/	CSC – Clear Sky Chart Homepage
http://www.deirdrekelleghan.net/	Deirdre Kelleghan's Astronomy Website
http://solarsystem.nasa.gov/index.cfm	NASA – solar system exploration
http://www.pcwobservatory.com/	PCW Memorial Observatory by Erika Rix
http://www.slackerastronomy.org/wordpress/index.php	Slacker Astronomy with excellent Podcasts
http://www.astroleague.org/	The Astronomical League
http://beltofvenus.perezmedia.net	The Belt of Venus by Jeremy Perez
http://scienceworld.wolfram.com/astronomy/	World of Astronomy by Eric Weisstein

Recommended Books

Cook, J., *The Hatfield Photographic Lunar Atlas*, Springer Science+Business Media, LLC, New York 1999. ISBN-13: 978-1852330187

Cook, J., *The Hatfield SCT Lunar Atlas: Photographic Atlas for Meade, Celestron and other SCT Telescopes*, Springer Science+Business Media, LLC, New York 2005. ISBN-13: 978-1852337490

Grego, P., *Astronomical Cybersketching: Observational Drawing with PDAs and Tablet PCs (Patrick Moore's Practical Astronomy Series)*, Springer Science+Business Media, LLC, New York 2009. ISBN-13: 978-0387853505

Grego, P., *Moon Observer's Guide*, Firefly Books 2004. ISBN-13: 978-1552978887

Handy, R., Moody, D., Perez, J., Rix, E., Robbins, S., *Astronomical Sketching: A Step-by-Step Introduction (Patrick Moore's Practical Astronomy Series)*, Springer Science+Business Media, LLC, New York 2007. ISBN-13: 978-0-387-26240-6

Hill, H., *A Portfolio of Lunar Drawings (Practical Astronomy Handbooks 1)*, Cambridge University Press, New York 1991. ISBN-13: 978-0521381130

Rükl, A. (ed. Seronik, G.), *Atlas of the Moon: Revised, updated edition*, Sky Publishing Corporation, Cambridge, MA 2007. ISBN-13: 978-1931559072

Rükl, A. (illustrations), *Sky & Telescope's Field Map of the Moon*, map edition, Sky Publishing Corporation, Cambridge, MA 2007. ISBN-13: 978-1931559225

Rükl, A. (illustrations), *Sky & Telescope's Mirror-Image Field Map of the Moon*, map edition, Sky Publishing Corporation, Cambridge, MA 2007. ISBN-13: 978-1931559294

Wood, C., *The Modern Moon: A Personal View*, Sky Publishing Corporation, Cambridge, MA 2007. ISBN-13: 978-0933346994

* You can support LPOD (Lunar Photo of the Day) when you buy any book from Amazon through LPOD: http://www.lpod.org/?page_id=591

Index

A
Acetone, 10
Acrylic base resin, 10
Agrippa, 181–184
Alpine Valley, 185, 189
Anchor marks, 217
Antoniadi scale, 217
Arago, environs of, 76–80
Archiving, 195, 203–205
Aristillus, 185, 188, 189
Artist's palette, 133, 218
Autolycus, 38, 185, 188

B
Basin rings, 120
Bessel, 33
Binocular, 123, 144, 147, 160, 164–166, 205–207
Birt, 100, 103–106
Blending stumps
 loaded, 46, 47, 55, 63, 83, 110, 130, 219, 223
 stumps rubbed in charcoal, pastels, and graphite (*see* Blending stumps, loaded) tortillon, 1, 2, 4, 53, 54, 82, 83, 103, 104, 106, 225
Bulb air blower, 218
Bullialdus, 95, 96, 185, 192
Bürg, 108, 110

C
Canvas, 94–98, 100, 195, 204, 223, 224
Card stock, 202
Carpentry pencil sharpener, 218
Cassini, 185, 189
Catharina, 112, 115, 119, 185, 189, 190
Cauchy, 64–68, 116–119
Central mountain, 16, 17, 21
Chalk. *See* Contè; Pastels
Chamois, 1, 5, 53, 55, 82, 103, 106, 125, 173, 175–177, 218
Charcoal
 compressed, 2, 3, 53, 55, 82, 104, 124, 126, 219
 pencils, 1–6, 53, 54, 56, 82–84, 86, 103–106, 123, 126, 174–176, 219
 vine, 2, 219
Circle Protractor, 129, 130, 219
Clavius, 21–24, 190
Cleomedes, 27
Clothing, 195, 207–208
Colored
 lunar eclipse, 166
 pastels, 166–171
 pencils, 124, 125, 219
Comfort
 eyepieces, 206
 general, 195, 207–208
 observing, 195, 199, 205, 207
Compass, 123, 124, 133, 173, 174, 206, 220
Complex, 16, 18, 58, 61, 81, 91, 97, 112, 198
Contè
 crayons, 7–9, 17–22, 25–30, 32, 37, 58–61, 76–80, 87–91, 108, 116, 124, 153, 156, 163, 165, 189, 196, 198, 218, 220, 221
 pastel pencil, 7, 51, 87, 89, 91–94, 108, 110, 125

Copernicus, 1, 15–18, 81, 154, 164, 171, 177, 182, 185, 193, 204
Craft Needle, 163, 165, 220
Crater
　Agrippa, 181–184
　Arago, 76–80
　Aristillus, 185, 188, 189
　Autolycus, 38, 185, 188
　Bessel, 33
　Birt, 104, 105
　Bullialdus, 95, 96
　Bürg, 108
　Cassini, 185, 189
　Catharina, 112, 115, 119
　Cauchy, 66, 116
　Clavius, 21
　complex, 16, 18, 81, 91
　Copernicus, 1, 16, 17
　Cyrillus, 185, 189, 190
　Delisle, 181–184
　Diophantus, 181–184
　Eratosthenes, 11–15
　Gassendi, 7–11
　Geminus, 1–7
　Hortensius, 153–157
　Hyginus, 54
　Kepler, 81–87, 90
　Langrenus, 19
　Maginus, 91, 93
　Maurolycus, 185, 191
　Milichius, 154
　Nicollet, 100
　Parry, 181
　Petavius, 185, 191
　Pitatus, 99
　Porter, 21, 22
　Prinz, 46
　Proclus, 133, 135
　Ptolemaeus, 192
　Rosse, 96
　Rutherfurd, 21
　Schiller, 191
　Theophilus, 180
　Triesnecker, 60–62, 64
　Tycho, 33, 100, 160
　Wolf, 100
Craterlet, 3, 23
Crisium Ring, 26
cross-hatching, 13, 48, 113, 120, 121, 199, 220, 224
Cybersketching, 181–184
Cyrillus, 185, 189, 190

D
Danjon scale, 162, 221
Delisle, 181–184
Diophantus, 181–184
Dobsonian, 10, 24, 28, 36, 48, 75, 90, 93, 100, 101, 111, 118, 128, 162, 166, 177, 187, 192

Dome
　Cauchy Omega and Tau, 117
　Mons Gruithuisen Gamma and Delta, 149–153
Dorsa/Dorsum
　Oppel, 27
　Smirnov (Serpentine Ridge), 69–75
Drawing board, 11, 29, 49, 50, 76, 112, 133, 140, 150, 167, 202, 207, 221
Dry cleaning pad, 221

E
Earthshine, 130, 142, 145, 173–177
Easel, field, 15, 23, 25, 26, 202, 221
Eclipse
　sketching, 170
　sketching in color, 159, 164, 166, 221
　umbral, 160, 168, 169
Ejecta, 1, 16, 17, 19, 32, 37, 81, 87, 90, 95, 97
Environs of Arago, 76–80
　Equipment. *See also* Light source or Mountsequatorial platform, 10, 36, 48, 64, 75, 90, 93, 111, 162, 187, 206
　eyepieces, viewing comfort, 195, 206
　observing, 195, 205
　seating, 207
　telescopes, 160, 191, 195, 205
Eraser
　art gum, 7, 18, 38, 58, 87, 90, 91, 108, 153, 159, 217
　kneaded, 3, 69, 222
　Pink Pearl, 18, 38, 58, 70, 87, 90, 91, 153
　plastic (vinyl), 29, 225
　shield, 33, 34, 45, 61, 73, 149, 221
Eratosthenes, 11–15
Escarpment. *See* Scarp
Etching, 221
Eyepieces, viewing comfort, 195, 206

F
Facial tissue, 33, 45, 61, 62, 73, 128
Fault. *See* Lacus Mortis
Filing, 173
Fixatives, 163, 173, 203, 222

G
Gassendi, 9–11
Geminus, 1–7
Gradation, 222
Graphite
　compressed, 197
　pencils, 11–15, 33, 62, 150, 182, 195, 197, 224

H
Heating, 195, 208
Herschel, J., 133, 137, 185
Hortensius, 153–157

Index

Humidity, 6, 57, 68, 86, 108, 127
Hyginus, 53–57

I

Identification, of sketched features, 195, 209
Ink
 black, 43, 44, 137, 222
 India, 42, 43, 133, 179, 183, 199, 221, 222
 wash, 132–139, 178, 179, 193, 199, 223
 white, 41, 45

K

Kepler, 81–87, 89, 90, 95, 96, 164, 171, 177
Knife
 craft, 76, 140, 167, 173, 174, 196, 198, 220, 226
 exacto, 2, 124
 painting, 223, 224
 palette, 95, 97, 98, 100, 118, 224

L

Lacus Mortis, 108–118
Langrenus, 18–21
Light source
 flashlight, 167, 197
 headlamp, 207
 sketch lighting, 33, 81, 166, 208
Liquidtex, 94, 223
Lunar
 eclipse, 159, 160, 162, 163, 165, 168, 221
 eclipse, sketching with color, 160, 166
 limb, 142, 145, 161

M

Maginus, 91–94
Mare (sea/maria)
 Crisium, 25–28, 37, 182
 Imbrium, 37, 41, 185, 188
 Orientale, 185, 186
 Serenitatis, 33–36, 69–71, 73
Masking
 fluid, 134, 223
 tape, 137, 223
Massifs. *See* Mons
Maurolycus, 185, 191
Media overviews, 196–200
Milichius, 153–157
Mistakes, correcting, 33
 Mons (mountain). *See* MontesGruithuisen, 149–153
 Pico, 41–45, 49–52
 Montes (mountain range). *See* MonsApenninus, 11, 37–41, 125
 Harbinger, 45–49
 Teneriffe, 37, 41–45, 49–52
 Moon. *See* Phaseslimb, 18, 25, 129, 161, 192

Mounts
 Dobsonian, 28, 162, 206
 driven, 11, 15, 32, 52, 79, 115, 152, 171, 189, 206
 equatorial, 206
 non-driven, 11
Mungyo soft pastels, 25, 94, 144, 224

N

Nicollet, 100

O

Observing
 equipment (*see* Equipment) forms, 67, 209
Oil
 paint, 223
 pastel crayons, 159, 160

P

Paint
 acrylic, 94–96, 200, 217
 oil, 223
 watercolor, 134, 223
Paintbrush, 133, 143, 199, 223, 225
Painting knife, 223
Palette, artist's, 133, 218
Palette knife, 95, 97, 98, 100, 118, 224
Palus (marsh)
 Epidemiarum, 28–33
 Somni, 28
Paper
 Artagain, 7, 10, 18, 37, 42, 58, 87, 90, 91, 93, 108, 111, 119, 123, 125, 153, 173, 202
 black, 9, 15, 18, 19, 21, 24–26, 28, 29, 37, 41, 42, 49, 58, 59, 76, 77, 79, 87, 89, 91, 93, 108, 109, 116, 117, 119, 121, 125, 127, 140, 144, 145, 147, 153, 155, 157, 159, 161, 163, 165–167, 169, 171, 173, 174, 189, 190, 192, 202
 cartridge, 11, 112, 128, 150, 159, 200, 201
 colored, 139–144
 copy. (*see also* Cartridge), 33, 128, 159, 173, 175, 182, 195, 203, 204Daler-Rowney 'Bockingford' watercolor, 221
 Daler-Rowney 'Canford,' 29, 49, 76, 140, 167, 173, 202, 220, 221
 durability, 200
 Rite in the Rain, 11, 53, 65, 82, 85, 103, 201, 224,
 sizes for sketching, 199, 217
 Strathmore 'Artagain,' 18, 37, 42, 58, 87, 91, 108, 119, 123, 153, 173, 202
 thickness/weight, 200
 tooth/roughness, 200
 towel, 7–9, 33, 45, 61–63, 128, 130, 159–161, 197, 198
 watercolor, 132–134, 136, 179, 197, 201, 220, 223, 226
 white, 33, 64, 65, 67, 81, 151, 159, 161, 163, 164, 173, 186, 187, 189, 191, 201

Parry, 1881–184
Pastel
 colored, 166–171
 grated, 116, 118, 163–166, 200
 Mungyo, soft, 25, 94, 100, 144, 224
 oil, 159–162, 198, 223
 pencil, 49, 50, 88, 91–94, 108, 125–127, 196, 198
 Schmincke, soft, 144
 Sennelier, soft, 94
Pen
 artist's, 65, 182, 221
 black felt-tipped, 64–68
 white felt-tipped paint, 119–122
Pencil
 carbon, 69–72, 197, 218
 colored, 124, 125, 219
 Conté, 8, 18, 37, 38, 58, 90, 153–154, 190, 192, 196–197, 201
 gradation, 179
 graphite, 11–15, 33–36, 45–49, 61–64, 73–75, 111–115, 128–132, 149–153, 159, 160, 163, 182, 186, 188–191, 193, 195, 197, 220, 222
 pastel, 7, 49, 50, 88, 92, 108, 124–126, 196, 198
 watercolor, 197, 226
Pencil grading, 224
Permanent marker, 65, 199
Petavius, 185
Phase
 first quarter, 128–132
 full, 123–128
 gibbous, 133, 135, 137
 waning, 1
 waning gibbous, 36, 108, 128–132
 waxing, 48
 waxing crescent, 139–144
 waxing gibbous, 48, 132–139, 144–147
Pitatus, 99
Planning, of observing sessions, 208, 228
Plato, 41–44, 133, 177, 185, 193
Porter, 21, 22
Preservation of sketches, 202–203
Prinz, 46, 185, 189
Proclus, 28, 133, 135, 164
Protractor, 128, 130, 159, 160, 206, 219
Ptolemaeus, 185, 192

Q
Quill, 224
Quilling needle, 25, 163, 224

R
Rays
 crater, 131, 133–135, 137
 ejecta, 81, 87, 90, 96
 sunlight, 91
Resin, acrylic base, 10
Ridges. *See* Dorsa
Rille. *See* Rima

Rima (lava channel, rille)
 Ariadaeus, 58–61, 181–185, 190
 Cauchy, 64–68, 116–119
 Hyginus, 53–57
Rimae (group of rilles)
 Bürg, 108, 110
 Triesnecker, 58–64
Rite in the Rain, 1, 53, 65, 82, 85, 103, 201, 224
Rosse, 96
Rupes (scarp)
 Altai, 103, 111–115, 119–122
 Cauchy, 65, 66, 116–119
 Recta, 103–108
Rutherfurd, 21, 22

S
Sandpaper block, 7, 225
Scarp. *See* Rupes
Schiller, 185, 191, 192
Sea. *See* mare
Serpentine Ridge. *See* Dorsa Smirnov
Sharpening
 blending stump (tortillon), 2, 54
 pastels (chalks), 140, 167
 pencils, 61, 88, 124, 226
Sinus Iridum, 164, 181–184
Sketching
 binocular, 123, 160, 164, 165, 205, 207
 black on white, 10
 color on black, 7–11, 15–33, 37–45, 49–52, 58–61, 76–80, 87–94, 108–111, 116–119, 123–128, 140, 161, 163–171, 173–178, 207
 color on white, 8, 36, 48, 64–68, 159–162, 207
 Cyber, 181–184
 white on black, 8
Sketch lighting. *See* Light source
Sponge, 163, 225
Stippling, 64–68, 225
Storage of sketches, 203–204
Strathmore, 7, 18, 37, 42, 58, 87, 91, 108, 119, 123, 153, 173, 202, 225

T
Technique
 cross-hatching, 48
 etching, 221
 stippling, 225
 triangulation, 66
 watercolor, wet on dry, 132
Template circle, 140, 145, 167, 175
Terminator, 1, 2, 7, 8, 16, 17, 23, 25–27, 29, 30, 46–49, 51, 53, 69, 70, 73, 74, 76, 78, 91, 103, 108, 113, 115, 116, 119, 120, 126, 129, 133–134, 136, 141, 142, 145–146, 149, 164, 175, 181, 183, 189, 209
Theophilus, 178–180, 185, 189, 190
Tips, general, 195, 209
Tortillon. *See* Blending stumps

Index

Triangulation, 54, 66, 225
Triesnecker, 58–64
Tycho, 1, 33, 81, 94–101, 125, 133, 135, 160, 164, 171, 177

V
Virtual Moon Atlas, 205, 208, 228

W
Walled plain
 Cleomedes, 27
 Herschel, J., 133, 137, 185, 193
 Maginus, 91–94
 Plato, 41–44, 133, 177, 185, 193
Watercolor
 paper, 133, 226
 pencil, 226
 wet on dry technique, 132
Wolf, 100
Wolff, 69
Wrinkle ridges. *See* Dorsa

X
X-acto knife. *See* Exacto knife